Ex Libris

Anne Marie
Parker

Nature into Art

ENGLISH LANDSCAPE WATERCOLOURS

Lindsay Stainton

PUBLISHED BY BRITISH MUSEUM PRESS
IN ASSOCIATION WITH
THE NORTH CAROLINA MUSEUM OF ART

Published by British Museum Press
A division of British Museum Publications Ltd
46 Bloomsbury Street, London WC1B 3QQ

British Library Cataloguing in Publication Data
Nature into art: English landscape watercolours.
 1. English watercolour paintings – Catalogues
I. British Museum II. Stainton, Lindsay III. Nature into art:
English landscape watercolours from the British Museum
(Exhibition; 1991; Cleveland Museum of Art and North Carolina
Museum of Art). IV. Cleveland Museum of Art V. North
Carolina Museum of Art
759.2074
ISBN 0-7141-1649-1

Designed by Mavis Henley

Set in Monophoto Palatino Series 853 by
Southern Positives and Negatives (SPAN), Lingfield, Surrey
Colour origination by P. J. Graphics, London
Printed in Italy by Amilcare Pizzi, SpA, Milan

The exhibition *Nature into Art:*
English Landscape Watercolours from the British Museum
was organised by the North Carolina Museum of Art.
Glaxo Inc. is the sole sponsor of the exhibition.

The Cleveland Museum of Art
Cleveland, Ohio
January 15–March 10, 1991

North Carolina Museum of Art
Raleigh, North Carolina
March 23–June 2, 1991

CONTENTS

Preface

Lanscape, or Landscape, (An Art soe new in England, and soe lately come a shore, as all the Language within our fower Seas cannot fine it a Name, but a borrowed one...[from] the Duch.

So writes Edward Norgate in *Miniatura*, circa 1650, describing the rise of landscape art in England. Brought to England by itinerant Dutch artists in the late sixteenth and seventeenth centuries and merged with existing traditions of cartography and illuminated manuscripts, landscape developed into a distinct genre in England, partly as a consequence of Henry the Eighth's 1535 Act of Supremacy.

In addition to breaking from the Church of Rome, Henry's edict redistributed the wealth of the church to his supporters and also outlawed the production and display of religious art, setting the stage for the birth of an English school of landscape, and specifically landscape watercolours. The redistribution of wealth resulted in the creation of a landed gentry, and the education of this new class included learning to draw maps and prospects of their property. In *The Compleat Gentleman*, published in 1622, Henry Peacham recommends, 'I am bound also to giue [landscape]...for your exercise at leisure, it being a quality most commendable, and so many waies Vsefull to a Gentleman.' The king's ban on religious art contributed to the rebirth of Neoplatonic religious thought, which aesthetically equated the beauty of nature with God's beneficence. For the Neoplatonist, the goodness and beauty of nature were not merely a reflection of God, but actual symbols of God's goodness and wisdom.

English artists elevated the landscape watercolour to its highest level during the nineteenth century, attracting international attention and inspiring other artists to try their hand at the medium. Not all were successful, for in many ways watercolour and paper are the most unforgiving of all artistic materials. Corrections are difficult to make and never invisible. Unlike paintings and prints, watercolours do not improve with laborious working of the surface; they merely become murky and less luminous. Watercolour has always been the ideal medium to represent the beauty of the out-of-doors despite its technical complexities because it allows the artist to spontaneously and immediately capture a scene. Equally important to early landscape artists was convenience: watercolours and paper were the most portable materials available prior to the invention of the paint tube. This exhibition is a testimony to the tremendous range of both style and subject in British landscape artists' depiction of the beauty of their world, from John White's documentation of the New World to William Alexander's western gate of Peking. The works attest to the success and richness of the English school of landscape watercolour art.

The exhibition was first presented at the British Museum in 1985. Assistant Keeper Lindsay Stainton has been most generous in reshaping it for exhibition at the Cleveland Museum of Art and the North Carolina Museum of Art and has prepared this revised catalogue. Although somewhat smaller than the first exhibition, this show includes several important watercolours acquired by the British Museum since 1985, and we are honoured to be the first to share them with the public.

Our thanks are extended to Lindsay Stainton, who selected the watercolours and wrote the catalogue. Thanks are extended also to Bruce Robertson, whose knowledge and enthusiasm were vital to this project. Many individuals gave their time and talents to stage this exhibition, and we are

grateful to each one. At the British Museum, Janice Reading and Charles Collinson in the Prints and Drawings Department oversaw the many details involved with the transportation of these delicate works, as did Delbert Guthridge, registrar at the Cleveland Museum of Art, and Peggy Jo Kirby, registrar at the North Carolina Museum of Art. This handsome catalogue was edited by Jenny Chattington, and the production was supervised by Julie Young. New photography for the catalogue was undertaken by Graham Javes, Kevin Lovelock and John Williams, co-ordinated by Paul Dove.

The exhibition would not have been possible without the generosity of the Trustees of the British Museum. Their willingness to lend important pieces of their national heritage is greatly appreciated. The Director of the British Museum, Sir David Wilson, welcomes this opportunity to share this most characteristic form of British art with the American public. We are most grateful to Glaxo Inc., a subsidiary of British-based Glaxo Holdings p.l.c. Their generous support allowed this wonderful collection to come to Cleveland and Raleigh and to be viewed by American audiences.

EVAN TURNER
Director, Cleveland Museum of Art

RICHARD S. SCHNEIDERMAN
Director, North Carolina Museum of Art

5

Introduction

I have begun to take off a pretty view of part of the village, and have no doubt but the drawing of choice portions and aspects of external objects is one of the varieties of study requisite to build up an artist, who should be a magnet to all kinds of knowledge; though at the same time, I can't help seeing that the general characteristics of Nature's beauty not only differ, but are, in some respects, opposed to those of Imaginative Art; and *that*, even in those scenes and appearances where she is loveliest, and most universally pleasing.[1]

Samuel Palmer is here restating the age-old problem of reconciling Nature with Art. He expresses this in the most intense and personal — and thus Romantic — way. His older contemporaries Turner, Constable and Cotman expressed similar views, and artists and writers had pondered the question of how to portray the natural world since classical antiquity.

Aristotle, in his *Poetics*, had propounded the theory that even the most beautiful natural forms were inherently deficient and were thus unsuitable material for serious art. It was the *ideal* of Nature that was identified with ideal beauty, not its tangible form. The best-known proponent of the Aristotelian doctrine as it related to painting in England was Sir Joshua Reynolds, who in his *Discourses* to the Royal Academy between 1768 and 1790 elaborated on the theory and defined the ideal. For him the artist who faithfully reproduced nature was inferior to one who strove to discover its true inner essence hidden beneath outward visible forms.[2]

The theory of ideal beauty was evolved during the classical period for depicting the human figure, and the ideal resided in the combination of correct physical proportions and certain elevated moral principles. Only later was this ideal broadened to encompass other forms. During the Renaissance, when classical scholarship and art were being rediscovered, a hierarchy was established for categories of art. At its head was history painting, showing idealised figures taking part in some heroic or tragic story from the Bible, classical history or classical mythology. The genres of landscape, portraiture and still life were ranked in order below, and at first they were assumed not to require idealisation, as this was foreign to their purposes. The portraitist represented an individual man or woman, not a type. The landscape painter depicted actual nature; or rather, since his compositions were often invented, he depicted naturalistic effects such as hazy distances, light on trees and light on water. Perhaps surprisingly, even such an obviously (to us) ideal landscape painter as Claude Lorrain was praised in his own lifetime chiefly for his unrivalled skill in rendering these effects. Even if Claude was selective in how he depicted the beauties of Nature it was never suggested that he attempted to rise above nature to arrive at a theoretical ideal beauty.

However, during the eighteenth century the principle of hierarchy began to be admitted into the minor genres themselves. The first to hint at this for landscape painting was Roger de Piles, who in his *Cour de peinture par principes* of 1709 (translated into English in 1743) distinguished between two different categories, the heroic and the pastoral or rural. In the first 'if nature appears not there as we everyday casually see her, she is at least represented as we think she ought to be', whereas in the rural style 'we...see nature simple, without ornament, and without artifice'.[3] The former borrows from the rules of figure painting to make good the inherent defects of nature and is thus superior, but in the rural style nature appears 'with all these graces with which she adorns herself

much more, when left to herself, than when constrained by art'.[4]

By the second half of the century the hierarchy of landscape types was established. For example, in Salomon Gessner's *Brief an Herrn Fuesslin ueber die Landschaftsmalerey* (1770, widely-read in England in a rough translation of 1776), the author tells how he had begun by imitating nature exactly but how this had only led him to become over-involved in detail; he then decided to follow a progressive sequence of the best masters, from the Dutch painters to Salvator Rosa and Rubens, and finally to Claude and Poussin in whom he discovered 'the greatness, nobility and harmony' which his work had hitherto lacked.[5] Reynolds, in his *Discourses*,[6] places landscape among the comparatively inferior branches of art, but sets out a graduated range of landscape styles. 'There are, in works of that class, the same distinction of a higher and a lower style: and they take their rank and degree of proportion as the artist departs more, or less, from common nature, and makes it an object of his attention to strike the imagination by ways belonging especially to art'.[7] Unlike Gessner, Reynolds was prepared to find some merit in the work of the naturalists, particularly the Dutch landscape school — 'let them have their share of more humble praise'[8] — but he left no doubt as to where greatness lay:

If we suppose a view of nature represented with all the truth of the *camera obscura*, and the same scene represented by a great artist, how little and mean will the one appear in comparison of the other, where no superiority is supposed from the choice of the subject! The scene shall be the same, the difference only will be in the manner in which it is presented to the eye. With what additional superiority then will the same artist appear when he has the power of selecting his materials as well as elevating his style? Like Nicolas Poussin, he transports us to the environs of ancient Rome. . .or, like Claude Lorrain, he conducts us to the tranquility of Arcadian scenes and fairyland.[9]

Claude is no longer represented, as he had been by seventeenth-century critics, as a naturalist. On the contrary, said Reynolds, 'Claude Lorrain. . .was convinced that taking nature as he found it seldom produced beauty'.[10]

Almost wherever we look, we find the eighteenth century insisting that the good landscapist, like the serious figure painter, improves on nature[11] — a doctrine that also underlay the whole theory of landscape garden design, for which the very word 'improvement' was a common synonym. The same notion runs through the literature of the Picturesque,[12] and was forcefully expressed in Fuseli's words of contempt for the practice of topography: he contrasts the 'classic or romantic ground' evoked by Titian, Poussin, Claude and Rubens with 'the last branch of uninteresting subjects, that kind of landscape which is entirely occupied with the tame delineation of a given spot'.[13] Even Samuel Palmer was compelled to admit that art was superior to nature, though for him the difference was one of kind rather than degree. However much he was instinctively drawn to the natural beauty which he daily saw around him at Shoreham, he noted: 'Nature is not at all the standard of art, but art is the standard of nature. . . Sometimes landscape is seen as a vision, and then seems as fine as art; but this is seldom, and bits of nature are generally much improved by being received into the soul'.

Nevertheless, the eighteenth-century belief in nature as an entity, as distinct from the ideal nature conceived and supposedly imitated by the artist, was very strong. Pope's couplet, 'First follow nature and your judgement frame/ By her just standard which is still the same', expressed a principle with which no British eighteenth-century painter or poet, at least until the time of Fuseli and Blake, would have disagreed, and it was always acknowledged that beautiful scenery was a source of inspiration to the landscapist. Some writers even assumed that the possession of such scenery was a direct cause of a country's excellence in this department of art. Both the

Frenchman André Rouquet, in his *Present State of the Arts in England* (1755), and the anonymous writer of the article *Paysage* in the *Grande Encyclopédie* (1765), give the beauty of the English countryside as one reason for the success of landscape painting in Britain.[14] By the same token, it was asserted in the introduction to Earlom's publication of the *Liber Veritatis* (1777), that the superiority of Claude's work was in part due to his access to the uniquely beautiful scenery of the Roman Campagna. To discover this scenery for themselves was undoubtedly a compelling reason for British landscape painters to study in Rome in the second half of the eighteenth century. Ever since Addison had eulogised it in *Remarks on Several Parts of Italy* (1705) the Roman Campagna had been hallowed ground for all educated Englishmen. For Thomas Jones, who arrived in Rome in 1776, it was 'Magick land'.[15] However, if some artists and writers discovered in foreign landscapes sources of inspiration, John Constable, in the Romantic period, found it closer to home, claiming that his entire art owed its quality to a tiny area of his native Suffolk: 'Painting is but another word for feeling. I associate my "careless boyhood" to all that lies on the banks of the *Stour*. They made me a painter (& I am gratefull) that is I had often thought of pictures of them before I had ever touched a pencil'.[16]

For some artists the desire to interpret landscape more subjectively conflicted with the axiom that their duty was to elevate and improve common nature. Aristotle's principle of Mimesis, which underlay the theory propounded by Reynolds, advanced the idea that all of the arts are based on imitation, but this did not imply the slavish rendering of realistic details. Rather, the artist should select and present his material so that it expresses a deeper, inner truth. Aristotle's theory related principally to literature, but applied to the visual arts it could have a more literal application. After all, the artist, unlike the poet, is enabled by his medium to give an exact description of a given object or scene. In certain types of landscape painting, for instance that practised in the seventeenth century by the so-called estate cartographers, this was precisely the application it had. Several of these artists, notably Knyff and Siberechts, were of Dutch or Flemish origin, and specialised in bird's-eye views of country houses set in pleasure-grounds, neatly fenced off from the encircling countryside. Such paintings were expressions of the deep importance in British society attached to property, which itself had complex cultural, philosophical, economic, legal and dynastic roots.

Despite the injunctions of theorists such as Reynolds, topographical painting in the widest sense enjoyed enormous popularity in Britain over a long period, accounting for well over half the output of British watercolourists before 1800 and even after that date probably not much less than a third.[17] Topography is defined as the delineation or description of the features of a particular locality, but the degree of descriptiveness varies. Sometimes the artist depicts a complicated terrain with buildings, hills, water and evidence of human activity, drawn in detail and with a high degree of accuracy. At other times a single recognisable feature, such as a castle or mountain, appears as the focal point of a generalised composition. In the first case the end product is a representation of a kind of three-dimensional map; in the second it is more like a 'view' in which the topographical features may be subordinated to the representation of a weather effect. 'Topography' is therefore not an absolute term with clearly defined limits, although it is possibly true that topography requires some element of the panoramic. Thus Cotman's study of a drop-gate across a stream in Duncombe Park, Yorkshire, hardly qualifies as topography in the fullest sense of the term, nor do Constable's paintings and sketches of scenes on the River Stour. However great the accuracy with which they are represented, it is significant that the general public at the time

were rarely given an exact identification of the locations of Constable's paintings.

Another highly developed British characteristic which goes a long way to explaining the enduring popularity of topographical painting was the love of travel, at home and abroad. This came naturally to a trading nation; the eighteenth-century enlightenment brought, in addition, a powerful thirst for information about the natural world. The desire to record the impressions of travel was the basis for the first important sets of topographical watercolours produced for British patrons: Wenceslaus Hollar's views on the Rhine and the Danube (1636; chiefly in the Prague National Gallery) were made for the Earl of Arundel; and the same artist's views of Tangier (1669; chiefly in the British Museum) made for the British Crown. The latter were also concerned with property, since Tangier was part of the dowry of Charles II's queen, Catherine of Braganza. Both series of watercolours are topographical in the sense of being fully descriptive. In detail and with great clarity, relying on only the most discreet compositional aids, they explain the lie of the land and its relationship to the water, and the placing of the various buildings including (in the Tangier views) fortifications and harbour installations. Indeed, surveying for military purposes was another important aspect of topographical drawing, and in the eighteenth century several major artists were employed as military draughtsmen, notably Thomas and Paul Sandby.[18]

In Hollar's watercolours we find other features that became recurring characteristics of the topographical drawing. The most important, if the most obvious, was the practice of making two drawings of each subject, a sketch executed on the spot and a finished watercolour worked up afterwards. So firmly did this take hold that it was still Turner's method in his late Swiss watercolours of the 1840s. (This is not to say that there was not a great difference in *style*: furthermore Turner's habit was to make numerous rapid pencil sketches from which he would select a few to be worked up into finished compositions; Hollar, one feels, had chosen his final subject from the start.)

The practice of executing a watercolour in two or more stages had other consequences. For example, professional artists — even Girtin and Turner — were sometimes commissioned to produce finished watercolours on the basis of on-the-spot drawings by amateurs. Even as late as 1800 some doubt was felt as to whether a watercolour intended to be a work of art in its own right — not necessarily a 'finished' watercolour in the conventional sense — should be executed directly from nature. There are suggestions in Cotman's letters that this practice was unusual,[19] and the problem is one that concerns all British watercolourists of the period. Turner's many sketchbooks contain watercolours in varying stages of completion, but do not provide a clear answer, and Girtin's habits in the matter are completely mysterious. But the step from working out of doors to executing a finished watercolour in an inn-room on the same evening, or on a rainy day, was not a great one; in any case, the artist did not necessarily have to wait to get back to his studio. The dates on some of Hollar's finished views of the Rhine and the Danube show that they were executed during the journey.

A friend and admirer of Hollar was Francis Place (1647–1728), a gentleman of independent means who was the first landscape artist to visit the remoter parts of the British Isles.[20] He had an eye for landscape, usually with a town on the skyline, and he made numerous pen and wash drawings of views in the north of England, Wales and Ireland in a style ultimately derived from Hollar. However, Place's drawings remained unpublished and unknown, and the beginnings of a comprehensive topography of Britain or — to be precise — of British antiquarian remains, fell into the clumsy hands of the brothers Samuel and Nathaniel Buck. Between about 1720 and 1750, they produced over 500 engraved views of ruined

abbeys, castles, cities and towns, all, so they claimed, based on drawings made in front of the buildings themselves. It was also with these views that topography first became closely linked with engraving.

Engraving served as a natural link between the topographical artist and his audience, and could provide an important source of income. The subject matter of topography was, by definition, of interest either actually or potentially to a comparatively wide public but if there was no outside interest, and hence no market, the topographical artist had to rely on a patron. This was the case with views of the Swiss Alps in the 1770s and 1780s. William Pars visited Switzerland in 1770 with Lord Palmerston; J. R. Cozens in 1776 with Payne Knight and in 1782 with William Beckford. Both artists were able to find other private buyers for their finished watercolours of the mountains, and some of Pars's views were engraved, but there was no significant market. It is surely noteworthy that the third British artist to visit Switzerland in these decades, Francis Towne, did not have a patron, and that his Alpine views are as few in number as they are remarkable in style. Even in the early nineteenth century there was little demand for engravings of Alpine scenery, and Turner's great series of watercolours made after his Swiss tour of 1802 were executed as finished works, almost all for one patron, Walter Fawkes. Indeed, the patron played a crucial role, whether providing an artist with the experience of travel, acting as his host, buying his work or employing him as family drawing master. It was not until the development of exhibiting societies for watercolourists that more than a handful of artists could dispense with either patron or engraver, or reject the role of drawing master to rely on sales of their work to a wider public. This is not to say, however, that the relationship did not become freer as time wore on. Whereas Cozens and Pars had been treated as little better than servants, Turner's position was more that of an independent man of business.

If the topographical drawing originally found its function in reproducing accurately the details of a scene, by the second half of the eighteenth century a new impetus, which came from Italy, raised it to the level of a new kind of art form. In the topographical views of Hollar, Place and the Bucks the composition generally rises towards the centre, with perhaps a dark object or band of earth in an otherwise empty foreground. In the Italianate landscape the main focus of interest is placed in the middle distance; the eye is carried across the foreground and beyond the middle distance to the sky immediately above the horizon, which is the area of greatest light. The principal exponent of this type of composition was, of course, Claude Lorrain.[21] He himself seldom depicted actual views, but his convention was easily adapted to the purposes of the topographer. Topography came to share some of the characteristics of ideal landscape, not merely in composition but also in sentiment: the soft and varied light, the pervading air of amenity and repose and the sense of a landscape at peace with itself. These qualities, no less than Claude's compositional methods, could be adapted to the placid landscape of the Midlands and Home Counties as well as to the more dramatic scenery of Wales and the Lake District.

Another type of landscape, also originating in Italy, was the *veduta*, brought to England by Canaletto in the 1740s, when he painted a series of views of London and the Thames, as well as the country houses of his patrons. His Venetian views were also widely popular among English collectors. It is not too much to say that Canaletto popularised urban topography in England, but here it was taken up chiefly by watercolourists. Just as Claude's conventions were adapted to the English countryside, so Canaletto's served as a model for the clear, sharp, well-drawn and brightly coloured views of the new streets and squares of Georgian London and other cities by Thomas Malton; they were also to influence the young Turner.

The watercolourist most directly inspired by the example both of Claude and Canaletto in the third quarter of the eighteenth century was Paul Sandby. This is not to say that he was a pasticheur, for his style did not depend so much on direct copying of their compositional patterns as on his grasp of the principles that underlay them: the importance of balance in a composition, the value of creating a vista not necessarily at right angles to the picture plane, the use of silhouette, the principle of 'unity in variety' and, above all, the importance of the pellucid light of the sky. Sandby understood and exploited better than any other artist (except perhaps for Turner) the special quality of the watercolour medium – its transparency.

Although they differed in style from Sandby and from each other, the artists who worked in and around Rome at this time – Pars, J. R. Cozens, Towne, Warwick Smith and Thomas Jones – can legitimately be discussed in this context. They too borrowed from Claude but only Cozens directly emulated his compositions; for the others Gaspard Dughet was more of a model. But all followed the same underlying principles: a feeling for clarity and order, for the relation of parts to the whole, for the balance of form against form and light against dark, for the unifying power of light. Their attitude to the topography of Italy was distinctive. With the exception, once again, of Cozens, these artists tended to ignore grand vistas, such as views across the Roman Campagna from Tivoli or the Bay of Naples. They treated cities as places to walk about in, the characteristic experience of which was the sight in close-up of small hills, roads passing by garden walls, classical ruins and modern churches and palaces glimpsed through trees, in short the characteristics of *rus in urbe*. Although Sandby, Towne, Pars, Cozens and the rest would have been regarded in their own day as practitioners of an inferior branch of landscape painting[22] (as watercolour itself was considered an 'inferior' medium), they too were not unaffected by the contemporary desire to create a superior and more beautiful kind of nature; but they achieved this aim not so much by the adoption of recognised ideal style as by the imposition of a sense of order.

Meanwhile, an alternative aesthetic had emerged, which, while not overturning this order, had the capacity to confuse matters. This was the Picturesque,[23] not so much a theory of art but rather one of vision. To be more precise, it was a set of rules for looking at nature; a question of 'art into nature' rather than 'nature into art', though the two were so close, indeed opposite sides of the same coin, that they were often confused. Gilpin defined 'Picturesque Beauty' (a term he invented) as 'that kind of beauty which would look well in a picture', but he did not specify the type of picture that he had in mind. This enabled a whole range of artists' styles to be used as criteria either for judging a natural landscape or as models to guide other artists. The writers Richard Payne Knight and Uvedale Price were admirers of the seventeenth-century landscape painters, among whom they recognised differences in kind, not degree. They saw natural scenery in terms of the styles of Salvator, Claude, Rubens, and so on, and they equated these with the Sublime, the Beautiful or the Picturesque respectively, without considering any one category superior to any other. An amalgam of styles reduced to their lowest common denominator could provide a practical guide for artists. This was certainly Gilpin's own practice, and he illustrated the books which he published from 1782 onwards – the *Observations on the River Wye*, (or *The Mountains and Lakes of Cumberland and Westmoreland*, etc) *relative chiefly to Picturesque Beauty* – with compositions simple enough to be comprehended and imitated by the sort of reader he had in mind, the 'traveller with a pencil'. Nature was now acknowledged to be perfect in every respect but composition, as Gilpin indicated: 'Nature is always great in design. She is an admirable colourist also; and harmonises tints

with infinite variety and beauty: but she is seldom so correct in composition as to produce an harmonious whole'.[24] Otherwise, provided the light was right – varied – and the season was right – autumn – nature performed very well on her own.

Price and Knight, for whom the practical application of the Picturesque aesthetic was confined to landscape gardening, were devotees of nature in the raw, the wilder and more untouched by art the better. In their writing on gardening they castigated the designers of the previous generation, above all 'Capability' Brown, for interfering with nature too much and also for failing to use landscape painting as a guide. Both Price and Knight wrote, in effect, that Claude could have taught Brown what nature really looked like:[25] a curious reversion to the seventeenth-century view of him as the supreme naturalist.

One point about which all writers on the Picturesque were agreed was that its main characteristic was the combination of 'roughness and variety'. In any book on British landscape watercolours the late eighteenth-century section gives the impression of being a series of compositions of shaggy trees crowding in on cottages angled to display the greatest possible variety in their roof lines (while Gilpin disliked cottages, Uvedale Price and others recommended them). Michelangelo Rooker, Thomas Hearne, Dr Thomas Monro and Henry Edridge exemplify this type of Picturesque and so, of course, does Gainsborough, though what for others was merely a pictorial cliché was for him a vehicle for poetry. Gainsborough knew Price in Bath in the early 1760s and went on expeditions with him into the country; Price was a much younger man, and it has been suggested that Gainsborough probably influenced his theory of the Picturesque.[26] The descriptions of scenery that Price cites as model examples of the Picturesque closely resemble Gainsborough's landscape paintings and drawings. Painters, like travellers to the Lake District, responded to the qualities of the Picturesque long

before its codification into a theory. There were few British landscapists of the second half of the eighteenth century (with the possible exception of Towne) who were not to some extent influenced by the taste for the Picturesque, which affected topographers and non-topographers alike and blurred the distinction between them.

The Picturesque sharpened appreciation of natural scenery. Once provided with an appropriate vocabulary and standards of visual comparison, people learnt how to look. But these elaborately formulated aids to vision soon became a hindrance rather than a help to the more original minds of the time. Picturesque comparisons and a list of characteristics to watch out for took the observer only a certain distance. As an aesthetic of purely visual sensations, the Picturesque inhibited the deeper understanding of nature. One of the earliest protests is in Wordsworth's *The Prelude* (1805), where the poet regrets the insidious effect which Picturesque stock responses had had on his recollection of profound early experiences.[27] The same reaction showed itself in painting even earlier, towards the end of the 1790s, the decade in which the popularity of the Picturesque reached its height.[28] Specifically, this reaction can be seen in certain watercolours by Girtin and Turner, notably those made in Yorkshire and North Wales.

It is widely agreed that these watercolours marked a new departure in British landscape painting. What was this change, other than a reaction against the Picturesque? In the first place, there was the important technical development by which watercolour painting took the place of tinted drawing. Instead of adding thin washes of colour to an already more or less complete monochrome drawing, executed in pencil or pen and ink and varying tones of grey wash, the artist now applied colour more boldly and directly to the paper. Shadows are rendered as darker tones of the same colour as the form on which they fall, rather than by letting the grey show through from underneath. This led for a time to the use of super-

imposed washes of colour, as we see in the work of Girtin and in the earliest works of the longer-lived Cotman, Cox, Varley and De Wint. Another method of creating tonal variations, pioneered by Turner in his pre-1800 watercolour sketches, was to begin a wash with a strong, dark colour, having a sharp edge, and afterwards to let the wash become lighter and more transparent. Yet another method, also initiated by Turner, was to run one wash into another while the first was still wet. Both these latter methods were taken up by De Wint, in his mature work, and by Bonington. A further device was to introduce highlights by leaving small gaps between the washes or by wiping out with a damp sponge parts of a wash already applied, or even by scratching out with a knife.

These technical innovations[29] produced a style of landscape watercolour of much greater power and vitality than any that had existed before. Colours were richer (not necessarily brighter), tone-contrasts stronger, and forms given greater fluidity. Girtin's forms are relatively contained, but Turner's are treated with the utmost freedom. Both artists achieved in their watercolours a breadth and monumentality and a variety in composition which owed something to the study of paintings by the Old Masters. The new techniques enabled them to depict phenomena that had hardly been seen before in landscape painting. This is particularly evident in their rendering of cloud formations and of complex, transient weather effects, and above all in mountain landscapes. The sky often dominates the composition, and throughout Romantic landscape painting it is treated with heightened interest both as a phenomenon deserving of study in its own right and as a pictorial element.

Technical advances may have made possible new attitudes to landscape painting and a new naturalism, but they cannot be said to have caused them. The two developments went hand in hand. The barrier to an understanding of nature set up by the Picturesque concentration on externals was replaced by a desire to understand nature from within. The way was now open for a wholly naturalistic approach to landscape painting. Constable's comment on visiting the Royal Academy exhibition of 1802, 'There is room enough for a natural painter [or *peinture*]' has often been quoted. This change of emphasis was paralleled by the discoveries of natural science, particularly in geology and meteorology, the sciences of earth and sky, and optics, the science of light and sight. Turner's feeling for the geological structure of mountains, revealed first in 1798 in his North Welsh views, is something quite new in art; at the same time scientific investigation was beginning to reveal nature as the outcome of a continuous evolutionary process rather than as a static model of universal order. The descriptive mode of eighteenth-century 'tinted drawing' had been well suited to imitating that kind of order, just as it had been suited to idealising a view of a country estate or reproducing the irregular outlines characteristic of the Picturesque. The new conception of the evolutionary process of nature inspired a landscape art both more dynamic and more penetrating.

Art itself came to be considered as a branch of knowledge; Constable and Ruskin were in agreement that to draw or paint an object or scene was a means of discovering and stating the truth about it – an opinion that Turner would probably have shared. In the eighteenth century 'generalisation' had been the guiding principle; all nineteenth-century artists and critics, whatever their difference on other matters, united in substituting 'particularisation'. As Blake, neither a naturalist nor particularly interested in landscape, wrote in the margin of his copy of Reynolds's *Discourses*: 'To generalise is to be an idiot. To particularise is the Alone Distinction of Merit'. No painter of this period was able to ignore the particular, however temperamentally disposed to explore the world beyond phenomena.

Particular effects, in the form of minutely described natural details, were also the starting point for the visionary

landscapists Francis Danby and John Martin and were more than a starting point for Turner. A parallel can be drawn between Turner's fusion of exquisitely observed natural details with an overall poetic effect and Hazlitt's theory of the relationship between the realistic and the ideal in art, although Hazlitt was indifferent to Turner's work.[30] Hazlitt was an uncompromising champion of the naturalistic aesthetic without being an admirer of naturalistic landscape painting. His argument, directed against Reynolds, was that the ideal, far from requiring a rejection of individual particularities, was dependent on the immediate imitation of nature.[31]

Romantic writers and artists in Britain and Germany had become preoccupied with the 'inner life' of nature. It is significant that the German scientist and amateur artist Karl Gustav Carus should have wished to substitute for the passive word 'landscape' the awkward but more expressive term *Erdlebenbildkunst* ('painting of the life of the earth').[32] How far British artists consciously shared these preoccupations, however, is hard to say. Certainly, there is little overt symbolism in British Romantic landscape painting. What Lorenz Eitner has said of Constable might be said of all that artist's contemporaries, except possibly Palmer and his friends at Shoreham: 'In contrast to the Germans, Constable refrained from dramatising the type of spirit which he, like them, sensed in nature, through outright symbolism or stylistic devices'.[33] Furthermore, it is unwise to assume that the attitudes of writers and artists, however close the parallels, were identical, especially when there was no personal connection between them. Wordsworth's belief that it is the contemplation of the humblest objects in nature – a daffodil for example – that enables us to see 'into the life of things' would not have been echoed by most German thinkers. Constable, equal to Wordsworth in his power of empathy with nature, identified the spirit of nature not with an autonomous living force, but with the presence of God – as, in his own way, did Ruskin.

Turner, by all accounts a man without religious belief, is credited with one cryptic remark on the subject, uttered on his death bed: 'The Sun is God'.[34]

Even on a purely artistic level, there are differences between Constable's conception of truth to nature and what can be inferred of Turner's and that of other great watercolourists. Throughout his life Constable urged that the aim of the landscape painter must be truth to nature in all its particularity, without deviation into 'manner' or falsification for the sake of a higher beauty. For him there was beauty and spirit enough in nature itself – and he translated his aim, sometimes with great difficulty, into his own art at all levels. For other artists, however, such truth appears to have been only one consideration among several. These included design, colour, movement, poetic content – rather a traditional list, in fact. Yet these artists were united in approaching nature on the basis of personal experience in expressing, in their art if not always in words, their understanding of nature's processes as well as her superficial appearances, and in giving their work animation and breadth.

Ruskin also explored the relationship between truth and imitation, returning to the contrast between lower and higher forms, though with different premises and terminology. For him the lower form of imitation was mere 'imitation'; the higher was 'truth': 'Imitation can only be of something material, but truth has reference to statements both of the qualities of material things, and of emotions, impressions and thoughts'.[35] This definition (for all that its terminology discouraged understanding of the seventeenth-century masters) is not a bad summary of the approach to landscape painting of the British artists of his own time.

It was Ruskin who, in his extended investigation of Turner's art in *Modern Painters* (1843–60), identified not one truth but many. Some of these are repetitive – truth of clouds, of vegetation, water, and so on – but among them is the

recognition of a truth that may be inferred from Turner's mature and finished watercolours; this is what Ruskin called 'quantity in the universe'. Ruskin summarises Turner's second period, the 'Years of Mastership', 1820–35, thus: 'Colour takes the place of form. Refinement takes the place of force. Quantity takes the place of mass'. Quantity he defines in terms of the sheer number of objects in nature that Turner depicted. 'He had discovered, in the course of his studies, that nature was infinitely full...He saw there were more clouds in any sky than ever had been painted; ...and he set himself with all his strength to proclaim this great fact of quantity in the universe'.[36]

Ruskin's admiration for Turner's power of rendering nature's infinity of detail while retaining his grasp of the whole became the basis of his more general statement that detail should be pursued for its own sake, as a moral act carried out from a sense of duty to God's creation. At the end of the first volume (1843) of *Modern Painters* there is a famous paragraph which tells the artist 'to go to nature in all singleness of heart...rejecting nothing, selecting nothing and scorning nothing'. This caught the eye of the nineteen-year-old Holman Hunt who felt it had been written specially for him. It became the essential article of belief for the Pre-Raphaelites in their approach to landscape painting.

At the beginning of this introduction we saw Palmer puzzling over the problem of translating nature into art. It was suggested there that other artists experienced the same difficulty. Here is Constable: 'It is the business of the painter not to contend with nature & put this scene (a valley filled with imagery 50 miles long) on a canvas of a few inches, but to make something out of nothing, in attempting which he must almost of necessity become poetical'.[37] In Cotman's letters from Rokeby in 1805 we read of his struggles to capture 'Nature, that ficle Dame' in watercolour studies made out of doors.[38] Turner, characteristically, took a more positive attitude, and one — it must be said — that except for its stress on the practicable is not all that far from Reynolds: 'He that has the ruling enthusiasm which accompanies abilities cannot look superficially. Every glance is a glance for study: contemplating and defining qualities and causes, effects and incidents, and develops by practice the possibility of attaining what appears mysterious upon principle. Every look at nature is a refinement upon art. Each tree and blade of grass or flower is not to him the individual tree grass or flower, but what [it] is in relation to the whole, its tone, its contrast and its use, and how far practicable: admiring Nature by the power and practicability of his Art, and judging of his Art by the perceptions drawn from Nature'.[39]

The problem had become acute for the artist of the Romantic period because there were no longer any generally accepted rules. All the same, it was salutary that the problem was felt to exist; it is, after all, as Sir Ernst Gombrich showed in *Art and Illusion* (1959), a very real one. Those artists who forgot about it or came to believe that it was a chimera, and who felt that all the landscapist had to do was to sit down and draw what happened to be in front of him, brought about the noticeable decline in quality of much Victorian watercolour painting. The phrase 'the innocence of the eye' introduced in Ruskin's most Pre-Raphaelite book, *The Elements of Drawing* (1857), has a good deal to answer for.

NOTES

1 Letter to John Linnell from Shoreham, 21 December 1828 (see A. H. Palmer, *The Life and Letters of Samuel Palmer*, London 1892, p. 173.

2 See Sir Joshua Reynolds, *Discourse III*, 1770. The best modern edition of the *Discourses* is that edited by Robert Wark, New Haven and London 1975.

3 Quoted from E. G. Holt, *Literary Sources of Art History*, Princeton, 1947, p. 406. E. H. Gombrich, 'The Renaissance Theory of Art and the Rise of Landscape', *Norm and Form*, London 1966, pp. 107–21, has found the sources of De Piles's distinction in Vitruvius, but his suggestion that the ancient author considered one category of landscape superior to another could be queried.

4 Ibid.

5 *New Idylls by Gessner, translated by W. Hooper MD, with a Letter to Mr Fuslin on Landscape Painting*, London 1776, p. 96.

6 Sir Joshua Reynolds, *Discourse XIII*, 1786.

7 Ibid.

8 Sir Joshua Reynolds, *Discourse IV*, 1771.

9 Sir Joshua Reynolds, *Discourse XIII*, 1786.

10 Sir Joshua Reynolds, *Discourse IV*, 1771.

11 An exception is Hogarth (to whom landscape was only of incidental interest), followed by Diderot.

12 See, for instance, William Gilpin, *Observations on the River Wye*, London 1782, p. 31.

13 *Lectures on Painting IV*, 1805. Quoted from Eudo C. Mason, *The Mind of Henry Fuseli*, London 1948, p. 285.

14 André Rouquet, *The Present State of the Arts in England*, London 1755, p. 59. For the article in the *Grande Encyclopédie* see the essay by Gombrich cited above in note 3. The comments by these French authors are at variance with Horace Walpole's better-known lament that 'in a country so profusely beautified with the amenities of nature it is extraordinary that we have produced so few good painters of landscape. Our ever verdant lawns, rich vales, fields of haycocks, and hop-grounds, are neglected as homely and familiar objects': *Anecdotes of Painting in England*, IV, 1771, pp. 64–5. But the reasoning behind all three observations is the same.

15 See Thomas Jones's 'Memoirs', ed. A. P. Oppé, *The Walpole Society*, XXXII (1946–8), p. 55.

16 Letter to John Fisher, 23 October 1821 (*John Constable's Correspondence*, ed. R. B. Beckett, Suffolk Records Society, 1965–72, vol. VI, p. 78).

17 For instance, of the watercolours in this book, around two-thirds might be described as topographical or topographically based.

18 Military surveying became a lower and strictly utilitarian branch of topography; a necessary accomplishment for army officers but no longer for professional artists.

19 See no. 55.

20 Place was of the same generation as those first literary explorers of Britain, Celia Fiennes and Daniel Defoe, who showed little interest in uncultivated scenery but were fascinated by towns, agriculture, industries and local customs. See Esther Moir, *The Discovery of Britain 1540–1840*, London 1964.

21 John Barrell in *The Idea of Landscape and the Sense of Place*, Cambridge 1972, demonstrates effectively that it was this aspect of Claude's compositional approach which particularly struck eighteenth-century painters and poets.

22 Although Gainsborough was appreciative of Sandby's talent – which he described as 'genius' – he himself had little interest in this form of landscape painting.

23 Much has been written about the cult of the Picturesque and its personalities, but very little of value has been noted about its impact on landscape painting. Peter Bicknell's catalogue to the exhibition *Beauty, Horror and Immensity*, Fitzwilliam Museum, Cambridge 1981, is a most valuable exception.

24 William Gilpin, *Observations on the River Wye*, London, 1782, p. 31.

25 Uvedale Price, *Essays in the Picturesque*, I, London 1810, p. 121. See also Richard Payne Knight on Claude in *The Landscape: A Didactic Poem*, London 1794: 'Nature's own pupil, fav'rite child of taste'.

26 John Hayes, *The Landscape Paintings of Thomas Gainsborough*, I, London 1982, p. 163. Hayes also draws attention to an article in *The Repository of the Arts*, 1813, suggesting that it was really Gainsborough's sketches which created the taste for the Picturesque.

27 The cult of the Picturesque became a target of satire, which started in about 1810, the best-known example being William Combe's *The Tour of Doctor Syntax in search of the Picturesque. A Poem*, first published in *The Poetical Magazine*, 1809–11, and subsequently illustrated by Thomas Rowlandson 1812–21. See Bicknell, *op. cit.*, p. 44.

28 This was first suggested by John Gage in 'Turner and the Picturesque', *Burlington Magazine*, CVII, 1965, pp. 18–25, 75–81.

29 Several of the characteristics described here are already to be found, if not fully developed, in the work of J. R. Cozens. Although in terms of composition he remained a fairly typical eighteenth-century artist, his sensitivity to atmospheric effect and mood anticipated the achievements of Girtin, Turner and Bonington.

30 '[His] pictures are however too much abstractions of aerial perspective, and representations not properly of the objects of nature as of the medium through which they were seen...', *The Examiner*, 1816 (quoted by A. J. Finberg, *The Life of J. M. W. Turner*, 2nd edn, Oxford 1961, p. 241).

31 'It appears to me that the highest perfection of art depends, not on separating, but on uniting general truth and effect with individual distinctness and accuracy', 'The Fine Arts', article written for *The Encyclopedia Britannica*, 1816.

32 Extracts in English translation from Carus's pamphlet *Nine Letters on Landscape Painting*, 1831, are published with a brief but valuable commentary by Lorenz Eitner in *Neoclassicism and Romanticism*, II, 1970, pp. 47–52 (*Sources and Documents in the History of Art* series).

33 *Ibid*, p. 61.

34 The source of this famous utterance is Ruskin, who quotes it in *Fors Clavigera* without comment; see *The Works of John Ruskin*, ed. E. T. Cook and Alexander Wedderburn, London 1903–12, XXVIII, p. 147.

35 *Modern Painters*, I, 1843; see *Works*, *op. cit.*, III, p. 104.

36 Ibid, XIII, p. 129.

37 Letter to John Fisher from Brighton, 29 August 1824 (*John Constable's Correspondence*, ed. R. B. Beckett, Suffolk Records Society, 1962–75, VI, p. 172). Constable was evidently contemplating a painting of the Sussex Downs, a project which he took no further.

38 See no. 55.

39 Quoted from A. J. Finberg, *The Life of J. M. W. Turner*, 2nd edn, Oxford 1961, p. 230.

The Catalogue

1

Joris Hoefnagel 1542–1600

Nonsuch Palace, Surrey

Pen and ink with brown wash and watercolour; 220 × 464mm
Inscribed: *PALATIVM REGIVM IN ANGLIAE REGNO APPELLATVM NONCIVTZ Hoc est nusquam simile* and signed *Effigiavit Georgius Houfnaglivs Anno 1568*
1943-10-9-35. Bequeathed by P. P. Stevens

Born in Antwerp, Hoefnagel travelled extensively and drew many of the views engraved in Braun and Hogenberg's *Civitates Orbis Terrarum* (1572–1618), a six-volume collection of views and maps intended both to inform the stay-at-home and to guide the traveller. It is difficult for us today to realise the startling effect of this mass of information about the appearance of the great cities and buildings of the world. As Robert Burton wrote in *The Anatomy of Melancholy* (1621): 'What greater pleasure can there be than to view those elaborate maps of *Ortelius, Mercator, Hundius* etc. To peruse those bookes of Citties, put out by *Braunus* and *Hogenbergius'*. Hoefnagel contributed three English views to the *Civitates*: this drawing is the basis of plate I in volume v (published in 1582). The inscribed date of 1568 is generally supposed to record a visit to England by Hoefnagel in that year, although there is no other evidence.

This drawing is an important record of the great Tudor palace of Nonsuch (that is, *Nonpareil*); Henry VIII began the palace in 1538, but it was unfinished at his death in 1547 and was completed by Henry FitzAlan, Earl of Arundel, who bought it from Mary Tudor in 1556. In 1592 his son-in-law Lord Lumley sold Nonsuch to Queen Elizabeth, for whom it was a favourite house. Hoefnagel thus shows it when it belonged to Lord Arundel, although it was Henry VIII

who was responsible for the fantastic character of the towered façade, decorated with elaborate plasterwork in a Franco-Italianate style which recalls that at Fontainebleau. Nonsuch was almost entirely demolished between 1682 and 1688, but excavations in 1959–60 recovered the entire plan and many details of the decoration, which confirm the accuracy of Hoefnagel's drawing.

The scene here is traditionally said to show the arrival in state of Elizabeth I, but there is no record of her visiting Nonsuch in 1568, although Arundel had entertained her at enormous expense for five days in 1559, an event which this drawing perhaps commemorates.

2

John White fl.1585–1593

North America from Florida to Chesapeake Bay

Pen and brown ink with watercolour, on two conjoined sheets;
370 × 472mm
Extensively annotated with place names
1906-5-9-1 (2)

White's date and place of birth are unknown, and nothing certain is recorded of the artist until 1585, when he sailed as draughtsman-surveyor with the expedition dispatched by Sir Walter Raleigh to establish the 'First Colony' of Virginia. He worked in close collaboration with the astronomer and mathematician Thomas Hariot, who went as scientific observer. The frontispiece of his *Briefe and true report of the new found land of Virginia* (1590) mentions the 'true pictures and fashions of the people...Diligentlye collected

and drawne by Ihon White'. White was expected to make a graphic record of the coasts, harbours and encampments, the flora and fauna, and the types and customs of the natives encountered on the voyage. He had an accomplished predecessor in the French Huguenot artist Jacques Le Moyne, whom White probably knew; Le Moyne lived in London for some years before his death in 1588. His position on the French expedition to Florida in 1564 closely anticipated White's, and both men enjoyed Raleigh's patronage.

Raleigh's expedition left Plymouth in April 1585 under the command of Sir Richard Grenville; the colonists reached the island of Roanoke in the Croatan Sound later that summer and remained until June 1586, White being one of the leaders of a group sent to explore the neighbouring Indian villages of Pomeiooc, Aquascogoc and Secoton. In July 1587 a second expedition from England reached Roanoke, under White's leadership. Raleigh had licensed White and his associates to settle part of the territory in his grant – Raleigh in Chesapeake Bay – but the expedition never got that far, soon encountering difficulties, so that after less than two months White returned to England for further supplies, leaving behind his daughter Elinor Dare and a grand-daughter, Virginia, the first child born of English parents in North America. After an abortive attempt to relieve the colony in April 1588, White eventually returned in August 1590, but failed to discover any trace of the colonists.

In a letter of 1593 to Richard Hakluyt, White recorded that on his last unhappy visit to Croatoan he found 'the frames of some of my pictures and Mappes, rotten and spoyled with rayne'. Other drawings must have been taken back with him in 1586 or 1587, for in 1588 the Flemish engraver and publisher Theodor de Bry obtained from White in London a number which were used to illustrate the first part of his famous publication, *America*. White was clearly a highly trained and experienced cartographer, and must have been familiar with such contemporary Flemish work as the maps of Ortelius, engraved by Hogenberg, which may have provided the model for his decorations of sea-monsters, ships and so on.

This map, bearing the arms of Sir Walter Raleigh, shows the Florida peninsula and the mainland of south-eastern North America northwards to the opening of Chesapeake Bay with part of Norumberga (New England) as a promontory (or island); there is an indication of Bermuda to the right, and below and on the left the Bahama Islands, greatly exaggerated in size. Out to sea various vessels flying the English flag are shown. Along the coast of North Carolina Indian villages are indicated by red dots. A companion map, showing the coast from Cape Lookout to Chesapeake Bay, was published by De Bry in 1590. These were the first maps of North America to be based, at least by an Englishman, on a survey made on the ground, probably by White himself.

3

John White fl.1585–1593

Indians Fishing

Watercolour with touches of white and gold; 353 × 235mm
Inscribed: *The Manner of their Fishing* and *A Cannow*
1906-5-9-1 (6)

White shows a group of Indians fishing, some from dug-out canoes, others wading, and carefully depicts a variety of techniques, as well as many different species of fish and marine creatures, birds and plants. This is a composite drawing, presumably based on individual sketches, and intended to convey as much information as possible. He shows both night fishing, in which a fire was lit in the canoe to attract the fish, which were then speared, and daytime fishing, using a dip-net (shown hanging over the stern to starboard) and spearing by waders. In the middle distance is a fish-weir of stakes, with a rectangular fish-trap; further away is another canoe with two figures. This is one of White's most elaborate surviving watercolours and was engraved by De Bry as plate XIII in *America*, part I (1590).

A fuller account of White's Roanoke drawings has been published by Paul Hulton in *America 1585: The Complete Drawings of John White* (1984).

4

Wenceslaus Hollar 1607–1677

The Tower of London

Pen and brown ink with watercolour over black lead; 111 × 283mm
Inscribed: *Den Tower van London* and *Thamesis fluvius*
1859-8-6-389

Hollar was born in Prague, where his father was an official in the service of Emperor Rudolf II. He may have been a pupil of the Fleming Aegidius Sadeler, principal engraver to the imperial court. In 1627, probably for religious reasons, Hollar left Bohemia for Stuttgart, and subsequently worked in Strasbourg, Frankfurt and Cologne. It was in Cologne in 1636 that Hollar joined the entourage of Thomas Howard, Earl of Arundel, the most distinguished English connoisseur and patron of the period, who was leading an embassy to the Emperor. Hollar recorded their journey along the Rhine and the Danube in a series of watercolours, before returning to London with Arundel, under whose patronage he worked for several years. A royalist supporter, Hollar went into exile in Antwerp in 1644, where he lived until 1652. On his return to London his most important project was an enormous map of the city with a perspective delineation of all the major buildings, but the Great Fire of 1666 rendered his surveys and drawings obsolete. Three years later he accompanied Lord Henry Howard on an expedition to Tangier, where he made drawings of the English settlement and its fortifications. His etched œuvre amounts to nearly 2,800 plates, but despite his remarkable output he died in poverty. His influence in England was particularly notable in the development of topographical art during the latter part of the seventeenth century and the early years of the eighteenth century.

The Tower of London, begun in the reign of William I (1066–87), has served as fortress, palace, prison and place of execution. Hollar's view looks north-east across the Thames; the Traitors' Gate can be seen in the centre of the outer wall, built between 1275 and 1285, with the keep – the White Tower – dominating the skyline. In the foreground is a three-masted ship flying St George's flag, which

was customary for merchant ships. The drawing was made during Hollar's first period in England and was presumably taken with him to Antwerp in 1644, where it was used as the basis of an etching, published in 1647 as one of four views of London. The lettering in English on the etchings suggests that they were intended for the English rather than for the Netherlandish market.

5

John Dunstall d.1693

A Pollard Oak near West Hampnett Place, Chichester

Watercolour over black lead, touched with white on the figures, on vellum; 134 × 160mm
Signed: *John Dunstall fecit*
1943-4-10-1

Dunstall was one of a number of native-born seventeenth-century draughtsmen who came within the sphere of Hollar's influence. He published several small sets of etchings intended as copy-books for aspiring draughtsmen and a treatise on *The Art of Delineation*. The locality depicted in this charmingly naive drawing is established by Dunstall's etching of Hampnett House, one of a series of five views in the neighbourhood of Chichester, Sussex. Comparison with an eighteenth-century map of the area shows that in order to frame the distant view of Chichester Cathedral more picturesquely, the artist has altered the position of the mill and the stream. West Hampnett Place, a red-brick gabled house of the late sixteenth century built by Richard Sackville, was greatly altered in later times and destroyed by fire in 1930. The costume of the diminutive figures in the foreground suggests a date of about 1660.

Dunstall's use of opaque watercolour on vellum is a survival of a technique derived from manuscript illumination of the medieval period, which continued chiefly for drawing maps and semi-cartographical bird's-eye views.

6

Jan Siberechts 1627–c.1703

A View of Beeley, near Chatsworth

Watercolour and bodycolour heightened with white; 285 × 455mm
Signed and dated: *Bely in darbyshair 22 August 1694 J. Sybrecht.f.*
1952-4-5-10

Siberechts settled in England in 1673 or 1674. He had established
a reputation in his native Antwerp for paintings of pastoral subjects,
but in his adopted country became the leading topographical
painter of the period, merging his own style with the demands of
country house portraiture. Siberechts had the softest and most
atmospheric style of those Netherlandish artists who worked in
England during the seventeenth century. This drawing and three
related studies of the countryside around Chatsworth in Derby-
shire, dated variously 1694 or 1699 (in the Rijksprentenkabinet,
Amsterdam, and the Institut Néerlandais, Paris), are probably
connected with an intended 'portrait' of the magnificent house and
its setting: the village of Beeley lies immediately to the south of
Chatsworth but was not part of the estate until 1747. In 1699
Siberechts and Leonard Knyff (1650–1722) were called to Chats-
worth by the 1st Duke of Devonshire to take prospects of the
house, probably to record the completion of a phase of new
building, but although an engraved view by Knyff was published in
Britannia Illustrata (1707), no existing painting of Chatsworth can
convincingly be attributed to either artist.

 Siberechts's view combines the approach of a landscape painter
with that of a cartographer. Figures in the foreground are seen
admiring the prospect, a traditional visual convention, but the
landscape is observed with a directness that is new in British art.
The artist's method of drawing with the brush in colour differs from
the usual practice at this period of laying in the tones in grey wash
and superimposing the tints at a subsequent stage.

7

Samuel Scott c.1702–1772

St Paul's from the Thames

Pencil, pen, ink and watercolour, squared for enlargement; 179 × 444mm
On the *verso*: A plan of a theatre, a row of windows and a diagram in
pencil and watercolour, inscribed *Scott*.
1868-3-28-338

Until the 1740s Scott was almost exclusively a marine painter in the
tradition of Willem van de Velde, whose work was to remain a
dominant influence throughout his career. It is often said that in his
London views Scott was emulating Canaletto, who came to London
in 1746, but the dating of his preparatory drawings on external
topographical grounds establishes that he was making sketches of
London in the early 1740s. If there were a foreign influence it could
well be the townscapes of contemporary Dutch painters, such as
Van der Heyden.

 This drawing has every appearance of being made on the spot. It
must date from the last years of his life, for Blackfriars Bridge was
not completed until 1769. The pencil squaring suggests that Scott
intended to enlarge the composition either as a more finished
drawing or as an oil painting, although no related picture is known.

 Scott's viewpoint is from mid-stream, near the Temple; from left
to right are the Temple Stairs, the spires of St Bride's and St
Martin's, St Paul's Cathedral and, in the distance, the City churches.

8

William Taverner 1703–1772

Landscape with a Winding River and Nymphs Bathing

Watercolour heightened with touches of bodycolour; 253 × 386mm
1953-5-9-4. Bequeathed by Sir Edward Marsh through the National Art-Collections Fund

Taverner was by profession a lawyer and must therefore be considered as an amateur, but he enjoyed a considerable contemporary reputation as a landscape artist. George Vertue noted in 1743 that he had 'an extraordinary Genius in drawing and painting Landskips. Equal if not superior in some degree to any painter in England'. To judge from the few examples of his work that survive, he seems to have been one of the earliest English artists to use pure watercolour without pen outlines, and also bodycolour, the latter perhaps in emulation of Marco Ricci, whose gouaches were much admired by English collectors. He occasionally painted in oils, and here his inspiration was Gaspard Dughet, whose reputation in England was at its height during the 1730s and 1740s. This *Landscape with a Winding River and Nymphs Bathing* is one of a number showing nude figures in a landscape setting recalling the cabinet paintings of Dutch Italianate artists such as Cornelis Poelenburgh (1586–1667) and Bartolomaeus Breenbergh (1599–1659); their influence is also apparent in the work of George Lambert (1700–65), with whom Taverner may have studied in the 1750s.

Taverner also painted informal watercolour studies, mostly of views in the environs of London, which are strikingly direct and unmannered for the period, comparable with Gainsborough in their absence of any obviously topographical content.

9

Thomas Gainsborough 1727–1788

A Cart passing along a Winding Road

Watercolour heightened with touches of white bodycolour over black chalk; 237 × 317mm
Stamped with the artist's monogram *TG* in gold. On the verso: A study of a tree against a hilly background
1899-5-16-10

Gainsborough hardly ever concerned himself with topography in the sense of making views of particular places, nor, save in disguised form, with the Italo-French tradition of ideal landscape. He concentrated instead on pastoral fantasies that embodied many of the characteristics later singled out as 'picturesque' by the theoretical writer Uvedale Price, who as a boy had accompanied him on sketching excursions into the countryside around Bath where Gainsborough lived between 1759 and 1774: 'all intricacies... all the beautiful varieties of form, tint, and light and shade; every deep recess, every bold projection – the fantastic roots of trees – the winding paths of sheep'. Another friend, the artist Ozias Humphrey, who was then a student, recalled that when 'Summer advanced, and the luxuriance of Nature invited and admitted of it, he accompanied Mr Gainsborough in his Afternoon Rides on Horseback to the circumjacent scenery, which was in many Parts, picturesque, and beautiful in a high Degree. – To those and succeeding Excursions the Public are indebted, for the greater Part of the Sketches, and more finished Drawings from time to time made Public by that whimsical, ingenious but very deserving Artist'.

This is a rare example of Gainsborough's use of full watercolour, a medium he hardly used after around 1770; but he is known to have admired Paul Sandby's work, and was perhaps influenced by the example of artists like William Taverner as well as by seventeenth-century Flemish landscape drawings in watercolour of the type traditionally attributed to Van Dyck. He almost never made drawings for sale after he had established himself as a painter

in oils, preferring to draw for pleasure; he gave many of his drawings to friends, occasionally, as here, stamping his monogram in gold, or adding a tooled border made with a bookbinder's rouleau.

10

Thomas Gainsborough 1727–1788

Landscape Composition

Black chalk and stump heightened with white on prepared paper;
226 × 320mm
1910-2-12-259. Salting Bequest

The imagery of this drawing, which dates from the last years of Gainsborough's life, affords a parallel with one aspect of the theoretical writings of the Picturesque movement. Although Gainsborough's inclinations were not literary, neither was he wholly the instinctive and unacademic artist he often made himself out to be: for instance, it is clear from his correspondence that he had read Dr John Brown's descriptive guide to the Lake District before going there in 1783. Drawings like this example suggest that he also knew the series of 'Picturesque Tours' which the Revd William Gilpin began to publish in the early 1780s. While Gainsborough may have agreed with many of Gilpin's observations, it would, however, have been uncharacteristic of him to derive his subject matter directly from literary models; in fact, many of the landscape features singled out by Gilpin as being particularly picturesque had figured in Gainsborough's work from the 1750s onwards. It is in his later and more generalised landscapes that his imagery comes closest to Gilpin's, in its emphasis on 'the castle, or the abbey, to give consequence to the scene', the irregular silhouettes of distant mountains, and rocky clefts overhung with trees.

No less important for Gainsborough at this period, as indeed for Gilpin, was the influence of the Old Masters, seen particularly in

their preference for artificial compositions, not based on direct observation of nature but intellectually conceived, and for the technique of black chalk on coloured or prepared paper. The present idealised composition was at least partly inspired by Gaspard Dughet, but may also reflect Gainsborough's 'habit of making what might be called models for landscapes, which he effected by laying together stones, bits of looking glass, small boughs of trees, and other suitable objects, which he contrived to arrange, so as to furnish him with ideas and subjects for his rural pictures'. The technique used by Gainsborough in drawings such as this was described by the same writer as 'a process rather capricious... many were in black and white, which colours were applied in the following manner: a small bit of sponge tied to a bit of stick, served as a pencil for the shadows, and a small lump of whiting, held by a pair of tea-tongs was the instrument by which the high lights were applied; beside these there were others in black and white chalks, India ink...with these various materials he struck out a vast number of bold, free sketches of landscape... all of which have a most captivating effect to the eye of an artist, or connoisseur of real taste' (Edward Edwards, *Anecdotes of Painters*, 1808).

11

? Thomas Sandby 1723–1798 and
Paul Sandby 1731–1809

Westminster Abbey from Somerset House

Watercolour; 122 × 572mm
1880-11-13-5847

Thomas and Paul Sandby were both trained as military topographers. Thomas served under the Duke of Cumberland, George II's second son, in the 1745 Jacobite Rebellion, and was subsequently employed by him as draughtsman and engineer at Windsor. Paul, also employed by the Board of Ordnance (the branch of the army responsible for building, maintaining and

surveying military establishments and for supplying arms and equipment), was posted as chief draughtsman to the newly established Ordnance Survey of Scotland in 1747, set up to provide the army with reliable topographical information following the Rebellion, when the English had been hampered by wholly inadequate maps. In 1752 he returned to London and resigned from military service, establishing himself as an artist, engraver and drawing master, and working closely with his brother, who had developed his skills as an architectural draughtsman. The Sandbys were active in supporting newly established exhibiting societies and in helping to raise the status of artists: Thomas was a director of the St Martin's Lane Academy in 1754, and both were founder members of the Society of Artists in 1761 and the Royal Academy in 1768, Thomas being the Academy's first Professor of Architecture.

The difficulty of attributing drawings to one or other of the Sandbys with any certainty remains problematic. This view, looking west along the Thames to Westminster Abbey, from the gardens of Somerset House, home of the Royal Academy, is very probably by both artists, Thomas being responsible for the precise, refined architectural details (perhaps with the aid of a camera obscura) and Paul for the figures. Dating is equally difficult: the costumes here suggest the 1760s but on occasion Paul added figures, based on sketches made many years earlier, at a later date.

12
Paul Sandby 1731–1809
Windsor Bridge from Datchet Lane

Watercolour, heightened with bodycolour, pen and ink, over pencil;
277 × 564mm
1878-7-13-1280

Paul Sandby spent much of his time at Windsor, where his brother Thomas was in royal employment. He seems to have been mostly active there between about 1760 and 1771, although he continued to repeat his views of Windsor for many years, exhibiting them between 1763 and 1807, first at the Society of Artists, and later at the Royal Academy, of which he was a founder member. Surprisingly, there is no evidence that any of his Windsor views were acquired for the Royal Collection before the sale held two years after his death, when the Prince Regent made a number of purchases.

Probably dating from the 1770s, this view of Windsor shows the influence of contemporary European view painting, notably Canaletto's views of English houses and castles (including Windsor). Although Sandby sometimes used oil, his achievement was to have raised the status of watercolour as an exhibition medium in its own right, by developing the tradition of the tinted topographical drawing with a new sophistication and assurance. He only rarely dated his watercolours and the various versions of a composition cannot always be placed in chronological order, but it would seem that this, with its exceptional clarity of light and colour, is probably the earliest version of a view that he continued to repeat throughout his life. A larger version in bodycolour is signed and dated 1798 (Royal Library, Windsor Castle).

The view shows Windsor Bridge in the middle distance, the river and houses of Eton to the right. On the extreme left the west corner of St George's Chapel can be seen above the houses of Datchet Lane. The Sandbys used a repertoire of small pencil studies as reference for their figures, many of which are now in the Royal Library, Windsor, the Victoria and Albert Museum and the British

Museum. For example, the figure of the seated stonecutter in this watercolour also appears in an aquatint of 1776 and in a view of Julius Caesar's Tower (Royal Library), the preliminary drawing probably being one in the Victoria and Albert Museum. Although primarily topographical in intention, Sandby's sensitivity to atmosphere is apparent. As his son noted: 'he aimed at giving his drawings the appearance of nature as seen in a camera obscura with truth in the reflected lights, clearness in shadows and aerial tint and keeping in the distance and skies'.

13

Paul Sandby 1731–1809

The Artist's Studio, St George's Row, Bayswater

Watercolour and bodycolour on grey paper; 229 × 280mm
1904-8-19-63. Bequeathed by William Sandby

Paul Sandby moved to 4 St George's Row, Bayswater (then a quiet semi-rural part of London) in 1772; later known as 23 Hyde Park Place, the house was demolished in 1901. This informal study, taken from a back window of the house looking down the garden towards his elegant studio, apparently newly built in the neo-classical style – perhaps, one wonders, designed by his brother – is characteristic of his late work at its most appealing. Two pencil drawings in the Victoria and Albert Museum are studies for this watercolour, of which a weaker version, with different figures, is in the Castle Museum in Nottingham. The style of dress suggests a date in the 1790s.

14

Jonathan Skelton c.1735–1759

The Medway near Sheerness

Watercolour over pencil; 257 × 570mm
Inscribed on the verso: *Sheerness from yͤ Tower of Gillingham Church near Rochester, I. S. 1757*
1909-4-6-12

Almost nothing is known of Skelton's life before he went to Italy in 1757, and his work was entirely forgotten until 1909, when a group of eighty-four drawings appeared at auction. Of his surviving works, the earliest dated drawings – views in and around Croydon, Surrey – are from 1754. An inscription on one provides a clue to Skelton's identity and circumstances, suggesting that he was a servant in the household of Thomas Herring, Archbishop of Canterbury. Skelton's movements, as recorded by inscribed drawings, accord with this statement; the Archbishop's usual residence was at Croydon, or occasionally Lambeth Palace, and from time to time he visited Rochester on the Medway, the deanery of which he retained. Additionally, the patron who financed Skelton's visit to Italy was a cousin of the Archbishop, William Herring of Croydon.

It is possible, according to several references in his letters from Italy, that Skelton had been a pupil of the landscape painter George Lambert. He seems also, to judge from watercolours like this example, to have known the work of Samuel Scott. In some ways, however, Skelton's watercolours surpass Lambert's and Scott's in their subtlety of conception and execution. Indeed, this atmospheric study seems almost a prefiguration of J. R. Cozens's watercolours. In Italy Skelton was to paint from nature, and it is possible that he may have begun to do so while still in England. This view over the Medway, taken from the tower of the church at Gillingham near Rochester, may have been drawn on the spot, although it was almost certainly coloured later.

15

Jonathan Skelton *c.1735–1759*

Tivoli

Watercolour, with pen and ink; 264 × 370mm
Inscribed on the verso: *a part of Tivoli Part of Tivoli J:Skelton. 1758*
1909-4-6-11

Skelton arrived in Rome at the end of 1757 and died there in January 1759 after a painful illness, exacerbated by anxiety at not selling his work and by extreme poverty, 'a happy release to a very good young man', as a friend noted. His stay in Italy is fully documented in the letters that he addressed to his patron, William Herring. These give a detailed account of his daily life, his experiments with various techniques, his attempts to improve his figure painting, his exploration of the Roman Campagna, and even the political intrigues of the Jacobite exiles surrounding the Young Pretender. It appears that he visited Tivoli twice, briefly in April 1758 and again towards the end of July, when he stayed for over two months. As he told Herring: 'This ancient city of Tivole I plainly see has been ye only school where our two most celebrated Landscape Painters Claude and Gasper studied'. The influence of Gaspard Dughet in particular is evident in his views of Tivoli. Compared with his landscape on the Medway of the previous year (no. 14), these are much more elaborately conceived and sometimes even include an element of the *capriccio* that may also suggest knowledge of the work of Giovanni Paolo Pannini (1690/1–1765), the most fashionable Roman *vedutista* of the day. However, his letters show that the study of nature was his chief preoccupation: 'I am...taking all opportunities of making drawings from Nature', Skelton wrote, 'some in Indian ink, and some in Colours where I find the colouring very fine in Nature'. The greater part of the present watercolour does look as if it had been drawn on the spot, although the foreground is obviously contrived according to a standard pictorial convention. Skelton's letters also reveal that he was among the earliest British artists to have experimented with open-air sketching in oil, a procedure that he seems to have found unsatisfactory: 'in the open daylight [oil-colours] shine so much when they are wet that there is no such thing as seeing what one does'. His solution to this problem was to paint studies from the window of his bedchamber, rather as Thomas Jones was to work some twenty years later (see no. 19). None of Skelton's *plein air* oil sketches have yet been identified.

Like the view on the Medway, this was among the large group of works by Skelton auctioned in 1909 which came from the Blofeld Collection at Hoveton House, Norfolk, assembled in the eighteenth century.

16

Francis Towne *1739/40–1816*

Ariccia

Watercolour with pen outlines; 321 × 468mm
Signed and dated: *Larice July 11 1781 Francis Towne delt* and inscribed on the backing sheet *Italy Laricea July 11 1781 Morning Sun breaking over the Church & Buildings. Francis Towne delt. A copy of this painted on canvas for James Curtis, Esqre 1784*
1973.U.1348. Bequeathed by the artist, 1816

Towne's exact date and place of birth are uncertain, but he was probably born in Exeter, Devon. By the mid-1750s he had moved to London, where he studied and first met Thomas Jones. Until he went to Italy in 1780 he worked chiefly in the neighbourhood of Exeter, making topographical paintings and drawings (some of which he exhibited in London) and teaching well-to-do amateurs. His distinctive style developed in the 1770s, and is apparent in the watercolours he made during a tour of Wales in 1777, but it found its fullest expression in the years 1780–1 when he visited Rome and Naples. On his death in 1816 Towne left a group of seventy-five Italian watercolours to the British Museum, the first such bequest by an artist. His work was not greatly appreciated in his lifetime, perhaps because he deliberately rejected currently fashionable

Picturesque notions in favour of a spare, linear style, dependent on bold pen outlines and flat washes of colour, often ignoring conventional ideas of perspective and recession. An unsuccessful candidate for election as an Associate of the Royal Academy on four occasions, the lack of recognition and the appellation of a provincial drawing master left him embittered. It was perhaps this sense of disappointment with the art establishment that led him, in 1805, to organise his own one-man exhibition in London, an event which passed almost entirely unnoticed. Towne's preoccupation with outline tempts one to consider him closer in spirit to contemporary figure-draughtsmen, notably Flaxman and Blake, than to most late eighteenth-century landscapists.

Towne arrived in Rome in October 1780. Although he did not keep a written journal as Thomas Jones did, his carefully annotated and dated watercolours form a visual account of his movements. In Rome he went on sketching trips with fellow artists, including 'Warwick' Smith, and there exist in the British Museum several examples of watercolours made on the same occasion by both artists. Towne's œuvre includes only a handful of studies of the scenery around the Alban Hills to the south of Rome, but it is hard to imagine that this landscape could fail to have pleased him. Ariccia was a resort for Romans and visitors seeking to escape the summer heat of the city, and Towne records that he made this drawing in the early morning of 11 July 1781. Sunlight is shown striking the foreground and the cupola of Bernini's S. Maria dell'Assunzione, while the dark olive-green trees still retain their coolness. By comparison with drawings made at the outset of his visit to Rome in the autumn of the previous year, the bold pattern and simplified and contrasted masses of colour in this view of Ariccia show the full development of Towne's highly personal manner. Striking though such drawings are, however, their exaggerated stylisation – in the all-purpose convention for foliage, for example – and Towne's emphasis on compositional pattern-making tend to obscure the individual qualities of the place represented. Although many of his watercolours were drawn on the spot, the spontaneity suggested by his notes on the date, time and light conditions is misleading. Towne imposed a ruthless selectivity on his material, excluding all unnecessary detail in the interest of his overall design.

17

Francis Towne 1739/40–1816

Lake Albano with Castel Gandolfo

Watercolour with pen outlines on two pieces of paper conjoined;
321 × 702mm
Signed and dated: *No 7 Francis Towne delt July 12 1781* and inscribed on the backing sheet *Italy No. 7 Lake of Albano taken July 12th 1781 Francis Towne Morning light from the left hand*
1972.U.646. Bequeathed by the artist, 1816

This watercolour is one of the last painted by Francis Towne before he left Rome in July 1781 to return to England in the company of John 'Warwick' Smith. They travelled via Florence and the north Italian lakes to Switzerland, where they spent part of September sketching in the Alps, an experience which inspired a small group of watercolours justly considered his masterpieces.

The view of Lake Albano is immediately familiar from the watercolours of John Robert Cozens, but it is unlikely that Towne then knew these. Cozens returned from his first visit to Italy in 1779, and there is no evidence, either stylistic or documentary, that Towne had seen any of the resulting finished watercolours before he himself left for Italy in 1780. Towne's whole approach was quite unlike that of Cozens; his careful definition of form through outline is the opposite of Cozens's subtle modulation of surface texture by means of tiny strokes of related colours. Towne is interested in light rather than atmospheric effect. All his forms are distinct, though drawn with increasing delicacy as they recede towards the background. Unfinished watercolours in the British Museum suggest that his method was usually to draw the subject on the spot, and perhaps to put in some grey wash, adding the colour and pen outlines later on. Like Cozens and 'Warwick' Smith, he used the drawings he had made in Italy as the basis for later watercolours and for a number of oil paintings, although he received few commissions. Largely ignored in his own lifetime, Towne's concentration on pattern and bold effects led to a reawakening of interest in his work in the present century.

18

Thomas Jones 1742–1803

Genzano, Lake Nemi

Watercolour over pencil; 286 × 428mm
Inscribed: *7/On the Banks of the Lake of Nemi*, indistinctly dated, probably *May 1777*, *Gensano* and *Caesarini palace*
1984-6-9-12

The younger son of a Welsh landowner, Jones was intended by his family to become a clergyman, and was studying at Oxford when his great-uncle, who was financing his education, died. He decided to follow his own inclination to become an artist, studying at Shipley's School as a pupil of Henry and William Pars and at the St Martin's Lane Academy. The main formative influences on Jones, however, were the period he spent as a pupil of Richard Wilson from 1761 to 1763, and his visit to Italy from 1776 to 1783. Even in Italy Jones was at first still under Wilson's spell and saw the landscape through his eyes; as he noted in his memoirs: 'In fact, I had seen and Copyd so many Studies of that great Artist Mr *Richard Wilson* which he had made here, and was so familiar with, & enamoured of *Italian* forms, that I enjoyed pleasures unfelt by my Companions'.

Jones at first based himself in Rome, hoping to attract patronage from visiting Grand Tourists. The memoirs he later wrote, based on the journal he kept in Italy, are an invaluable source of information on the daily lives of fellow artists and their relationships with patrons, his views on the customs of the Italians, and descriptions of sketching expeditions in the Campagna with fellow artists. The memoirs record that he stayed at Genzano between 29 April and 24 May 1777 in company with William Pars and his wife and various other friends, sketching in the neighbourhood of Lake Nemi and Lake Albano. Although Jones records sketching in the area with 'little Couzins' in June 1778, they do not seem to have worked together in 1777. However, a dated pencil sketch by Cozens shows that he too was in Genzano in April 1777. The difference between the two artists in vision and technique is clearly illustrated by comparing this view with Cozens's watercolour, taken from a similar though higher viewpoint (no. 30): Jones records exactly what he saw, including the unbeautiful scrubby terrain, and annotates his drawing with the names of the principal features in the landscape. Cozens concentrates on evoking atmosphere and melancholy beauty, ignoring exact topography in order to intensify the poetic mood of his composition.

19

Thomas Jones 1742–1803

Houses in Naples

Oil on paper; 254 × 381mm
Signed and dated on the verso: *Naples August 1782 TJ*
1954-10-9-12

During his seven-year stay in Italy, Thomas Jones made two extended visits to Naples. In 1778–9 he spent four months in the city, and then returned in 1780 to live there until his final departure for England in August 1783. The most remarkable achievement of this second visit was the sequence of oil sketches he painted in 1782–3. In 1954, around fifty 'studies in oil on thick primed paper – after nature', to use Jones's own words, appeared at auction in London. Hitherto completely unseen, they revealed Jones as one of the most original artists of the eighteenth century – 'a sporadic genius', as he has been described. When and where Jones learned to make sketches of this sort, which are not preparatory studies for larger paintings but works complete in themselves, is a matter for interesting if inconclusive speculation. Among French landscape painters there had been an established tradition of sketching directly from nature in oil since at least the time of Jean-François Desportes (1661–1743); it was carried on, particularly in Rome, by many French artists, especially Joseph Vernet in the 1750s, and in the 1780s by Pierre Henri de Valenciennes (1750–1819). Jones's master, Richard Wilson, had known Vernet in Rome, but there is no

evidence that he ever followed Vernet's precept, as recorded by Joshua Reynolds, 'paint from nature instead of drawing': he seems always to have recommended to his pupils his own practice of drawing from nature in black and white chalk on tinted paper. Valenciennes did not seriously begin to make oil sketches in Rome until 1781, following a brief period of study with Vernet in the course of a visit to Paris, but by this time Jones was already living in Naples. Some of Jones's earliest oil sketches are in fact dated before his departure for Italy, and no evidence has yet come to light to disprove the possibility that he evolved the technique independently.

Jones recorded in his memoirs that on 8 June 1782 he moved into the third floor, 'reckoned the genteelest and consequently the dearest...with the exclusive use of the Lastrica', of a house in the Vicolo del Canale below Capodimonte, opposite a church which he called S. Maria della Segola (S. Maria Antesecula, destroyed by bombing in 1943): 'From this *Lastrica* by which term the flat roofs of the houses in Naples... are called...you Commanded a view over great part of the City...on the other Side, the Rocks, Buildings & Vineyards about Capo di Monte – and where I spent many a Happy hour in painting from Nature... It was in this House I may say, that I spent by far the more agreeable part of my time during my Sojourn in Naples'. Of a few simple elements – the crumbling walls of two characterless houses, punctuated by shuttered windows and scaffolding holes, some nondescript vegetation in the foreground and a strip of sky – he has distilled the essence of the city in which he lived but which was ignored as unworthy of attention by his contemporaries.

Jones's Neapolitan sketches are indeed his most brilliant and spontaneous. The fact that the group sold in 1954 were until then in the possession of his descendants suggests that they were made by the artist for his own instruction and pleasure, rather than for sale. In this way they are comparable with the group of about 120, mostly of Rome or its immediate environs, by Valenciennes. The comparison cannot be pushed beyond a certain point, however, for Valenciennes was concerned above all with seizing transient effects of light and atmosphere. Some of his sketches are cloud studies in which the sky, lovingly and precisely studied, is the principal

element. Jones, whose skies are treated conventionally, had a strong sense of pictorial structure and a great feeling for architectural mass, analysing the relationship between forms with almost geometric precision and clarity. Eight years older than Valenciennes, Jones remains an essentially eighteenth-century artist, whereas the other seems to anticipate the fully developed Romantic approach to nature of Constable and his contemporaries.

20
William Pars 1742–1782
A Sepulchral Monument at Mylasa

Watercolour with pen and grey ink with some bodycolour and gum arabic; 285 × 471mm
Mm. 11-73. Presented by the Society of Dilettanti, 1799

In 1764 William Pars, aged twenty-two, was engaged to accompany Richard Chandler and Nicholas Revett's expedition to Asia Minor, in order to record the sites they visited. The commission came from the Society of Dilettanti, a group of noblemen and gentlemen founded in 1733, whose aims included a furthering of the appreciation of the Antique. Hitherto Pars seems to have practised as a portrait painter and to have aspired to history painting; there is little evidence of any accomplishment as a topographical or landscape artist before this expedition. His Ionian watercolours are therefore even more remarkable achievements. In them Pars rose to the challenge of his first major commission, developing both the extreme precision necessary in an archaeological draughtsman and a sensitive response to the exotic landscape and its inhabitants. Richard Chandler's account of the expedition, *Travels in Asia Minor* (1775, reprinted in abridged form in 1971, with a commentary on Pars's watercolours by Andrew Wilton), describes the itinerary, while Pars's watercolours (of which seventeen are in the British Museum) were engraved both in *Ionian Antiquities* (vol. I, 1769; vol. II, 1797), published by the Society of

Dilettanti, and as aquatints by Paul Sandby between about 1777 and 1780.

In this watercolour the central focus of the composition is a tomb of Hellenistic or Roman date, which still stands complete just outside the ancient city of Mylasa (now Milas); the burial chamber is in the lower storey. Pars probably worked up his drawings after returning to London in 1766, with the requirements of the engraver in mind. However, several unfinished compositions which include a good deal of colour suggest that he worked in front of the motif at least to a fairly advanced stage.

21

William Pars 1742–1782

The Rhône Glacier and the Source of the Rhône

Watercolour, pen and ink, with touches of gum arabic over pencil; 331 × 488mm
1870-5-14-1219

The group of Swiss watercolours which Pars exhibited at the Royal Academy in 1771 were the first specifically Alpine views to be seen publicly in England. They anticipated by several years those by John Robert Cozens (see no. 29) and Francis Towne. In 1770, four years after his return from Turkey and Greece (see no. 20), Pars was engaged by Lord Palmerston, who as a member of the Society of Dilettanti would have known his Ionian watercolours, to accompany him on a journey through Switzerland. Palmerston's detailed account of their itinerary reveals what the party found most noteworthy (see Andrew Wilton, *William Pars, Journey through the Alps*, 1979). For some of the time they were guided around the glaciers by Horace Bénédict de Saussure (1740–99), a naturalist and geologist whose *Voyage dans les Alpes* was to be published between 1779 and 1796. Though Pars seems to have been expected to record such natural phenomena in an objective and scientific spirit, in the resulting watercolours he succeeded in conveying the scale

and grandeur of the Alps in a way that makes the best of his Swiss drawings extraordinarily impressive. This view of the Rhône glacier is among the finest of the series. Based on studies drawn on the spot, Pars depicts the Alpine landscape with a cool clarity.

The Society of Dilettanti, sponsors of the earlier expedition to Asia Minor, maintained their interest in Pars, supporting him when he went to Italy in 1775. Here he lived for seven years, eking out his allowance by making copies after the Old Masters and obtaining a few commissions for portraits, until his sudden death in 1782 from an illness apparently contracted from standing in the cold water at Tivoli while sketching. Thomas Jones, his close friend, recorded in his memoirs that Pars 'had an inward bias in favour of landscape, though brought up to Portrait…though in a fit of splean, he would sometimes curse his Fate in being obliged to follow such trifling an Employment; as he called it – it was with the greatest difficulty his Friends could detach him from his favourite Study'.

22

Thomas Hearne 1744–1817

Elvet Bridge, Durham

Watercolour with touches of ink over grey wash; 203 × 255mm
1859-5-28-207. Presented by John Henderson

Hearne was one of the leading topographical draughtmen of his day. As a young man he had been apprenticed to the engraver William Woollett, and in 1771 was appointed draughtsman to the Governor of the Leeward Island (a view of Antigua is in the British Museum). On his return to England after three and a half years he devoted himself almost exclusively to British antiquarian subjects and landscape, his most ambitious project being the joint publication with William Byrne of *The Antiquities of Great Britain*, issued in parts between 1777 and 1806, to which he also contributed over fifty drawings.

Elvet Bridge, Durham is a later and more elaborate version of a

1789 opened an evening drawing school. One of his pupils was the youthful Turner, whose architectural subjects of the 1790s reflect Malton's influence particularly in their low, often oblique viewpoint.

26

John 'Warwick' Smith 1749–1831

The Villa Medici, Rome

Watercolour with pen and Indian ink wash; 336 × 531mm
Inscribed on the verso: *Villa Medici at Rome*
1936-7-4-27

Smith was known in his own day by two nicknames: 'Warwick', a sobriquet derived from his patron, the 2nd Earl of Warwick, who financed his stay in Italy, and 'Italian' on account of the large quantity of Italian subjects which stemmed from the material gathered between 1776 and 1781. Smith figures frequently in Thomas Jones's *Memoirs*, which contain several references to sketching excursions with 'my friend Smith the Landscape painter'. The finest of his Roman views remained in the Warwick collection until 1936, when they were acquired by the British Museum. They show Smith working in a broader, bolder and more atmospheric style than is usually associated with him; by comparison his post-Italian work is much more conventional, and his reputation has suffered from his many indifferent repetitions of earlier subjects.

In July 1779 Thomas Jones recorded: 'Smith returned from Naples where he had sojourned ever since March last twelvemonth – and took *Appartments* at the *Monaco*, a house standing singly under the hill of the Trinida de Monti. On top of this house was a delightful Loggia or Open Gallery where we spent many agreeable Evenings *with Song and Dance &c*.' The house was in the Via del Babuino, just below the Villa Medici on the Pincio, and Smith must have taken this view from a window or the 'delightful Loggia'. Although on a considerably larger scale, this watercolour has some

affinities with oil sketches made from nature by Thomas Jones in Naples in 1782–3 (see no. 19), and it is possible that Jones's interest in such apparently unpromising subject matter as rooftops and the walls of houses was prompted by Smith's example.

27

John 'Warwick' Smith 1749–1831 and
Julius Caesar Ibbetson 1759–1817

The Hon. Robert Fulke Greville's Phaethon crossing the Mountains between Pont Aberglaslyn and Tan-y-bwlch

Watercolour; 318 × 438mm
1985-2-23-9

In the summer of 1792 'Warwick' Smith and Ibbetson accompanied Robert Fulke Greville, the younger son of Smith's patron, the Earl of Warwick, on a sketching tour of Wales. The country was still largely unknown at that time, the generation of Romantic artists who were to explore it and derive inspiration from the wild grandeur of its landscape had still to emerge, although coincidentally 1792 was the year in which Turner made his first extended tour of Wales. Travel could still be hazardous: in this watercolour, in which the landscape is by Smith and the figures by Ibbetson, the dangers of crossing the Pass of Aberglaslyn are evident. Ibbetson shows himself placing a rock behind the wheels of the phaethon to act as a brake. He subsequently worked this subject up into an oil painting in 1798 (Temple Newsam House, Leeds), in which he heightened the drama of the scene by changing the fine summer weather of the watercolour into a thunderstorm.

28

John Webber 1751–1793

A View in Nootka Sound, Vancouver Island

Pen and black ink over pencil with grey wash and watercolour;
515 × 368mm
Signed and dated: *J Webber. del. 1778*
1859-7-9-102

Webber succeeded William Hodges as draughtsman on Captain Cook's third and last voyage to the South Seas in 1776–80. He was the son of a Swiss sculptor who had settled in London, and he himself was trained in Switzerland, where he was apprenticed in 1767 to Johann Ludwig Aberli, the leading landscape artist. He later continued his studies in Paris, but in 1775 he returned to London, where he was admitted as a student at the Royal Academy. His exhibits at the 1776 exhibition attracted the interest of the botanist Dr Solander, through whose recommendation he was appointed to join the *Resolution*.

This watercolour was made in the course of the expedition, such studies forming the basis of larger and more elaborate compositions which were subsequently engraved for the official account of the journey, published in 1784. This publication was intended for a serious audience, but in 1808 Boydell issued a further series of engravings catering to a less scientific interest in the exotic.

The *Resolution* and *Discovery* put into Nootka Sound, Vancouver Island, at the end of March 1778, staying for a month, and Webber produced many sketches of great documentary value. A member of the expedition described the landscape: 'The land round the Sound is very much broken into high Precipices & deep Chasms; all parts of which are wooded, & continue so down to the water side, where the shore is steep and rocky...the whole has a *melancholy* appearance'. Another account noted that: 'The woods bespeak there being sometimes very Turbulent weather here; there are many trees blown down, and a vast number of others confoundedly mutilated by the rough Gales', descriptions confirmed by this watercolour. Webber made several drawings of the native Indians, in which he

depicted their costume with great accuracy, but here, perhaps in the interests of decency, he has modified that of the central spear-carrying man. According to Captain Cook, '...the lower garment is mostly worn by the women, the men seldom wearing any thing about their Middles nor are they ashamed to appear naked'. A related watercolour and oil painting exist, both dating from the mid-1780s, which must have been based on this record made on the spot.

29

John Robert Cozens 1752–1797

From the Road between the Lake of Thun and Unterseen

Watercolour; 237 × 365mm
1910-2-12-242. Salting Bequest

In 1776 Cozens accompanied the antiquarian and collector Richard Payne Knight (1751–1824) on a tour through Switzerland and on to Rome, where he stayed until 1779. His Alpine views played an important part in encouraging a taste for dramatic landscape, and in the 1790s they were admired and copied by Girtin and Turner when students in Dr Monro's informal academy. This is one of a number of watercolours based on studies made by Cozens in Switzerland in the late summer of 1776: other comparable examples are dated 1778 and 1779, which shows that he must have worked up some at least of these subjects while he was in Rome between the autumn of 1776 and April 1779. This is an elaborated version of a drawing now in the Yale Center for British Art, New Haven, which is inscribed on the verso in the artist's hand with the topographical details.

The soft, atmospheric and romantic character of this watercolour shows Cozens developing mastery of subtle effects of light and tone despite the use of a very limited range of colour – soft greys with touches of blue.

30

John Robert Cozens 1752–1797

Lake Nemi, looking towards Genzano

Watercolour over pencil; 370 × 534mm
Gg. 3-395. Cracherode Bequest, 1799

John Robert Cozens, who had accompanied Payne Knight through Switzerland in the late summer of 1776 (see no. 29), was in Rome by 27 November, when Thomas Jones records meeting him with other 'Old London Acquaintances' at the English Coffee House near the Piazza di Spagna. Dated inscriptions on drawings in a volume in the Soane Museum show that he was sketching in the Alban Hills in April 1777, and there are glimpses of him in Jones's memoirs. On 1 June 1778 Jones records 'many very agreeable excursions to a Villa near S'a Agnese without the Porta Pia', belonging to a Signor Martinelli with whom 'Little Couzins the landscape painter lodged in Rome', and describes sketching expeditions with Cozens (who was not well) 'riding about on a JackAss'. On 8 April 1779 he recorded Cozens's departure for England.

The Alban Hills, extinct volcanoes whose craters contained lakes, had attracted artists since the seventeenth century, and from the 1750s onwards the area became a favourite with French and British artists in Rome. Cozens's views of Lake Albano and Lake Nemi were his most popular and frequently repeated subjects; in some cases there are as many as eight or nine slightly different versions of the same composition. They are not easy to date, for Cozens's work is not susceptible to straightforward stylistic analysis. In some ways his art is more closely dependent on the then received conventions of picture-making than, say, Thomas Jones's oil sketches or Francis Towne's watercolours. Cozens was deeply influenced by the work of Claude, often using similar compositional devices and the same receding, misty distances. The origin of the uniquely melancholy beauty of Cozens's art may be seen in the elegiac quality of many of Claude's paintings. Cozens's achievement lay in transforming such prototypes into genuinely Romantic works which are among the greatest achievements of the period.

Lake Nemi looking towards Genzano is taken from a similar though rather higher viewpoint to that chosen by Thomas Jones in no. 18. It was bequeathed to the British Museum, two years after the artist's death, by the Revd Clayton Mordaunt Cracherode, who had been one of the subscribers to a fund established in 1794 for Cozens's support during his last years of insanity. Cozens died in the care of Dr Thomas Monro, in whose collection the young Girtin and Turner studied his work.

31

Francis Nicholson 1753–1844

A View at Stourhead

Watercolour with ink wash; 406 × 555mm
1944-10-14-138. Presented by Miss M. H. Turner

This is from a series of twenty-five watercolours in the British Museum which record the appearance of the grounds at Stourhead in Wiltshire at the period of their full maturity, about 1813–16. This celebrated landscape garden, with its temples and a grotto grouped around a lake, was mainly created by Henry Hoare the Younger (1705–85), who had inherited the estate in 1741. His intention was to create a real landscape in imitation of the idealised Virgilian scenes painted in Rome in the previous century by Claude Lorrain, Nicolas Poussin and Gaspard Dughet (see Kenneth Woodbridge, *Landscape and Antiquity*, 1970). From the 1760s onwards, however, he began to introduce into his landscape a number of exotic features, some Gothic and some Oriental, which can be seen in other watercolours in the series.

In 1783 Henry Hoare made over Stourhead to his grandson, the antiquary and historian of Wiltshire, Richard Colt Hoare (1758–1838), and it was he who commissioned the series of views from Francis Nicholson. He made a number of changes to the landscape in an effort 'to render the design of these gardens as chaste and correct as possible', and in the early 1790s embarked on a massive

planting programme which was to give the lakeside its present character of an arboretum. Some of these developments can be seen here, where the Temple of Apollo (derived from a plate in Wood's *Ruins of Baalbec*, 1757) appears almost to float above the densely grouped trees on the left. At the far side of the lake is the Pantheon, completed by 1757, which was inspired by similar buildings in several paintings by Claude, notably *Aeneas at Delos*.

The cycle of nature and art at Stourhead came full circle in Nicholson's watercolours, in which the landscape garden, itself based on art, is translated back into a series of ideal landscape compositions. Nicholson might almost have been thinking of Henry Hoare's principles of planting when painting the series: 'The greens should be ranged in large masses as the shades are in painting, to contrast the *dark* masses with the *light* ones, and to relieve each darkness itself with little sprinklings of lighter greens here and there'. A founder member of the Society of Painters in Water-Colour in 1804 and a fashionable drawing master, Nicholson was essentially a rather old-fashioned artist whose style seems to have been crystallised in the Picturesque manner of the 1780s and 1790s; his drawing manual, *The Practice of Drawing and Painting of Landscapes from Nature in Water Colours*, was published in 1820.

32

Thomas Rowlandson 1756–1827

Greenwich Fair

Watercolour over pencil with pen and ink; 425 × 543mm
1868-8-8-3193

The most prolific and spirited humorous draughtsman of his period, Rowlandson is known above all for his keen observation of human foibles. But as a young student at the Royal Academy in the 1770s his initial ambition was to be a serious history or figure painter. He was also a talented landscapist, whose imitations of Gainsborough's drawings are extraordinarily deceptive. Temperamen-

tally, however, he was (like Gainsborough) unsuited to topography, the form of landscape most in demand in the latter part of the century: his vital and energetic pen-line were ill adapted to the discipline of architectural draughtsmanship or exact physical detail. However, he was able to develop a format that suited his particular talents, in which the landscape became a stage set for his figures. In this large but unfinished watercolour of Greenwich Fair, the central section of which was etched by Rowlandson for publication in 1816, his talent for candid, shrewd observation of his fellow man is readily apparent.

33

William Blake 1757–1827

Beatrice on the Car, Dante and Matilda

Pen and watercolour over pencil; 367 × 520mm
Inscribed: *P-g Canto 29*
1918-4-13-5

Although Blake himself can hardly be thought of as a landscape artist, he was a powerful influence on a group of younger painters whose perception of landscape was in great measure shaped by his vision – John Linnell (no. 71), Samuel Palmer (nos 81–3) and his circle, the so-called Ancients (no. 76). It was through Linnell, his most loyal supporter and patron in the 1820s, that Blake was commissioned to illustrate Thornton's *Virgil* (1820–1) and it was Linnell who in 1824 commissioned his final project, a series of watercolours to be engraved as illustrations to Dante's *Divine Comedy*, which he left unfinished at his death. For the young Samuel Palmer, the wood-engravings for Thornton's *Virgil* were 'visions of little dells, and nooks, and corners of Paradise: models of the exquisitest pitch of intense poetry'. Palmer may have added something of his own vision of landscape to his interpretation of the *Virgil* series, for a note in Blake's hand on one of the Dante watercolours suggests that his own view of nature was more

equivocal: 'Every thing in Dante's Comedia shows that for Tyrannical Purposes he has made This World the foundation of All, & the Goddess Nature Memory is his Inspirer & not the Imagination the Holy Ghost'. Nevertheless, Blake also had an intense delight in, and identification with, the natural world. Palmer later recalled to Blake's biographer, Alexander Gilchrist: 'To walk with him in the country was to perceive the soul of beauty through the forms of matter.'

This watercolour, an unfinished illustration to *Purgatorio*, Canto XXIX, 13–150, is among the most beautiful of the series. Dante, still in Purgatory, glimpses Paradise across the River Lethe; Matilda, at the sight of Dante, drops the flowers she has picked from 'the tender may-bloom flush'd through many a hue,/ In prodigal variety' while walking in the Garden of Eden. Behind her approaches the procession as described by Dante, with many allusions to the Book of Revelation, from which are taken the candelabrum of 'seven trees of gold' (the flames of which leave a trail of the colours of the rainbow), the four and twenty elders and Beatrice's car drawn by a gryphon. The richness of imagery and the exquisite and expressive use of colour shows that Blake was still at the height of his powers at the end of his life. Samuel Palmer saw him working on the series: 'We found him lame in bed, of a scalded foot (or leg). There not inactive, though sixty-seven years old, but hard-working on a bed covered with books sat he up like one of the Antique patriarchs, or a dying Michael Angelo. Thus and there was he making in the leaves of a great book...the sublimest design from his...Dante. He said he began them with fear and trembling. I said "O! I have enough of fear and trembling". "Then" said he, "you'll do".'

34
William Alexander 1767–1816
Pingze Men, the Western Gate of Beijing

Watercolour over pencil with touches of black ink: 284 × 448mm
Signed and dated: *W. Alexander.f.1799*
1882-8-12-225

Alexander was the first Keeper of Prints and Drawings at the British Museum, being appointed in 1808. He had had a respectable career as a draughtsman of topographical subjects and for the previous six years had been Master of Landscape Drawing at the Royal Military College, Great Marlow. Although his own style was not innovative, he associated with, and to some extent was influenced by, the most progressive young artists of the day, being a member of Girtin's Sketching Club, and copying drawings in the collection of Dr Monro where his fellow students included Turner.

It is for his Chinese subjects that Alexander is best known. He accompanied Lord Macartney's embassy to Beijing, leaving England in 1792 and returning in 1794, and was the only artist of the period to visit the interior of China. Although the diplomatic mission, whose purpose had been to secure trading concessions with China, was a failure, Alexander (who had also kept a journal) returned with a considerable body of entirely new and vividly depicted visual information. After his return to England he made numerous drawings worked up from sketches taken on the spot, and publications including engravings after his views of China continued to appear as late as 1814. Another version of the present drawing is in the Museum and Art Gallery at Maidstone (Alexander's home town); an engraving by J. Dadley, dated 1796, appears as plate xx to Sir George Staunton's *Authentic Account of an Embassy from the King of Great Britain to the Emperor of China*, published in 1797.

The entry of the British embassy into Beijing on 21 August 1793 was described by Staunton: 'The arrival of the Embassador was announced by the firing of guns; and refreshments were made ready for all the gentlemen, at a resting place within the gate. Over the

gate was a watchtower several stories high. In each story were portholes for cannon, painted, as sometimes on the sides of merchant vessels which have none. Around the gate, on the outside, was a semicircular wall, with a lateral gate, upon the plan of European fortifications, which may be a modern addition. The city walls were about forty feet in height. The parapet was deeply crenated...the thickness of the walls was at the base about twenty feet' (vol. II, pp. 115–16). Pingze Men, the main western gate of Beijing, was demolished in the 1950s together with the walls shown in the drawing, but the bridge in the foreground still stands.

35

John Glover 1767–1849

A Rocky Gorge

Watercolour; 107 × 183mm
1948-4-10-12. Presented by F. J. Nettlefold

One of the founder members of the Society of Painters in Water-Colours and a prolific contributor to their early exhibitions (he showed 176 works between 1805 and 1812), Glover was the leader of the group who broke away in 1813 to set up the rival Society of Painters in Oil and Water-Colours. His public style (rather like that of William Havell) was the classic pastoral landscape conceived in emulation of Claude, which made him popular with conservative-minded patrons but earned him the criticism of more forward-looking artists like Constable, who considered Glover a mere pasticheur. However, Glover also made numerous small-scale studies which are striking in their freshness and immediacy. He was well known for his technique of dividing the hairs of the brush into small sections and going over the surface of his watercolours with scumbled, feathery strokes of black or grey Indian ink to suggest the play of light, a device clumsily imitated by numerous followers, but, as in this study, capable of achieving considerable liveliness.

Glover emigrated to Tasmania in 1831, where he painted some

of his most original works; whether this watercolour shows an English or Tasmanian view is uncertain.

36

Joshua Cristall 1768–1847

A Cottage at St Lawrence, Isle of Wight

Watercolour touched with white over pencil; 326 × 466mm
Signed and dated: *Joshua Cristall 1814*
1980-10-11-1

Cristall was one of the original members of the Society of Painters in Water-Colours, founded in 1804; he was President in 1816 and 1819 and again from 1821 to 1831, but was unusual in being essentially a figure-painter. His early works in watercolour were large classical scenes, notable for their fine sense of composition and breadth of manner. In later years he painted rustic and domestic subjects which, as contemporary critics noticed, often have classical echoes.

It was probably at the suggestion of one of his patrons, James Vine, who lived at Niton on the Isle of Wight, that Cristall visited the island in 1812. This watercolour (which is in particularly good condition, having been kept in an album for many years) was exhibited at the Society of Painters in Water-Colours in 1815. It makes an interesting link between the eighteenth-century rustic genre scenes of Francis Wheatley and George Morland and their Victorian counterparts such as Birket Foster and Helen Allingham. Ackermann's *Repository of the Fine Arts*, in a note on a similar work by Cristall, remarked: 'Such as we wish to meet in every village are here represented by the elegant mind of this artist...the group of figures, nay, the whole picture, raises in the mind of the spectator none but images of pleasure'. This idealised view of the supposed charms of rural life was characteristic of many writers and painters of the period.

37

Thomas Girtin 1775–1802

Landscape with Hills and Clouds: Mynydd Mawr

Watercolour; 149 × 256mm
1855-2-14-58. Presented by Chambers Hall

Even before Girtin's early death at the age of twenty-seven he was being spoken of as a great master of landscape. The diarist Joseph Farington noted on 9 Febraury 1799 that two of the leading patrons of the day proposed 'Girtin against Turner – who they say effects his purpose by industry – the former more genius – Turner finishes too much'. He began as a topographical draughtsman working in the style of his master, Edward Dayes, but by the mid-1790s his style had developed a new freedom and expressiveness.

Like many other artists of the period, Girtin made annual sketching tours; initially, as in his tour of the Midlands made in 1794, these were in search of antiquarian and architectural subjects, which formed the basis of finished exhibition watercolours. However, by 1796, when he visited Yorkshire for the first time, he came into contact with a type of landscape – broad stretches of moorland punctuated by barren hills, low horizons and rolling skies – that evoked a new and profound response. In 1798 he made a tour of North Wales, sketching the wild landscape in a series of small studies. They are suffused with a powerful sense of solitude, isolation and sometimes melancholy, effects enhanced by his use of a deliberately limited range of colours – grey, green and blue – and are rivalled only by Turner's exactly contemporary Welsh watercolours. In the following year Girtin exhibited two Welsh subjects at the Royal Academy, of which a critic noted that they showed 'all the bold features of genius', a comment equally applicable to studies such as this, only recently identified as a view of Mynydd Mawr, between Beddgelert and Caernarvon.

Girtin's style was probably the strongest influence on the generation of watercolourists who came to maturity in the first decade of the nineteenth century. They included Varley, Cotman, Cox and De Wint.

38

Thomas Girtin 1775–1802

The Great Hall, Conway Castle

Watercolour; 368 × 209mm
Signed: *Girtin*
1855-2-14-63. Presented by Chambers Hall

There is uncertainty about the dating of this watercolour; it has been related to Girtin's tour of North Wales made in 1798 and also to a supposed visit in 1800, when he may have stayed with Sir George Beaumont, who spent much of that summer near Conway. The castle was a popular subject with topographical artists: Sandby made several views of Conway, and both de Loutherbourg and Turner exhibited paintings of the castle about 1802–3. Girtin's choice of motif here, however, is very different from theirs, and instead of showing the castle as the focus of a landscape composition, he chooses to place himself inside the Great Hall – not, as an architectural topographer like Malton might have done, in order to render a detailed drawing of the building, but rather, as in Turner's watercolour of the interior of Tintern Abbey (RA, 1794), to suggest the essential character of the crumbling yet beautiful structure.

39

Thomas Girtin 1775–1802

Kirkstall Abbey

Watercolour over pencil; 320 × 518mm
Signed and dated: *Girtin 1800*
1855-2-14-53. Presented by Chambers Hall

This is one of two late views of Kirkstall Abbey by Girtin (his earliest was a copy after Edward Dayes, *c.*1792). The other, in the Victoria and Albert Museum, is undated but was probably also

painted about 1800 – that is, during the brief period of Girtin's full maturity. This type of apparently conventional topographical composition, when compared with the work of most of Girtin's contemporaries, explains Farington's comment in 1799 that he was being spoken of as 'a genius'. The other drawings by Girtin included here are sketches or working studies; this, on the other hand, would have been regarded by his contemporaries as a finished water-colour. At first sight this seems a quintessentially picturesque view – an ancient abbey set in a wide valley through which meanders a river, a background of hills with their neatly intersecting outlines and variegated clumps of trees, peopled by farm-labourers about their work – but Girtin's treatment is wholly unpicturesque in its directness and breadth. The composition has unity as well as variety; and while, characteristically, he represents a panorama, the spectator's eye is not encouraged to travel slowly across it. The view can in fact be taken in at a glance: the whitened ruins in the middle distance on the right and, in the same plane on the left, the bend in the river which catches the light, capture the spectator's attention in the same moment. Beyond are puffs of smoke (a favourite compositional device of Girtin's) from a local lime-kiln. The sweeping simplicity and grandeur of the landscape are emphasised by the distribution of light and shade, which cut across the lie of the ground and swallow up the smaller details or run them together in a band of shadow; the sky plays an essential part in the total effect.

40

Thomas Girtin 1775–1802

The Thames from Queenhithe to London Bridge

Watercolour over pencil; 206 × 444mm
1855-2-14-28. Presented by Chambers Hall

One of a group of six studies in the British Museum made by Girtin in preparation for his *Eidometropolis* or panorama of London. They provide the only reliable surviving evidence for the appearance of the circular 'Great Picture of London' which Girtin probably completed shortly before he went to Paris late in 1801. His early training as an architectural draughtsman must have influenced his decision to undertake the project, for which his previous experience had in no way prepared him. It was to be executed on a truly enormous scale – his 1802 press announcement described it as one hundred and eight feet in circumference and eighteen feet high – and apparently in oil, a rare instance of his use of the medium. Many previous artists had found the banks of the Thames a rich source of subject matter, but Girtin's immediate inspiration must have been the detailed large-scale panorama of London from the Albion Mills which Robert Barker and his son Henry had exhibited in 1792, and two other panoramas painted by friends of his in 1800. Girtin seems to have recognised that this highly popular art form offered him the opportunity of demonstrating his skills as a painter without being dependent on a private patron. The *Eidometropolis* was exhibited at Spring Gardens from August 1802 until Girtin's death on 9 November, and was subsequently reopened until the end of March 1803, when it was put into storage. To judge from Book Seven of *The Prelude*, it may well have been among the sights of the city to which Charles Lamb took the Wordsworths. According to one account, the panorama was sold about 1825 to a Russian nobleman.

Girtin brought to the panorama, hitherto conceived in terms of dry topography, an entirely new understanding of atmosphere, light and distance. A review in the *Monthly Magazine* for October 1802 noted: 'the artist…trusted to his eye, and has by this means given a most picturesque display of the objects that he has thus brought into his great circle; and, added to this, he has generally paid particular attention to representing objects of the hues which they appear in nature, and by that means greatly heightened the illusion. For example, the view towards the east appears through a sort of misty medium arising from the fires of the forges, manufacturers etc.'. The amount of exact detail in the completed panorama is suggested by some of the meticulous pen and ink drawings squared for enlargement that also survive (in the British Museum, the Guildhall Library and the Yale Center for British Art). Girtin may have used a camera obscura or some similar optical

apparatus, although the *Monthly Magazine* account stated that 'the artist, it seems, did not take the common way of measuring and reducing the objects, but trusted to his eye'. This may have been a case of the art that conceals art.

This study, for the fifth section of the panorama, is the most dramatic of the series. The spires and towers of the city churches punctuate the horizon, which is further dramatised by the threatening storm clouds. The view is looking towards the north bank of the Thames, from the churches of St Augustine and St Benet on the left, to the Monument, and on the extreme right, London Bridge and a glimpse of the Tower.

There is a squared working drawing in pen and ink for this section in the Guildhall Library, and it has been suggested that detailed studies of this kind must have preceded the watercolours, being made in preparation for them, but each type of drawing surely had a distinct purpose; in the pen and ink drawings Girtin is concerned with establishing the correct relationship of the elements of the composition, while in the watercolours he is striving after atmospheric effect.

41

Joseph Mallord William Turner 1775–1851

Bolton Abbey, Yorkshire

Watercolour with scratching out and gum arabic or varnish;
278 × 394mm
Signed and dated: *IMW Turner RA PP 1809*
1910-2-12-282. Salting Bequest

Turner first made his name as a painter of topographical water-colours of Picturesque subjects. Here, as so often, he seized on an existing trend, exploiting it more vigorously than anyone else – in this case it was the fashion for touring the more remote parts of the British Isles in order to admire the scenery. There was also an awakening interest in medieval remains – castles, ruined abbeys and

Gothic cathedrals. A considerable literature had developed in which the two enthusiasms – Picturesque and antiquarian – were combined, and by the 1780s artists such as Thomas Hearne and Edward Dayes had begun to make regular sketching tours. Engravings after their work were used as illustrations to antiquarian publications and guidebooks. This was the environment in which Turner began his career. Annual sketching tours, whether in Great Britain or, as in later years, on the Continent, were to become a regular feature of his life. The sketchbooks that he filled on these tours provided him with material for the topographical water-colours on which his early reputation was founded, and they became a source of reference used throughout his life.

Turner's first visit to Yorkshire was made in 1797, but his long and intense attachment to the region developed from his friendship with Walter Fawkes (1769–1825) of Farnley Hall near Leeds, whom he knew well from about 1803. His first visit to Farnley Hall was probably in the summer of 1808, when his sketchbooks record a tour up the valley of the River Wharfe and include a preparatory drawing for this watercolour, which was almost certainly painted for Walter Fawkes. Turner noted on 20 February 1809 that he had received a draft of a hundred pounds for ten drawings, of which this seems to have been one. His association with Fawkes was, with the possible exception of Lord Egremont, the most important of his career. By the time Fawkes died in 1825 his collection included seven oil paintings and about two hundred and fifty watercolours by Turner, including many of Farnley and the surrounding Yorkshire countryside. Although Turner visited Farnley almost annually between 1808 and 1825, he returned to Yorkshire only once – in 1851 – after Fawkes's death. According to Ruskin, Turner could never speak of the Wharfe, 'about whose shores the shadows of old thoughts and long-lost delights hung like morning mist, but his voice faltered'. Turner was held in great affection by the Fawkes family, and continued to receive a Christmas hamper of game and goose-pie until his own death in 1851.

This late-afternoon view of Bolton Abbey, seen from the north, shows Turner's application of a new quality of naturalism that he had developed in the preceding two or three years. Nevertheless, the composition is artfully arranged: the high viewpoint and the

winding river that leads the eye into the distance were to become favourite compositional devices. The use of gum arabic or varnish allowed Turner some of the effects that are more often associated with oil painting. The initials *PP* refer to Turner's election in 1807 as Professor of Perspective at the Royal Academy.

42

Joseph Mallord William Turner 1775–1851

On the Washburn

Watercolour with scratching out; 277 × 393mm
Signed: *IMW Turner RA*
1910-2-12-287. Salting Bequest

This view on the Washburn looking south along the valley was painted about 1815–16 for Sir William Pilkington, a relation by marriage of Turner's patron Walter Fawkes. Pilkington himself owned some twelve watercolours by Turner, mostly of Yorkshire subjects. The basis for this watercolour was a drawing made during Turner's tour of central Yorkshire in 1815 (Turner Bequest CXXIX–41); it predates most of the Washburn Valley views that were made for Fawkes.

43

Joseph Mallord William Turner 1775–1851

Weathercote Cave, near Ingleton, when half-filled with Water and the Entrance Impassable

Watercolour with scratching out and gum arabic or varnish;
301 × 423mm
1910-2-12-281. Salting Bequest

This is Turner's watercolour for one of the series of twenty views engraved after his designs for *The History of Richmondshire*, published by Longman's between 1819 and 1823; it was engraved by Samuel Middiman in 1821. Turner received the commission from the antiquarian author Dr Whitaker (originally for a much larger series covering the whole of Yorkshire) early in 1816, and executed the finished watercolours at a fee of twenty-five guineas each. No expense was spared on the publication – the engravers were paid between sixty and eighty guineas per plate – and it was generally considered a success. The intention to continue the series to cover the rest of Yorkshire was abandoned, partly on the grounds of cost, but chiefly because of the death in December 1821 of Dr Whitaker.

The series dealt with that part of Yorkshire bordering on Westmorland and Lancashire, centred on the town of Richmond (see no. 44), and includes many of the finest dales and rivers of the area. In July 1816 Turner made a tour to gather material for the project. The journal kept by Mrs Walter Fawkes, and Turner's own correspondence, record the worst kind of English summer weather: 'rained all day', 'heavy rain', 'weather miserably wet'. Nevertheless, Turner filled several sketchbooks with rapid studies, including a drawing which he later used as the basis for this watercolour (Turner Bequest CXLVII–33a). Turner had visited Weathercote before, probably in 1808, when he had been able to go into the cave, but this time the entrance was impassable: the normally dry, seventy-foot-deep cave was 'half full of water', no doubt because of the unusually wet summer. The drawing in the sketchbook has no indication of the rainbow that is such a striking feature of the finished composition, but it may be that Turner had in mind the description of Weathercote by John Hutton in *A Tour of the Caves in. . .the West Riding of Yorkshire* (1781): 'The sun happening to shine very bright, we had a small vivid rainbow within a few yards of us, for colour, size, situation, perhaps nowhere else to be equalled'.

44

Joseph Mallord William Turner 1775–1851

Richmond, Yorkshire

Watercolour; 275 × 397mm
1910-2-12-276. Salting Bequest

During the 1820s and 1830s Turner undertook a number of projects to illustrate topographical publications; the most ambitious was to be *Picturesque Views in England and Wales*, initiated about 1825 by the engraver and publisher Charles Heath. One hundred and twenty copperplate engravings after watercolours by Turner were planned, but only ninety-six were published. The engravings were issued in twenty-four parts between 1827 and 1838, each containing four plates with a descriptive text. Turner himself supervised the engraving process in minute detail, attaching considerable importance to the prints, for him the culmination of the whole creative process. Commercially the enterprise was a failure.

In 1831 Heath's first co-publishers sold out their share in the venture and he experienced continuous difficulty in financing so ambitious a project. In 1839, the year after the last number was published, Longman's (who had eventually assumed responsibility for the debts incurred by Heath over the series) put the entire stock of plates and unsold prints up for auction. Turner himself bought them for £3,000, probably in order to prevent the plates from being ruined by clumsy reworking. Despite this, the watercolours (groups of which were exhibited in 1829, 1831 and 1833) and the prints were admired by critics and collectors. Turner lavished immense care on the series, which constitutes the most sustained expression of his powers as a watercolourist.

Richmond was among the earliest views to be published; the engraving by W. R. Smith was issued in part II in June 1827. The watercolour, like all the Yorkshire subjects in *England and Wales*, was based on sketches made about 1816, when Turner was gathering material for an earlier engraved series, *The History of Richmondshire* (see no. 43). The castle and town are shown in early morning light, which Turner renders with extraordinary virtuosity.

45

Joseph Mallord William Turner 1775–1851

Lancaster Sands

Watercolour; 278 × 404mm
1910-2-12-279. Salting Bequest

Turner made the journey across Morecambe Bay, of which Lancaster Sands are a part, on at least two occasions, first in 1797 and then in 1809. The Sands are fordable at low tide, and there were guides who would lead travellers across. Sudden fogs, dangerous quicksands and unexpected changes in the tides made such assistance essential. The plight of the imperilled traveller was a subject that Turner depicted on several occasions; *Calais Pier*, an oil painting exhibited at the Royal Academy in 1803, was the first. In 1814 or 1815 an earlier watercolour of *Lancaster Sands* was painted for Walter Fawkes, as also one that recorded Turner's return from Italy in 1820, *Snowstorm, Mont Cenis*. In 1829 he continued the same theme with *Messieurs les Voyageurs on their return from Italy (par la diligence) in a Snow Drift upon Mount Tarrar*, and in 1842, *Snow Storm – Steam-boat off a Harbour's Mouth*, one of his most powerful paintings.

In this watercolour, painted for the *England and Wales* series about 1825–7 and engraved by R. Brandard in 1828, Turner shows a group of figures hurrying to cross the Sands before nightfall, aware of the rising tide; in the distance the sea has already overtaken a cart and horses. The background is among the most beautiful in the series, inspiring Ruskin in 1843 to write a characteristically extravagant yet perceptive passage: 'It is of an evening in spring, when the south rain has ceased at sunset; and, through the lulled and golden air, the confused and fantastic mists float up along the hollows of the mountains, white and pure, the resurrection in spirit of the new fallen rain, catching shadows from the precipices, and mocking the dark peaks with their own mountain-like but melting forms till the solid mountains seem in motion like those waves of cloud, emerging and vanishing as the weak wind passes by their summits; while the blue level night advances along the sea, and the

surging breakers leap to catch the light from the path of the sunset' (*Modern Painters*, vol. I, 1897 edn, p. 274).

46
Joseph Mallord William Turner 1775–1851
Louth, Lincolnshire

Watercolour with scratching out; 285 × 420mm
1910-2-12-278

Picturesque Views in England and Wales reflects almost every aspect of Turner's interests in both natural and man-made landscapes; the series has been described as 'modern history pictures in which the common man is the hero'. Human activity is the main theme of this wonderfully vivid account of a country town horse-fair and market. Although Ruskin, who at one time owned this drawing, thought that Turner had made it as a sop to the publisher, there can be little doubt that he enjoyed depicting such down-to-earth and robust subjects. His lively observation of the crowd of people gathered together here – humble farm-workers with their families, the townspeople, horse-dealers and buyers striking their bargains – is in the tradition established by Hogarth and Rowlandson. At the same time, he has carefully balanced the composition so that the spectator's eye is guided towards the splendid medieval church of St James. In 1797, some thirty years before this watercolour was painted, Turner had recorded the appearance of the church in a pencil study (Turner Bequest XXXIV–80); this use of drawings made on his earliest sketching tours was typical of Turner's working methods.

Louth was originally owned by Thomas Griffith, Turner's agent and later an executor of his will; it was among the seventeen *England and Wales* watercolours exhibited at the Egyptian Hall, Piccadilly, in 1829 and was engraved in the same year by William Radclyffe.

47
Joseph Mallord William Turner 1775–1851
A Storm on the Lagoon, Venice

Watercolour with pen and bodycolour; 218 × 318mm
1915-3-13-50. Sale Bequest

Turner visited Venice for the first time in 1819, and although his stay lasted only five or six days, it fixed the image of the city in his imagination. His second visit was probably in 1833 and his third and last in 1840, but it is characteristic of his secretive nature that we are not entirely sure in which year his visits were made. Between 1833 and 1846 Turner exhibited a series of oil paintings of Venetian subjects at the Royal Academy, but none of his watercolours of the city, of which there are about 170, was seen publicly until after his death. The problem of dating the Venetian watercolours is not yet entirely solved, but they can be grouped into sequences that seem to belong together and to have been executed at around the same time.

Most of these watercolours probably date from the 1840 visit or shortly afterwards, some perhaps painted when he returned to his studio in London. A few of them are more highly finished than others, and it is possible that Turner was contemplating painting a sequence of more fully developed watercolours for particular patrons, as he did in the early 1840s with a number of Swiss subjects. They include some of the most astonishing watercolour studies ever painted. Some groups can be distinguished by stylistic differences, and others classified by size or type of paper. In some the most evanescent impressions are conveyed by vaporous washes; in others the architecture of the city is defined and emphasised by pen and ink; in others again there is dramatic use of bodycolour on brown or grey paper.

Turner's primary concern was not with the detailed representation of the architecture of Venice (here, of course, he differs fundamentally from Canaletto and from his contemporary and admirer, Ruskin), profound though his understanding of architectural forms was. Instead, he attempted to capture his impressions of

the city's special atmospheric qualities. This is one of the most dramatic of a group of storm scenes. His virtuosity in depicting the menacing sky, the drift of misty rain through which a campanile (indicated simply by dragging a brush through the wet paint) looms out, and the churning sea is extraordinarily powerful. Clarkson Stanfield's attempt at a similar subject (no. 72), although successful in conventional terms, seems puny by comparison. The gondola in the foreground, painted with a few sweeps of the brush, is a perfect visual parallel to the poet Shelley's eerie description: 'The gondolas. . .are things of a most romantic and picturesque appearance; I can only compare them to moths of which a coffin might have been the chrysalis'.

48

John Constable 1776–1837

A Farmhouse near the Water's Edge

Pen, brown and grey ink and watercolour with scratching out;
145 × 196mm
1888-2-15-33. Presented by Miss Isabel Constable

The majority of drawings and watercolours by Constable now in the British Museum date from the last twenty years of his life, and were presented by his younger daughter, Isabel, who also gave the Victoria and Albert Museum their magnificent and representative collection of her father's work.

Although this is a finished watercolour (perhaps identical with one of those exhibited at the Royal Academy in 1832 or 1833), it also forms part of a sequence begun in 1819 with *The White Horse* (Frick Collection, New York), the first of Constable's large-scale paintings of scenes on the River Stour; the sequence continued into the 1830s with three oil sketches, which (to judge from references in his correspondence) were perhaps studies for a larger picture suitable for exhibition. The farmhouse that forms the central motif in these later sketches and the present watercolour is Willy Lott's

house on the Stour, which is among the most constant motifs in Constable's œuvre, appearing on the left in *The White Horse*. In 1829 financial difficulties compelled Constable's friend, Archdeacon Fisher, to sell some of his pictures back to Constable. These included *The White Horse*, and Graham Reynolds has suggested that its repossession may have stimulated Constable to take up the theme again. This is borne out by a pen and ink drawing, dated 1829 (BM 1971-1-23-1), which is essentially a repetition of the left-hand side of *The White Horse* and which seems to have been the point of departure for Constable's later treatment of the subject, including the present watercolour.

This extended sequence of variations on the same motif illustrates the complex nature of Constable's working procedure and also his tendency, in later years, to be obsessed with certain themes that had occupied him in youth. One such motif was Willy Lott's house, which developed into a symbol of an idealised way of life that had become increasingly remote as his visits to Suffolk diminished, and he came to treat it with an ever greater degree of abstraction, adhering less and less to precise topography with the passage of time.

The surfaces of Constable's late paintings are made up of thick layers of rough impasto: he seems to have been unable to let well alone and, as he himself said, he found it impossible to stop 'oiling out, making out, polishing, scraping, &c'. For his critics, the encrusted finish was as if the pictures 'had been powdered over with the dredging box or under an accidental shower of white lead'. Many of his later watercolours have the same heavily textured and highly wrought surface, but the similarly restless effect is achieved not so much by superimposing layers of pigment as by scratching through the pigment to reveal the white paper.

49

John Constable 1776–1837

Folkestone Harbour, with a Rainbow

Watercolour with scratching out; 127 × 210mm
1888-2-15-37. Presented by Miss Isabel Constable

Constable is associated above all with the landscape of his native Suffolk: unlike Turner, he never travelled far afield in search of subject matter, but concentrated on a small number of places with which he felt a deep personal bond and which were closely associated with his family, friendships and affections. To a greater extent than with most artists, the development of his art is intimately bound up with the history of his personal life. During the 1820s and 1830s Constable spent comparatively little time in Suffolk, but, through various friendships, made visits to Wiltshire and Sussex (nos 50, 51, 52). After the death of his wife in 1828 he was faced with greater responsibilities in the care of their seven children, whose ages ranged from ten to only a few months old. He took great pains in finding suitable schools for them, and it was on this account that he twice visited Folkestone, Kent, in 1833. In August he took his two eldest sons to a boarding school there and stayed for a few days while they settled in. He returned in October because the elder, John, had fallen and hurt himself while sleep-walking. Finding that the injury was more serious than he had been led to expect, Constable spent two weeks in the town, and made a number of watercolours which are now in the British Museum.

In choice of motif, scale and to some extent technique, this watercolour recalls Turner's *Southern Coast* series of the 1820s. This view of the harbour at Folkestone is more highly finished than others in the series, which may suggest that it was completed in the studio.

50

John Constable 1776–1837

Cowdray House: the Ruins

Pencil and watercolour; 267 × 274mm (the width includes a strip added by Constable on the right)
Inscribed: *Sep 14 1834* and on the verso *Internal of Cowdray – the Oriel Window, Mowbray* [sic] *Castle Septr 14 1834* and *Cowdray – Sepr 14 – 1834*
1888-2-15-31. Presented by Miss Isabel Constable

51

John Constable 1776–1837

Tillington Church

Pencil and watercolour; 232 × 264mm (the width includes a strip added by Constable at the bottom)
Inscribed: *Tillington Sepr 17 1834*
1888-2-15-49. Presented by Miss Isabel Constable

In September 1834 Constable, who had been seriously ill in the early part of the year, was invited to stay at Petworth, Sussex, by one of the most notable patrons of the period, Lord Egremont. C. R. Leslie, his closest friend in the 1830s, was a fellow guest and recalled their visit in his *Life* of the artist, published in 1843: 'Lord Egremont with that unceasing attention which he always paid to whatever he thought would be most agreeable to his guests ordered one of his carriages to be ready every day, to enable Constable to see as much of the neighbourhood as possible. He passed a day in company with Mr and Mrs Phillips [Thomas Phillips RA] and myself, among the beautiful ruins of Cowdry [sic] Castle, of which he made several very fine sketches…While at Petworth… he filled a large book with sketches in pencil and watercolours, some of which he finished very highly'. This watercolour, showing Tillington Church, a few miles from Petworth, and no. 50, with the creeper-clad ruins of Cowdray

Castle, which had been destroyed by fire in 1793, are both from this sketchbook, and form an instructive contrast with no. 48, a heavily worked studio composition executed from imagination. In his last decade Constable rarely sketched from nature, but when he did so it was in a fresh, colourful, almost relaxed manner, often of subjects he had never treated before. Neither of these watercolours could be mistaken for works of the artist's early period – the forms (except for Tillington Church tower) are too impressionistically rendered – but there is in them none of the tension and melancholy that characterise his attempts towards the end of his life to express the ultimate mystery that resided for him in themes long remembered and pondered over, like Salisbury Cathedral, Stonehenge or the landscape of his native Stour Valley.

52

John Constable 1776–1837

Stonehenge

Watercolour over black chalk, squared for transfer; 168 × 250mm
1888-2-15-38. Presented by Miss Isabel Constable

In his later years Constable became increasingly obsessed with the idea of the past, which he found both awe-inspiring and melancholy. The last works that he exhibited in his lifetime (at the Royal Academy in 1836, the year before his death) had for their theme the passage of time. One was *The Cenotaph* (National Gallery, London), a tribute both to Sir Joshua Reynolds, who was revered by Constable as the founder of the British school, and to Sir George Beaumont, Constable's first supporter and an ardent admirer of Reynolds, who had erected the monument in the grounds of his house at Coleorton. The other was a watercolour of *Stonehenge* (Victoria and Albert Museum), for which this drawing is a preparatory study. On his only recorded visit to Stonehenge, in July 1820, he made a sketch (Victoria and Albert Museum) which he used in 1835 as the basis for the finished watercolour. The present

intermediate study shows Constable in the process of transforming his original straightforward record into the dramatic watercolour exhibited in 1836 with a text reflecting Constable's consciousness of the phenomenon of time: 'The mysterious monument... standing remote on a bare and boundless heath, as much unconnected with the events of the past as it is with the uses of the present, carries you back beyond all historical records into the obscurity of a totally unknown period'. In 1834 he had contemplated adding a view of Stonehenge to the series of mezzotints after his compositions, *English Landscape Scenery*, issued in parts between 1830 and 1845, noting that it would be 'a poetical one. Its literal representation as a "stone quarry", has been often enough done'. It was this poetical, haunting quality that characterised his subsequent interpretation of the subject. This dramatic motif served to emphasise Constable's conviction that no effect of nature was too grand for such an inherently Sublime subject. As in many of his late works, he included a double rainbow, one of the most fleeting of natural phenomena – a symbol of hope – which in its transience contrasts with the permanence of the stones.

53

John Varley 1778–1842

A Cottage near an Estuary

Watercolour; 253 × 226mm
1859-5-28-130

Varley was an influential figure for the generation of water-colourists born in the 1780s and 1790s. In 1804, when he became a founder member of the Society of Painters in Water-Colours, to whose annual exhibitions he became a profuse contributor, he was already a well-established teacher, both of aspiring professionals and of amateurs. He encouraged his pupils, who included Cox, De Wint and Linnell, to adopt a naturalistic approach to landscape with an emphasis on sketching from nature. Many of his own

watercolours relied on the somewhat schematised ideal composi-tions which he popularised in teaching manuals, notably *A Treatise on the Principles of Landscape Design* (1816–21), but the more informal side of his work is characterised by lively, unaffected topographical studies, mostly made on the outskirts of London.

Cottage scenes represent one of Varley's great staples for exhibition; the Picturesque aesthetic as represented by such subjects was one to which he drew attention in his *Principles of Landscape Design*: 'the great interest which is excited by cottage scenes, originates in the facility of finding so many of those subjects in nature. . . in all their primitive and formal eccentricities and offensive angles; where age and neglect have both united to obliterate the predominance of art, and to blend them with nature by irregularity of lines. . .with growth of weeds, varieties of plaster, mortar, bricks, tiles, old greenish glass windows, inequalities of ground, with homely figures. . .ancient and greyish beams of timber'.

This watercolour, probably dating from about 1815, originally belonged to Cotman's patron, the antiquarian Dawson Turner.

54

John Sell Cotman 1782–1842

The Drop Gate, Duncombe Park

Pencil and watercolour; 330 × 230mm
1902-5-14-14

Cotman was born in Norfolk. He arrived in London in 1798, and for a period of about seven years seems to have been regarded as an outstandingly promising young artist, inheriting Girtin's role as the leading member of the Sketching Society, an informal group whose intention was to establish 'a school of Historic Landscape, the subjects being designs from poetick passages'. It was at meetings of this Society that Cotman's style evolved; it was one that he was to develop between 1803 and 1805, and it found its fullest expression in the watercolours inspired by his annual visits to Yorkshire.

The Drop Gate, which has become one of Cotman's most famous works, has traditionally been identified as a view in Duncombe Park, not far from Brandsby where Cotman was staying in the summer of 1805 as the guest of the Cholmeley family. No previous British artist — though precedents are not lacking in seventeenth-century European art — had made a complete composition from so humble a motif seen from such a close viewpoint, and it shows Cotman's 'pattern-making' style at its purest. This style is characterised by the reduction of natural forms to simple, flat shapes arranged in planes as far as possible parallel to the picture surface; the representation of these shapes by transparent washes, defining the boundaries of form by their crisp edges rather than by shading or outlines; the device of placing a light form in front of a darker one, so that the effect of recession is minimised, though not denied; the use of pure, translucent colours without monochrome under-painting; and the avoidance of any effect of movement. All this implies a rejection of illusionism, and of the traditional conception of landscape painting as a reconstruction of imaginary space, in favour of the imposition on nature of a semi-abstract design. The relationship between recession in depth and surface design is very subtle. What happens beyond the river bank at the top left? Is the view blocked by some object or are we meant to see a sharply foreshortened field stretching back into the distance? Without the tree on the right and the slight convergence of the horizontal rails of the two parts of the gate, the large beam would appear strictly parallel to the picture surface and almost parallel to the line of the stream. Drop-gates were pieces of fencing without hinges which were hung over streams to prevent cattle from straying; a similar wooden fence seems to continue beyond the tree. Yet Cotman shows no interest in the function of this primitive rustic device and concentrates only on its pictorial possibilities. The repeated uprights make for a unified effect, while all the strips of wood are subtly differentiated in shape in accordance with the classical formula for beauty: 'unity in variety'. The play of light on the gate is no less beautiful: the wood is paler in tone than the bank and the water behind it, and the strength of the light on the surface varies subtly from sunshine to deep shadow. The effects, indeed, in the whole composition are most refined and carefully calculated.

In his Greta watercolours and others in the same style, Cotman was obsessed by the aim of translating nature into art. With few exceptions, such as *The Ploughed Field* (Leeds City Art Gallery), these watercolours are without figures and reflect no interest in literature or history or even in topography (the introduction of classical allusions in one group is for formal purposes only).

The contemporary indifference to Cotman's Yorkshire water-colours, characterised as they are by delicate observation of isolated natural motifs, was extended to his first collection of prints, *Miscellaneous Etchings*, published in 1811. Although Francis Cholmeley's sisters praised 'the trees at Duncombe Park...as most like Rembrandts', he reported a comment from a bookseller: 'He said his subscribers did not like the view in Duncombe Park, because it might be *anywhere*. Two-thirds of mankind, you know, mind more about what is represented than *how* it is done'. In contrast with all other British landscapists of the late eighteenth and early nineteenth centuries, Turner in particular, Cotman is not an 'associationist'. His wholehearted desire to render his own personal sensations and to follow the dictates of his own imaginative life has no parallel in English landscape before Samuel Palmer at Shoreham; and the shock of having to consider the demands of a patron, as Cotman had to do from 1812 onwards when he began working almost exclusively for Dawson Turner, must have been as great as that which Palmer experienced when he came under the cold eye of his father-in-law, John Linnell. There is a fundamental difference, however, between Cotman and Palmer in that the visionary quality of Palmer's Shoreham period arose from a youthful romantic intensity which inevitably diminished as he grew older, whereas Cotman's achievement proceeded from an intellectual reassessment of the nature of landscape art.

A future that had seemed so promising for Cotman came to an end in 1806, when he was blackballed, for reasons that remain mysterious, by the Society of Painters in Water-Colours. Later that year, disappointed by his lack of public success in London, he returned to Norfolk, where he was to remain in provincial isolation for the next twenty-seven years. Like so many other drawings by Cotman that are now regarded as masterpieces, *The Drop Gate* remained unsold in his lifetime, perhaps for the reasons noted by

Francis Cholmeley, and was among a large number of drawings and watercolours later pledged to a pawnbroker by his son.

55

John Sell Cotman 1782–1842

The Scotchman's Stone on the Greta, Yorkshire

Watercolour over pencil; 267 × 394mm
1902-5-14-12

At the end of July 1805 Cotman was invited to Rokeby Park in North Yorkshire, where he stayed for about four weeks, first as the guest of the Morritts and then at the local inn. His hosts were richer and more learned that the Cholmeleys of Brandsby (see no. 54) – John Morritt was a classical scholar, had travelled extensively and was a collector of pictures, among them the *Rokeby Venus* by Velazquez, now in the National Gallery, London – but Cotman's relations with them were never as close. The surrounding countryside, however, to judge from his letters, fulfilled all his hopes. He particularly admired the park at Rokeby, which Sir Walter Scott (whose long narrative poem *Rokeby* appeared in 1813) considered 'one of the most enviable places I have ever seen'. The wooded banks with their winding paths and hidden dells threaded through by the River Greta inspired some of Cotman's finest watercolours. It is clear, however, that his highly distinctive style, of which the Rokeby drawings are the best-known examples, was not initiated nor even perfected beside the Greta, but had its sources in his earliest work.

The Scotchman's Stone is a boulder in the river above Greta Bridge, and Cotman refers, in a letter written in late August 1805, to having 'coloured a sketch of it'. He was certainly familiar with the traditional procedure then practised by almost all landscape watercolourists, of making pencil sketches on the spot and working them up into finished watercolours in the studio, in some cases perhaps years later. At the same time some artists, Cotman

included, were beginning to use colour while working in front of the motif. Cotman wrote to his Norfolk patron, Dawson Turner, from Yorkshire in 1805 that his 'chief study has been colouring from Nature', adding that many of his works were 'close copies of that ficle [sic] Dame', which might suggest that he found the process unfamiliar and somewhat difficult. The problem is to distinguish, in terms of the period, between a coloured sketch and a finished watercolour. This ambiguity arises particularly in connection with some of Cotman's most famous works, such as the present drawing and *The Drop Gate, Duncombe Park* (no. 54). The artist's biographer, Sydney Kitson, writing in 1937, assumed that they were outdoor studies for fully worked-up exhibition pieces which have subsequently disappeared. More recently (1970 and 1982), Miklos Rajnai has argued that the designs are too subtle and the colours too arbitrary for this to be the case, and that these drawings are in fact those executed in the studio and exhibited: this watercolour for instance he reasonably believes to be the *Study of a Rock, Greta River*, shown in Norwich in 1808. It is, however, possible that it was painted on the spot in 1805 but not exhibited until three years later. What is interesting is that there should be this ambiguity. Cotman, just as Constable was doing with the medium of oil paint at the same time, was narrowing the gap between sketch and finished picture, imbuing the latter with much of the freshness of a *plein air* study and, still more important, imposing on the former some of the contrivances of picture-making.

56
John Sell Cotman 1782—1842
Durham Cathedral

Watercolour over pencil; 436 × 330mm
1859-5-28-119

After staying for just over four weeks at Rokeby Park and at the inn beside Greta Bridge, bad weather, which had made sketching difficult, drove Cotman to go on to Durham, where he arrived on 4 September. Mrs Cholmeley had urged him to 'storm Durham', for she believed that the mighty cathedral and its majestic setting would inspire him; he, however, was inclined to resist her plea. As he wrote to her son on 29 August: 'but seriously what have I to do with Durham? Am I to place it on my studies of trees like a Rookery. No and besides I have no time for Durham'. In spite of this initial reluctance Cotman was sufficiently impressed to stay there almost a week, and found the cathedral 'magnificent tho not so fine as York'. He made at least five views, of which this is the finest, showing the cathedral perched like his 'rookery' high above the trees. It is probably the watercolour exhibited by Cotman at the Royal Academy in 1806 and at the Norwich Society of Artists in 1807. It subsequently belonged to his patron, the banker Dawson Turner, whose enthusiasm for the medieval would have found this subject of particular interest.

This was among the first watercolours by Cotman to enter a public collection, having been acquired on behalf of the British Museum at Dawson Turner's sale in 1859.

57
John Sell Cotman 1782—1842
Mousehold Heath

Pencil and watercolour; 299 × 436mm
1902-5-14-20

This is one of two watercolours of similar size showing the same scene, a favourite sketching ground for Norwich School artists (the other is in the Colman Bequest, Castle Museum, Norwich). A preparatory drawing in the British Museum is dated 20 April 1810, and this watercolour may have been one of the two *Views on Mousehold Heath* included in the Norwich Society of Artists exhibition in the same year. Cotman's attachment to the Heath was life-long. In November 1841 he wrote to Dawson Turner, recalling

his last day in Norfolk that autumn: 'I galloped over Mousehold Heath on that day, for my time was short, through a heavy hailstorm, to dine with my Father – but was obliged to stop and sketch a magnificent scene . . . Oh! rare and beautiful Norfolk'.

By this stage in Cotman's development, delicate detail has been largely suppressed, and his treatment of forms is much bolder. In its rich colouring this drawing anticipates Cotman's style of the 1820s. The panoramic vista is made even more striking by the intricate pattern of the paths undulating across the heath. Compositionally there is an echo of Gaspard Dughet (whose paintings Cotman greatly admired), in the introduction of a reclining figure in the left foreground and in the general structure of the design. Cotman had at this stage little interest in Dughet's classical subject matter, but seized on his feeling for mass and his reliance on a compact yet fluid pictorial architecture.

This was among the drawings that never left Cotman's studio; one of his sons later pledged it to a pawnbroker, and when auctioned in 1862 it failed to reach its reserve price.

58

John Sell Cotman 1782–1842

The Dismasted Brig

Pencil and watercolour; 201 × 310mm
1902-5-14-32

Just as Cotman brought an immediately distinctive style to his treatment of landscape subjects, so his seascapes are unmistakable. *The Dismasted Brig*, one of the artist's most celebrated watercolours, has been variously dated – by Sydney Kitson to *c*.1824–5 and by Miklos Rajnai to *c*.1808. It could be argued, however, that it can be dated soon after Cotman's move in 1812 from Norwich to the port of Yarmouth, the home of his principal patron at this period, the banker Dawson Turner. Cotman acted as drawing master to Turner's wife and six daughters, and found himself increasingly

involved with Turner's antiquarian publications, so that he was devoting most of his energies to architectural etching. A letter from the artist to his Yorkshire friend, Francis Cholmeley, on 13 April 1812, describes his new house in Yarmouth and his fascination with the sea: 'My small garden leads me on to the road. . .Then, a green meadow, then the view along the banks of which, directly before my house, lies the condemned vessels of every nation, rigged and unrigged in the most picturesque manner possible. . .From my house we reach the sea in about $\frac{3}{4}$ of a mile, on which rides at time[s] the Navey dimly moved in view. Today at sea a frigate and open brigg c[a]me to anchor. In short I have nev[er] saw so animated a picture as this spot affor[ds], it is always changing, always new'. Here Cotman's instinctive feeling for pattern and simplification, and the exclusion of all unnecessary detail, has resulted in a strikingly powerful image. *The Dismasted Brig* was brought from the artist by another of his Norfolk patrons, the Revd James Bulwer: at the sale held after Bulwer's death in 1836, Cotman bought it back for only seventeen shillings.

59

John Sell Cotman 1782–1842

A Mountain Tarn

Watercolour; 180 × 265mm
1902-5-14-28

By the late 1820s Cotman's style had undergone a considerable change, most notably in his use of a much brighter range of colours than hitherto. This reflected a more general trend among artists, and was partly due to the introduction of superior machine-ground pigments and new colours. After seeing drawings from J. F. Lewis's Spanish tour, Cotman lamented that his much criticised palette seemed tame by comparison (see no. 80). He also began to experiment with the texture of his watercolours, scraping away and reworking the surface to achieve a softer appearance: the contrast

with the precisely applied transparent washes of his Yorkshire watercolours could hardly be more marked. In the 1830s he further elaborated his technique by combining watercolour with a thickening agent (perhaps derived from flour paste or size) which gave the medium some of the qualities of oil paint. Not only was the depth of colour intensified and enriched, but the pigment had a thicker, more malleable texture. The present watercolour is one of a group of Welsh subjects in this medium, which must have been based on impressions and recollections of his sketching tours in Wales in 1800 and 1802. Even when employing such radically different methods from those he used about 1805, however, Cotman's instinctive sense of form is apparent here, the distant range of blue and purple-wreathed mountains strikingly silhouetted to form a powerfully haunting image.

60
William Havell 1782–1857
Windermere

Watercolour; 248 × 340mm
1859-5-28-140

Havell was a founder member in 1804 of the Society of Painters in Water-Colours and initially one of their most popular exhibitors. It was probably in emulation of his rival John Glover, who according to the diarist Joseph Farington had had 'Great success...in selling his drawings of the Lakes', that Havell in 1807 made his first visit to the Lake District. With its rich colouring and classical topography, the present watercolour, which was exhibited in 1811, is a characteristic example of a type of landscape associated with the early years of the Society, which aspired to imitate the mellow golden tones of Old Master paintings (or, rather, of the discoloured varnish on them). Havell's friend Reinagle was so fond of this effect that he once postponed a sketching tour until the autumn, 'the country being before that time *too green* for colouring'. Writing in

1831, W. H. Pyne recalled that Havell's Lake District views 'suffered nothing in comparison of effect with paintings in oil'. It is significant that Havell was prominent in the group of artists who in 1812 dissolved the Society and founded a new Society of Painters in Oils and Water-Colours.

61
David Cox 1783–1859
Flying a Kite

Watercolour over pencil with bodycolour; 270 × 378mm
Signed and dated: *David Cox 1853*
1910-2-12-241. Salting Bequest

One of the major figures of British watercolour painting, Cox was born near Birmingham and studied locally before working as a theatrical scene-painter. In 1804 he moved to London, and was taught by John Varley, whose style was a major influence on his early work. For much of his life Cox was a drawing master, at first in the London area and from 1815 to 1827 at a girls' school in Hereford; he also published a number of illustrated manuals intended for the instruction of amateur artists. Cox's subjects were chiefly inspired by the picturesque scenery of North Wales (see no. 62), which he first visited in 1805, and the north of England. He also made several visits to the Continent, in 1826 to Belgium and Holland, in 1829 to Paris and in 1832 to Dieppe and Boulogne. In 1827 he returned to London, where he lived until 1841, and spent his last years in Birmingham, leaving an artist son, David Cox the Younger.

Cox's most characteristic watercolours are marked by an extremely free and bold handling of the medium that has its nearest contemporary parallel in the oil paintings of John Constable. Painted in the last decade of Cox's life, this watercolour shows him still at the height of his powers. The marked broadening of his style in the 1840s and 1850s was further emphasised by the rough-

textured paper he often used in this period (still sold today as 'Cox paper'). Much of the vigour that characterises Cox's landscape compositions lies in his vivid portrayal of nature's moods and his ability to capture the fleeting effects of light and shade, the sensation of movement and the feeling of blustery winds, as he does here, where the kite flutters against a cloudy sky.

62

David Cox 1783–1859

Stepping Stones, Bettwys-y-Coed

Watercolour over black chalk, with touches of bodycolour,
on two conjoined sheets of paper; 360 × 526mm
Signed: *David Cox*
1915-3-13-19. Sale Bequest

With the death of De Wint in 1849 and Turner in 1851, Cox was perceived as the last link with the great tradition of British watercolour painting. Many artists of a younger generation whose styles were to develop in a fundamentally different way, including George Price Boyce and A. W. Hunt, owed their initial inspiration to him, and although the true modernity of his work was only gradually appreciated, his influence proved to be long lasting. Cox's late works were distinguished from those of his fellow members of the Society of Painters in Water-Colours by their extreme freedom of handling. As he wrote to his son in 1853: 'it strikes me the committee think them too rough; they forget they are *the work of the mind*, which I consider very far before portraits of places' (N. Neal Solly, *Memoir of the Life of David Cox*, 1873, p. 228). Indeed, his style became yet bolder following a stroke in 1853: although his eyesight and sense of co-ordination were affected, he continued to paint until only a few months before his death. He developed a technique combining rough pencil or chalk drawing, often on coarse Scotch paper, with loosely applied low-toned watercolour washes; this was highly successful in suggesting the rugged, massive character of the

Welsh landscape that had become his preferred scenery, while retaining an essential suggestion of airiness.

From 1844 until 1856 Cox spent part of each summer in Bettwys-y-Coed, a small village in Caernarvonshire, North Wales, at the junction of three rivers, an area whose unusually varied and beautiful scenery attracted many painters. The Stepping Stones in Dolwydellan Valley were a favourite subject, and he continued to work on variations of this composition after his last visit to Bettwys-y-Coed in 1856. According to the catalogue of their bequest, Mr and Mrs Sale visited David Cox for the last time a few weeks before his death and bought four watercolours from him, including this sheet, which is thought to have been his very last work: 'Mr Sale paid £40 for the lot, and Mrs Sale knelt by the side of David Cox, and handed him the drawings for his signature.'

63

Samuel Prout 1783–1852

The Church of St Lô, Normandy

Watercolour with pen and brown ink; 355 × 236mm
1900-8-24-530. Vaughan Bequest

Prout was one of the most popular exponents of picturesque architectural topography from the 1820s until his death in 1852. His views of the quaint aspects of foreign medieval cities became widely known, chiefly through lithography. Prout played a leading part in popularising this medium, which appealed to a new middle class public, some of whom had begun to travel more widely, while others enjoyed the experience at second-hand in the form of illustrated travelogues, or as they were then known, 'picturesque annuals'. As a boy Ruskin had been a pupil of Prout, and he never ceased to express admiration for his work, praising his calligraphic outline, which derived from Canaletto via his English imitators. Prout's favourite compositional device, as in this drawing, was a corner or fragment of a building seen close up and enlivened by a

busy foreground scene. A semi-invalid, most of his travel took place in the 1820s and provided the material for subsequent compositions. Since he settled into a consistent style and was in the habit of repeating earlier compositions his work can be difficult to date. His influence was disseminated through a series of drawing manuals, including *A Series of Easy Lessons in Landscape Drawing* (1820) and *Prout's Microcosm: The Artistic Sketchbook of Groups of Figures, Shipping and other Picturesque Objects* (1841).

64

Peter De Wint 1784–1849

Harvesting

Watercolour over pencil; 130 × 578mm
1910-2-12-247. Salting Bequest

De Wint was one of the most prolific watercolourists of the age; as a young man he had been apprenticed to an engraver, but he became a landscape painter after studying with John Varley. Through Varley he was introduced to Dr Monro, whose collection of drawings, including a notable group by Girtin, greatly impressed him. Study from nature formed the basis of Varley's instruction, and to this De Wint added the example of Girtin's bold, sombre colouring, fluid brushwork and sweeping compositions. A critic writing in *Fraser's Magazine* in 1830 noted: 'What Girtin would have produced had he lived, can, of course, be but [a] matter for speculation...the man who comes nearest to him...is De Wint'. Although his landscapes rarely have the austere grandeur that characterises Girtin's work, De Wint's watercolours show the development of many elements of his style.

Harvesting is typical of De Wint in being neither signed nor dated. It shows his unrivalled ability to depict rural life. De Wint was undeterred by the disparaging opinion of Thomas Uwins, a fellow member of the Society of Painters in Water-Colours, that 'hay-making, reaping etc, are general, and known to everybody, and this is against it as an exhibition scene', and he exhibited numerous subjects of this kind, which are now regarded as some of his finest works. The poet John Clare, an agricultural labourer's son, whose poems about the English countryside are the most direct and poignant of the period, commented that in De Wint we 'see natural objects not placed for effect and set off by the dictates of the painter's fancy but as they are, just as Nature placed them'. 'Nothing', he once wrote to the artist, 'would appear so valuable as one of those rough sketches, taken in the fields, that breathe the living freshness of open air and sunshine'. Despite his success as a watercolourist − 'so congenial indeed to the collectors...that not only his larger works, but every scrap from his pencil is sought with avidity', as an article in the *Library of the Fine Arts* noted in 1831 − De Wint found difficulty in selling his oil paintings. These included *A Cornfield* of 1815 (Victoria and Albert Museum), which is one of the most remarkable observations of the English countryside hitherto painted; his taste for broad stretches of open landscape and his palette of rich gold and earth tones were ideally suited to such subjects.

65

Matilda Heming fl.1804–1855

A Backwater at Weymouth

Watercolour; 157 × 256mm
1877-5-12-197

Mrs Heming, daughter of the engraver Wilson Lowry, was an artist of professional standing; she was awarded a Gold Medal by the Society of Arts in 1804 and between 1805 and 1855 exhibited landscapes, miniatures and portraits. This watercolour suggests that she had genuine talent as a landscapist, working directly from nature in the idiom of Varley and Linnell.

66

Anthony Vandyke Copley Fielding 1787–1855

Scarborough

Watercolour and bodycolour over pencil; 309 × 447mm
Signed and dated: *Copley Fielding 1852*
1910-2-12-248. Salting Bequest

Fielding was one of four brothers, all watercolourists, whose family came from Yorkshire. He spent the early part of his career teaching and exhibiting in the North of England; in 1809 he moved to London, where he became one of the Varley circle. He first exhibited at the Society of Painters in Water-Colours in 1810, was elected a full member in 1812, and was President from 1831 until 1854. In all he exhibited 1,748 works at the Society, an average of over 40 at each show, a figure described by a critic in 1817 as 'appalling'. Fielding's facility and technical virtuosity made him a favourite with the public, who admired his atmospheric effects and sense of breadth and distance. His turbulent seas and skies owed a debt to Turner, but as Ruskin noted of marine watercolours such as this 1852 view of Scarborough, Yorkshire, 'had he painted five instead of five hundred such, and gone on to other sources of beauty, he might, there be little doubt, have been one of our greatest artists'. For much of his life, while maintaining a London studio, Fielding lived in various towns along the south coast, and died in Worthing.

67

George Fennel Robson 1788–1833

Sunset in the Highlands

Watercolour; 214 × 318mm
1900-8-24-535. Vaughan Bequest

Scotland and the poetry of Sir Walter Scott provided Robson with many of the subjects of his exhibition watercolours. Born in Durham, he went to London in 1804, where he was introduced to John Varley. He became a member of the Society of Painters in Water-Colours in 1813 and was elected President in 1820. Robson's first visit to Scotland in 1810 was decribed by Thomas Unwins: 'That he might enter entirely into the romance of the country he dressed himself as a shepherd, and with...Scott's poems in his pocket, he wandered over the mountains...fixing firmly in his mind the various aspects of nature, and collecting a fund of observations on which he might draw for the rest of his life'. This and subsequent tours inspired *Scenes of the Grampian Mountains*, published in 1814, and watercolours such as this. Twilight scenes, 'where he could dip his pencil in the purple gloom', were his favourite subjects. Originally inspired by Varley's idealised mountain compositions, Robson's dramatic interpretation of 'the sublime scenery of the Scottish Alps' may be compared with Francis Danby's paintings of desolate mountain landscape.

68

George Scharf the Elder 1788–1860

Laying the Foundations of the Lycian Room at the British Museum

Watercolour over pencil; 395 × 547mm
Signed and dated: *London G.Scharf senr. del 1845 B.Museum The Foundation of the Lycian Room*
1862-6-14-617

Scharf was born in Bavaria and spent the early part of his career as a miniature-painter, specialising during the Napoleonic Wars in portraying the officers of the contending armies. He served in the British Army at Waterloo and in 1816 settled in London. He had studied the new art of lithography before leaving his home country and became well known for precise illustrations of scientific and antiquarian subjects and for his views of London. In 1862 the British Museum purchased from his widow and their son, Sir George Scharf (1820–95), first Director of the National Portrait Gallery, the huge collection of studies of London life and topography from which this drawing comes. Scharf's detailed observation in these studies is that of a foreigner to whom everything is slightly unfamiliar and intriguing. His evident interest in the unpicturesque aspects of life – men laying water-pipes and sewers, the construction of railway stations, shop fronts in the city, hoardings covered with advertisements and so on – make his a unique record of a great city in the period immediately before photography came to be widely used.

Scharf knew the British Museum well, for he lived nearby, and over the years recorded its transformation from a late seventeenth-century mansion to the present Greek Revival building, designed by Robert Smirke. Here Scharf shows the early stages in the construction of a new gallery designed to house the then recently acquired Lycian marbles. This would have been of particular interest, because his son George had been one of the artists who had accompanied the 1843 expedition to Lycia (see also no. 87). His attention to the details of building activity is shown in some pencil studies he made in preparation for this watercolour, which are of the individual construction processes and include a carefully annotated drawing of the forge. In the background is the old gateway to the Museum, demolished in 1850. The Grenadier Guardsmen on duty are the picket provided until 1863, when they were replaced by civilians.

69

John Martin 1789–1854

A Meadow

Watercolour with scratching out; 254 × 340mm
Signed and dated: *J.Martin 1840*
1891-5-11-49

Martin made his name as the painter of a series of highly dramatic canvases depicting doom-laden scenes from the Bible or from mythology. His speciality was scale: tiny figures set in vast, eerie landscapes or against a background of stupendous fantastical architecture, which is often being torn apart by some cosmic disturbance. The smallness and helplessness of man against the powers of the universe was his central theme. The chief sources for these pictures were early works by Turner such as *The Fifth Plague*, 1800, or *The Destruction of Sodom*, *c*.1805, and Martin must also have been influenced by Piranesi. His first popular success was *Joshua Commanding the Sun to Stand Still*, exhibited at the Royal Academy in 1816, which was followed during the 1820s by a series of 'catastrophic' pictures. His own mezzotints of these paintings and others illustrating *Paradise Lost* and the Bible were widely circulated and for a while very profitable. Although his work was enormously successful with the public, Martin had many harsh critics. Charles Lamb deplored his 'phantasmagoric tricks', while William Hazlitt declared that 'he wearies the imagination instead of exciting it'. It has been suggested that Martin's imagery was partly inspired by the great engineering feats of the Industrial Revolution. He

certainly had a strong inventive streak, proposing improvements for lighthouses and safety in mines, and he devised ambitious schemes for ensuring the purity of London's water supply and for disposing of its sewage.

While the fame he enjoyed in his lifetime rested on his grandiose pictorial inventions, another aspect of Martin's art is revealed in a small number of landscape studies, mostly dating from the 1840s, which have generally been ignored in most accounts of British watercolour painting. Painted in tones of green and gold in a distinctive stippled technique, they have a gently lyrical quality that is the greatest possible contrast with his large-scale paintings.

70

William Henry Hunt 1790–1864

Bushey Churchyard

Pen and ink with watercolour; 320 × 415mm
1921-7-14-14

A protégé of the collector and physician Dr Monro (the early patron of both Girtin and Turner), Hunt was a frequent guest at Merry Hill, Monro's country house near Bushy in Hertfordshire. He was disabled, so Monro had him 'trundled on a sort of barrow with a hood over it, which was drawn by a man or a donkey while he made sketches'. A number of views in the neighbourhood of Bushey survive, but this example is of particular interest, since it shows the churchyard where two of Monro's other protégés and friends, Thomas Hearne (1744–1817; see no. 22) and Henry Edridge (1769–1821), were buried. Their tombs are shown, together with that of Henry Monro (1791–1814), the doctor's second son, a promising artist who died at the early age of twenty-three. At the extreme right is Dr Monro himself, on horseback. This is a replica, executed about 1822, of the original watercolour made for Dr Monro and now in the Yale Center for British Art. The vigorous, wiry pen outlines drawn in brown ink recall Hunt's early practice in

1806–11, when he was still a pupil of John Varley, of copying drawings by Canaletto in Dr Monro's collection.

In the mid-1820s Hunt largely gave up making topographical views of this sort and turned to still-life subjects and rustic genre, developing a distinctive technique of minutely applied touches of colour, quite the reverse of his earlier style in which translucent washes were subordinated to a firm outline. These were to be much admired by Ruskin and the Pre-Raphaelites, who approved of his concern for careful observation of natural detail, his sense of colour and technical mastery.

71

John Linnell 1792–1882

The Valley of the River Lea, Hertfordshire

Watercolour and black chalk heightened with white on blue paper; 340 × 540mm
Signed and dated: *River Lea. J. Linnell 1814* and inscribed, perhaps with colour notes, in a form of shorthand or cipher
1980-1-26-116

Linnell's journals record visits to the River Lea in 1814 in connection with a commission he had received for illustrations to a new edition of Izaak Walton's *Compleat Angler*; this drawing is one of a number of studies made on blue paper in that year.

His master, John Varley, had encouraged him to sketch small picturesque subjects from nature such as gnarled trees, broken fences and old cottages. At the same time Varley worked in a more formalised way for his exhibition watercolours, and Linnell absorbed both of these aspects of his teacher's style. In this group of Hertfordshire drawings Linnell has abandoned his earlier conventional notions of pictorial composition and picturesque motifs in favour of the faithful representation of broad stretches of open and often featureless countryside. His son-in-law, Samuel Palmer, was later to recall the advice of Mulready (a fellow pupil with Linnell of

John Varley) 'to copy objects which were not beautiful, to cut away the adventitious aid of association'. In fact, Linnell's obsessive concentration on transcribing exactly what he saw has resulted in a strikingly original image.

Straightforward naturalism of this sort, however, failed to satisfy Linnell. His great admiration for Blake, from whom he commissioned in 1824 the great series of Dante watercolours (see no. 33), instilled in him a feeling for the more poetical aspects of landscape painting. Although he had little sympathy for Palmer's intense, hermetic approach to his art, Linnell attempted in his own way to reconcile his ideas about landscape. In later life the oil sketches, watercolours and drawings that he had made in the years around 1814, so highly valued today, were regarded by Linnell only as the raw material for more substantial paintings.

72

Clarkson Stanfield 1793–1867

The Dogana and the Church of the Salute, Venice

Watercolour and bodycolour with scratching out; 220 × 315mm
1900-8-24-537. Vaughan Bequest

Stanfield's reputation was chiefly as a marine painter, and many of his contemporaries regarded him as the equal of Turner. With hindsight, this opinion is over-generous – an element of melodrama (he first achieved success as a scene-painter) is never far away – but Stanfield was undoubtedly one of the most accomplished painters of the period. A review in *The Times* in 1870 of a retrospective exhibition of his work noted 'his unerring sense of the agreeable and picturesque', qualities which help to explain his success.

During the 1830s Stanfield was one of the foremost contributors to the various illustrated travel books that had become so popular; Charles Heath's *Picturesque Annuals* for 1832, 1833 and 1834 were all solely illustrated by engravings after Stanfield. This watercolour – one of his liveliest and most accomplished – was based on

sketches made during a visit to Venice in 1830, and was engraved by Edward Goodall for the *Picturesque Annual* of 1832: 'The time chosen by the artist is during a storm . . . Woe betide the Gondoliers that have not time to get home before the riot commences! . . . All Venice is in an uproar!' Comparison with Turner's Venetian watercolours (see no. 47) reveals Stanfield's more limited imaginative response to the city. As Ruskin noted in the first edition of *Modern Painters* (1843), while Stanfield had feeling for the truth of architecture and water, yet 'it is all drawn hard and sharp, there is nothing to hope for or find out, nothing to dream of or discover; we can measure. . .This cannot be nature, for it is not infinity. No Mr Stanfield, it is scarcely Venice yet'.

73

David Roberts 1796–1864

Burgos Cathedral

Watercolour; 393 × 259mm
Signed and dated: *D.Roberts 1836*
1900-8-24-533. Vaughan Bequest

David Roberts, together with Samuel Prout, James Duffield Harding, Clarkson Stanfield and, to some extent, J. F. Lewis, belonged to the group of artists specialising in foreign topographical views who came to prominence in the 1820s and 1830s. Roberts was originally apprenticed as a house-painter in his native Edinburgh, but became a scene-painter. In 1822 he moved to London, rapidly establishing himself as the most sought-after painter for the theatre, as well as exhibiting topographical and historical paintings and watercolours; in 1831 he was elected President of the Society of British Artists. In October 1832 he left for Spain, and did not return to England until eleven months later. Although he had previously travelled in northern Europe, this was his first long and important journey abroad, a precursor of his tour to Egypt, the Holy Land and Syria in 1838–9. He seems to have

D. Roberts

been attracted to Spain because the country's pictorial possibilities had until then been neglected by British painters (it is true that David Wilkie had visited Spain in 1827–8, but he was chiefly interested in the depiction of genre subjects and daily life, rather than the landscape and architecture of the country). Roberts wrote from Cordoba: 'Those who could have appreciated the richness of its architecture have generally gone to Italy or Greece. My portfolio is getting rich, the subjects are not only good, but of a very novel character'. This element of novelty seems to have been of great importance; the 1830s were the decade of the new illustrated publications and Roberts was deliberately assembling material not only for worked-up watercolours and oil paintings, but also for reproduction in the form of steel-plate engravings and lithographs. His Spanish works were published in the *Landscape Annuals* from 1835 and in a separate volume, *Picturesque Sketches in Spain*, 1837.

This watercolour of Burgos Cathedral, described by Roberts as 'one of the finest in Spain', was worked up after he returned to England from a sketch that he had drawn in December 1832, and was engraved for the *Landscape Annual* of 1837. It is a fine example of his style on the small scale, combining architectural precision with atmospheric sensitivity, and with a faint echo of the kind of bizarre Sublime developed by John Martin in his architectural fantasies. So familiar did Roberts's Spanish views become that in his celebrated guidebook to Spain, published in 1845, Richard Ford referred to one aspect of Burgos Cathedral as 'forming a picture by Roberts'.

74
David Roberts 1796–1864
The Convent of St Catherine, Mount Sinai

Watercolour over pencil; 355 × 508mm
Signed: *David Roberts RA*
1957-4-13-4. Bequeathed by D. W. Fitzgerald

The discovery of new places to paint was of great importance for the topographical artist, as Roberts found with the success of his Spanish views (see no. 73). His journey to Egypt, the Holy Land and Syria in 1838–9 was undertaken with the deliberate intention of finding novel material which would appeal to a developing interest in ancient history and in Biblical archaeology. For many of his contemporaries the Near East was regarded primarily as the setting for the Bible; its archaeological remains, landscape and peoples were seen in relation to Biblical events and stories. During the 1830s several illustrated travel books had proved popular, notably Finden's *Landscape Illustrations of the Bible* (1836), which included etchings after travellers' sketches redrawn by Roberts, Turner and Clarkson Stanfield. Roberts, however, was determined to surpass all earlier publications. After spending three months in Egypt, where he drew every temple then known between Abu Simbel and Dendara, he was able to write: 'I am the first Artist at least from England that has yet been here and there is much in this'. He went on to Syria, and then to the Holy Land, where he travelled for a further three months. He stayed at St Catherine's, Mount Sinai, for five days in February 1839, and found the monks very hospitable. After visiting Baalbec and Beirut he returned to England in July with around 300 sketches, several sketchbooks and oil studies: 'at all events [they] carry novelty with them'.

The resulting series of 248 lithographs, for each of which Roberts prepared finished drawings for the lithographer Louis Haghe, was published in parts between 1842 and 1849; it was by far the most ambitious venture of its sort. Small-scale etchings, as in Finden's *Illustrations of the Bible*, were one thing; large coloured lithographs were quite another. Roberts's hard work was rewarded by the

success of *The Holy Land and Egypt,* which confirmed him as one of the leading artists of the day.

Although this watercolour is not dated, the inscription indicates that it must have been painted after Roberts's election as an Academician in 1841; it was lithographed by Haghe for the final part of *The Holy Land,* published in 1845.

75

Joseph Stannard 1797–1830

The Beach at Mundesley, Norfolk

Coloured chalks with touches of bodycolour over pencil and black chalk on brown paper; 149 × 466mm
Signed and dated: *J Stannard 182(?)*
1902-5-14-466

A comparatively little-known member of the Norwich school, Stannard was greatly influenced by Dutch art, and studied in Holland for a year in 1821–2. Although he exhibited in London from time to time, he was based in Norwich and his work was almost exclusively concerned with recording the scenery of his native area. Although uneven in quality, some of his etchings (which reflect his admiration for Rembrandt's landscapes) and drawings are of considerable merit. This view of the beach at Mundesley is unusual in technique: at first sight it appears to be a watercolour, but in fact it is largely executed in coloured chalks.

76

Edward Calvert 1799–1883

A Primitive City

Watercolour with pen and ink; 68 × 102mm
Signed and dated: EDWARD CALVERT 1822
1947-2-17-1. Presented by the National Art-Collections Fund

Almost all of Calvert's surviving works are from the latter part of his career. His small-scale, idyllic landscapes with figures have been ignored in favour of his earlier intensely romantic works but they are not without their own distinction. Vaguely classical or pastoral in feeling, light in tone and executed on paper in oil paint so thinly diluted as to have the appearance of watercolour, they have a beauty of a faint and somewhat monotonous kind: Lawrence Gowing has rightly drawn attention to them in a recent essay. But Calvert's fame as an artist rests on the group of fifteen little prints which he produced in the late 1820s and early 1830s – two lithographs, four engravings on copper and nine wood-engravings. He had been one of the group of youthful disciples, including Samuel Palmer, who gathered around William Blake in his last years, and his prints are directly inspired by Blake's wood-engravings for Thornton's *Virgil.* The *Primitive City* resembles them in scale, format, imagery and poetic intensity, and similarly represents a vision of a pastoral Arcadia; it is the only known drawing of this early phase of the artist's activity (before devoting himself to art in 1820, Calvert had served as a naval officer). In its diminutive size and richness of colouring it also recalls illuminated medieval manuscripts. The fact that it is dated two years before he left his native Devon for London suggests that the form, style and subject matter of his engraved compositions were determined before he came into direct contact with the Blake circle. He is known to have owned a copy of Blake's *Illustrations to the Book of Job,* and it seems probable that he also possessed the *Virgil,* published in 1821.

'I have a fondness for the Earth', he wrote, 'and rather a Phrygian mode of regarding it. I feel a yearning to see the glades and the nooks receding like vistas into the gardens of Heaven', sentiments

which exactly parallel those expressed by Samuel Palmer, one of his closest friends in the late 1820s and early 1830s, when Calvert was a fellow member of their self-styled group, the Ancients. So called on account of their belief that ancient man was superior to modern man, they attempted to lead lives of Virgilian simplicity in the village of Shoreham in Kent (see also nos 81, 82). But as with many English Romantic artists – Palmer is a conspicuous example, as were the Pre-Raphaelites a generation later – this mood of passionate poetic intensity was impossible to sustain for more than a few years.

77

Richard Parkes Bonington 1802–1828

The Institut seen from the Quai, Paris

Watercolour; 243 × 200mm
1910-1-12-244. Salting Bequest

Born near Nottingham in 1802, Bonington died of consumption in London in 1828, a month before his twenty-sixth birthday: his short creative life was concentrated into the years between 1817 and his death. When he was fifteen his family left England and settled first in Calais, where his father (who had been a drawing master and painter) set up a new lace manufacturing business, and then in Paris. Apart from three visits to his native country, Bonington spent the rest of his life in France, and it may be argued that he belongs essentially to that group of young French artists of the 1820s who rebelled against the neo-classical formulas of the previous generation. They had in common an enthusiasm for painting landscape, an interest in the history and architecture of France, a fascination with the Near East and a passion for poetry and for the novels of Sir Walter Scott: all of these tastes were reflected in Bonington's work, whether in his landscapes or in his exquisite small-scale historical paintings and figure subjects. However, Bonington also absorbed many of the traits associated with English art of the period, notably the importance attached by many of the most talented artists to

watercolour as an independent medium in its own right – by Turner and Constable above all, but also by Cotman, Callow, Prout and Shotter Boys.

Bonington's amalgam of Anglo-French characteristics echoed his artistic training. His first teacher was Louis Francia (1772–1839), who had spent many years in England, where he had been a member of Girtin's sketching club, and who was living in Calais when Bonington's family moved there. In 1819 Bonington entered the atelier of Baron Gros (1771–1835) in Paris at the Ecole des Beaux-Arts, where he remained until 1822. While a student he had been on sketching expeditions, including an extensive tour to Normandy with his friend Alexandre Colin (1798–1875), 'knapsack on his back over his long blouse, flat cap on his head and a stick in his hand'. By this time his watercolours had already begun to attract notice – he also began to paint *plein air* oil sketches – and he decided to become a landscapist.

The brilliance and luminosity of watercolours such as this view of the Institut inspired Bonington's fellow artists with admiration, if not envy. Delacroix, with whom Bonington shared a studio for some months in 1825–6, wrote: 'I could never weary of admiring his marvellous understanding of effects, and the facility of his execution'. Constable distrusted Bonington's sheer facility: 'but there is a moral feeling in art as well as everything else, it is not right in a young man to assume great dash – great compleation – without study or pains. Labour with genius is the price the Gods have set upon excellence', he noted somewhat bitterly. It is instructive to compare this watercolour of the Institut, probably dating from the end of Bonington's life, with another view of Paris by his contemporary and acquaintance, Thomas Shotter Boys (no. 78). Bonington has captured the essentials of the architectural detail with a beautifully nervous touch, transforming a familiar topographical subject that could well have been suggested by the work of someone like Prout (see no. 63). Where he differs from Prout is in his concern with light and atmosphere, rather than with the quaintness of architectural detail.

78

Thomas Shotter Boys 1803–1874

The Boulevard des Italiens, Paris

Watercolour heightened with bodycolour and gum arabic; 327 × 597mm
Signed and dated: *Thos. Boys 1833*
1870-10-8-2364

Trained as an engraver, Boys went to Paris in about 1823, and was there able to take advantage of the dearth of French experts in this field. By 1826 he was closely associated with Bonington, whose influence is apparent in his early watercolours, but from the outset his interests were different. Whereas Bonington displays romantic sensibility and response to the atmospheric quality of his surroundings, Boys's studies of Paris are primarily topographical. His main concern was to record the variety of architecture and human activity he observed around him. This is particularly marked in the early 1830s. Bonington had died in 1828, and, freed from his direct influence, Boys's style achieved its own distinctive maturity. This watercolour of the *Boulevard des Italiens*, dated 1833, is a splendid example of his mastery of urban topography, showing his technical virtuosity and his sense of design on a large sacale. His depiction of the architecture and of the figures is equally confident: these are not mere staffage (as in so many late eighteenth-century urban views, see no. 25), but fulfil an essential role in the composition. His success is combining architectural accuracy with human activity accounts for the great popularity of his lithographic series *London as it is* (1842), and suggests an interesting comparison with Turner's approach to urban topography (compare no. 46, *Louth*, for instance).

79

William Leighton Leitch 1804–1883

S. Croce in Gerusalemme, Rome

Watercolour and bodycolour over pencil; 339 × 227mm
1980-6-28-4

Leitch began his career as a decorator and scene-painter in his native Glasgow. In 1830 he went to London with an introduction to his fellow countryman, the well-known artist David Roberts. He began to paint watercolours and easel pictures, first publicly exhibiting his work in 1832. In the following year, financed at the outset by a collector who admired his work, he travelled to Italy. Here he soon found employment teaching drawing, chiefly to British visitors. This view of the church of S. Croce in Gerusalemme, on the south-eastern edge of the city just beyond the Lateran Basilica, must have been taken from the gardens of the Villa Wolkonsky, now the residence of the British Embassy.

The four years he spent in Italy were crucial in transforming him from a provincial scene-painter into one of the most popular drawing masters and landscape watercolourists of the Victorian period. By 1842 he was Queen Victoria's drawing master and numbered many distinguished amateurs among his pupils. Recognition from his professional colleagues was slower in coming, and it was not until 1862 that he was elected to the New Water-Colour Society.

80

John Frederick Lewis 1805–1876

The Alhambra

Watercolour and bodycolour on buff paper;258 × 360mm
Inscribed: *Alhambra, Oct 5, 1832*
1885-5-9-1644

Inspired by the example of his friend David Wilkie, Lewis travelled in Spain from 1832 to 1834, having, according to his patron Richard Ford, 'orders for young ladies' albums and from divers booksellers, who are illustrating Lord Byron'. The exotic and romantic character of Spain seems to have kindled Lewis's enthusiasm for distant places: for ten years from 1841 he lived in Cairo, and on his return to England was to cause a sensation with his watercolours of Arab subjects.

Lewis used the sketches made on his Spanish tour as the basis for later watercolours, as well as for two volumes of lithographs; this view of the Alhambra was used as the background for the *Distant View of the Sierra Nevada*, published in *Lewis's Sketches of Spain and Spanish Character* (1836). The vibrant colouring of studies such as this astounded Cotman when he saw Lewis's Spanish drawings in 1834: 'words cannot convey to you their splendour, *My* poor *Red Blues & Yellows* for which I have been so much abused and broken hearted about, are *faded fades*, to what I saw there, Yes and aye, *Faded Fades* & trash'. Lewis was subsequently to abandon the swift and fluent use of watercolours as seen here in favour of a microscopically elaborate and dense technique that rivalled the brilliance of oil paintings. In 1858 he resigned from the Water-Colour Society: 'I felt that work was destroying me. And for what? To get by water-colour art £500 a year, when I know that as an oil painter I could with less labour get my thousand'.

81

Samuel Palmer 1805–1881

A Cornfield by Moonlight with the Evening Star

Watercolour with bodycolour, pen and sepia ink, varnished;
197 × 258mm
1985-5-4-1. Acquired with the assistance of the National Heritage Memorial Fund, the Henry Moore Foundation, the Pilgrim Trust, the British Museum Society and contributions from members of the public

The fame of Samuel Palmer rests chiefly on the paintings and drawings he made over a period of around ten years, between 1824 and 1834. From around 1826 to 1832 he lived in seclusion as the leader of a group of young artists, self-styled the Ancients (see no. 76), in the village of Shoreham in the Darenth Valley, Kent, which he described as his 'Valley of Vision'. The drawings and paintings of this period are characterised by a combination of almost visionary exaltation and the close study of nature and rural life, which he invested with a spiritual quality. Here he was able to develop themes already present in his work, particularly in the sketchbook he kept in 1824–5 (British Museum) when he first came under the influence of Blake (see no. 33), and in the sequence of pen, ink, wash and gum drawings (Ashmolean Museum, Oxford) made in 1825. The works of the Shoreham period, with their immediately distinctive style, mark the apogee of his mystical celebration of nature; his flocks and sheaves of corn, his harvest moons and trees weighed down with blossom or fruit symbolise a passionate identification with a life of pastoral simplicity, inspired by his study of the Old Testament, Virgil and Milton. In time his imagery became less intense and his style more conventional as his youthful romanticism diminished, although a group of watercolours and etchings made towards the end of his life, again inspired by Milton and Virgil, recaptured something of the same mood.

This watercolour, painted about 1830, is one of Palmer's undoubted masterpieces. It belonged for many years to Kenneth Clark, and was well known in the circle of neo-Romantic artists who became famous in the 1930s and 1940s, including Graham

Sutherland, John Piper and John Nash, for whom Palmer was an important inspiration. Against an exquisitely rendered depiction of the Kentish landscape, the shepherd with his staff and dog, making his way through the harvest field, seems like a pilgrim about to enter Palmer's visionary world. 'Despite Nature's perfection', he had written in 1828, 'she does yet leave a space for the soul to climb over her steepest summits'. An enormous crescent moon, with Hesperus further off, bathes the cornfield with golden luminescence. In later years he recalled the intense inspiration of his youth: 'Thoughts on RISING MOON, with raving-mad splendour of orange twilight-glow on landscape. I saw that at Shoreham'. The landscape glows with a lunar richness that echoes the opening lines of a translation of Virgil's *Georgics*, an especial favourite of Palmer's: 'that makes the Fields of Corn joyous...Ye brightest Luminaries of the World, that lead the Year sliding along the Sky...Your bounteous Gifts I sing'. As Raymond Lister has written, this watercolour 'has a primitive power, as if just enough has been done to release the spirit of the work from the artist's basic materials; in short, it is one of Palmer's greatest achievements'.

82

Samuel Palmer 1805—1881

A Study for 'The Bright Cloud'

Black ink with scratching out; 152 × 151mm
1927-5-18-10

This is one of a group of small monochrome drawings, chiefly of moonlit scenes, which date from the latter part of Palmer's Shoreham period, c.1831–2. They were perhaps influenced by Blake's wood-engravings for Thornton's *Virgil*, which they to some extent echo in their pastoral subject matter, intimacy of mood and tonality. This is a preparatory study for the painting in oil and tempera of the same title, probably painted about 1834 (City Art Gallery, Manchester). While the chief characteristic of British

landscape painting in the early part of the nineteenth century was the triumph of naturalism, Palmer's works are among the most notable examples of the rejection of this aim. His future father-in-law, John Linnell (see no. 71), hoped to instil in him a more literal-minded approach to nature, but as Palmer confessed to his fellow Ancient George Richmond in 1828: 'Tho' I am making studies for Mr Linnell, I will, God help me, never be a naturalist by profession'. Although Palmer shared none of Constable's quasi-scientific interest in studying the sky, he was however responsive to its pictorial possibilities. In a letter to John Linnell of 21 December 1828 he wrote: 'Nor must be forgotten the motley clouding, the fine meshes, the aërial tissues that dapple the skies of spring; nor the rolling volumes and piled mountains of light'. The final composition, *The Bright Cloud*, shows the influence of Linnell's landscapes, and in the same letter Palmer noted: 'Those glorious round clouds which you paint I do think inimitably, are alone an example how the elements of nature may be transmitted into the pure Gold of Art'.

83

Samuel Palmer 1805—1881

Tintagel Castle

Watercolour and bodycolour over pencil and black chalk; 262 × 370mm
1910-7-16-17

By the mid-1830s Palmer had left Shoreham, and the circle of close artist friends — the Ancients — had dispersed. With his marriage in 1837 to Hannah Linnell he had to begin using his art to earn a living. On their return in 1839 from a two-year stay in Italy Palmer eked out a living as a teacher, achieving only modest success in selling his work. He lacked his father-in-law's supreme self-confidence, and agonised over his day-to-day difficulties. An undated note from a journal kept about 1845 is headed 'Designs prudentially considered' and shows him attempting to analyse the secrets of popular success. The search for more saleable subjects found him returning to

sketching tours; between 1848 and 1859 he made at least four visits to Devon and Cornwall. This drawing is related to his 1848 tour, when he made a number of broadly handled black chalk sketches of the dramatic, wind-swept coastline of north Cornwall and at least two watercolours of the cliffs at Tintagel surmounted by the crumbling ruins of the castle, popularly associated with King Arthur, a connection that greatly appealed to Palmer. This watercolour, with its bold chalk underdrawing, seems to have served as the basis for the more highly finished watercolour now in the Ashmolean Museum, Oxford, which is probably to be identified with one exhibited in 1849. Palmer there comes close to the Sublime landscape of Turner. That he knew well Turner's view of Tintagel is established by a reference to it in a letter of 1864. It was engraved in 1818 by George Cooke (a friend of Palmer's father) for the series *Picturesque Views on the Southern Coast*. Turner's practice of referring to local human activity may also have inspired Palmer's inclusion, in the Ashmolean version, of fragments from a shipwreck, with men hauling away a salvaged anchor.

84

Henry George Hine 1811–1895

Gravesend

Watercolour over pencil; 328 × 475mm
Signed: *H. G. Hine Below Gravesend*
1949-6-16-3. Presented by Christopher Norris

Hine was born in Brighton, Sussex, and spent his childhood among the boats on the beach, in the fishmarket, or out on the Downs (which were later to be a favourite subject). He was encouraged to paint by a local clergyman, who allowed him to study his collection of watercolours by Anthony Vandyke Copley Fielding (see no. 66). Fielding had settled in Brighton in 1829, where he lived until 1847, painting the sea and the Downs. Hine's own career began slowly. For a time he was apprenticed to an engraver, but in 1837 he went

to Rouen in northern France, where he worked for the next two and a half years in a style derived from Cotman and Prout. On his return to England in 1840 he resumed painting his favourite Brighton shore scenes and marines, but lack of financial success forced him to return to engraving and illustration, and he found himself involved in the beginnings of illustrative journalism, contributing to the first issues of *Punch* and *The Illustrated London News*. It was not until about 1860 that he began to achieve any degree of recognition for his watercolours; in 1865 he was elected a member of the Institute of Painters in Water-Colours and in 1887 (at the age of seventy-six) its Vice-President.

Initially Hine's subject matter and style were considerably influenced by Copley Fielding. From the 1860s, however, he developed a more individual manner, painting the wide sweeps and curves of the Downs and the sea under changing light conditions with particular subtlety and delicacy. Hine was chiefly based in London from 1840. This undated *plein air* sketch, made at Gravesend near the mouth of the Thames, shows his work at its most informal and attractive.

85

William Bell Scott 1811–1890

King Edward's Bay, Tynemouth

Watercolour and bodycolour over pencil; 251 × 353mm
Signed: *W. B. Scott*
1954-3-2-1. Presented by J. A. Gere

William Bell Scott, the younger brother of the painter David Scott, whose life he wrote, trained at the Trustees Academy in Edinburgh and moved to London in 1837. There he became associated with a group of young artists, including Dadd, Frith and Egg, known as the Clique. Disappointed by the rejection of his submission to the Royal Academy in 1842, Scott accepted the post of Master of the newly established Government School of Design in Newcastle,

offered to him after the exhibition of his work in the competition for the decoration of Westminster Hall. Like Dante Gabriel Rossetti, Scott was a poet as well as a painter, and his association with the Pre-Raphaelites stemmed from Rossetti's admiration for his volume of poetry *The Year of the World* (1846). They became close friends (although they later quarrelled), but until 1864, when Scott resigned his post and was able to spend more time in London, the fact that he was employed in Newcastle resulted in a certain degree of artistic isolation. Scott's commitment to art education and public patronage was particularly important: he was successful in encouraging local collectors to buy Pre-Raphaelite paintings, and it was his friendship with Sir Walter and Lady Trevelyan of Wallington that led to him being commissioned to decorate the Hall between 1856 and 1868, the largest project of its sort in north-east England.

Scott travelled in Germany in the 1850s and works such as this watercolour of a coast scene near Newcastle, which probably dates from the late 1850s or early 1860s, and others of desolate seashores at twilight, seem to owe some debt to German Romantic painting. Scott's method of working was different from that adopted by the Pre-Raphaelites; he did not follow their practice of painting directly from nature, but shared something of the same sensibility.

86
Edward Lear 1812—1888
Choropiskeros, Corfu

Watercolour with pen and brown ink and coloured chalks; 478 × 349mm
Inscribed: *14 June 1856 (6)*
1929-6-11-70. Presented by Messrs Craddock and Barnard

Lear is best known for his *Nonsense* verses, intended for children, and his illustrations to them which he produced concurrently with his life-long activity as a landscape painter and watercolourist. He was one of the few mid-nineteenth-century practitioners of the linear technique of watercolour, which can be seen as a reversion to

the 'tinted drawing' manner of a hundred years earlier. At the same time he clearly shared the contemporary view that the finished work should preserve the spontaneity and liveliness of the sketch. Lear's technique was to make a pencil drawing of the motif with written notes of colour and tone, and then to work over the outlines with pen and ink and washes of colour in the winter evenings. Much of his life was spent abroad, and he died in San Remo on the Italian Riviera, where he had settled in 1871. In the late 1850s and early 1860s he made several extended visits to Corfu (his first short stay had been in 1848), which as one of the Ionian Islands had been ceded to the British under the terms of the Congress of Vienna in 1815 and remained under their rule until 1863. Here he seems to have been particularly attracted by the quality of the light and the wild, luxuriant vegetation. He wrote in his diary the year before he left Corfu: 'the more I see of this place, so the more I feel that no other spot on earth can be fuller of beauty & variety of beauty'. This watercolour is a particularly subtle and delicate example of a characteristic composition — a complex spatial recession from a high viewpoint towards a distant ridge of mountains.

87
William James Müller 1812—1845
The River Xanthus

Watercolour; 365 × 535mm
Inscribed: *River Xanthus & Mount Taurus Lycia*
1878-12-28-103. Henderson Bequest

A pupil of J. B. Pyne in his native Bristol (his father had been a Prussian refugee from the Napoleonic wars and had settled there), Müller was influenced by studying the Cotman drawings belonging to the Revd James Bulwer to visit Norfolk for two months in 1831; in the following year he founded a Sketching Club in Bristol, inspired by that of Girtin and Cotman. Although he aspired to recognition as an oil painter, it was for his rapid and fluent water-

colour sketches that he was chiefly known. Like many other topographical watercolourists of the period, Müller travelled abroad extensively, both in Europe and further afield, visiting Athens and Egypt in 1838–9. In 1843–4 he was one of the artists (George Scharf the Younger was another, see no. 68) who accompanied an expedition led by Sir Charles Fellows to Lycia, and made a series of thirty-six watercolours (all in the British Museum), from which this comes; he died in 1845 at the age of thirty-three.

Charles Fellows had first discovered the ancient city of Xanthus, capital of Lycia, in 1838, and continued his excavations over several years. As the antiquities arrived in England between 1842 and 1844 they caused a sensation almost as great as the Elgin Marbles forty years before; all are now in the British Museum, the best known being the Nereid Monument and the Harpy Tomb reliefs. Müller, however, was inspired less by the individual ruins than by the magnificent scenery, and his Lycian watercolours constitute his finest work. They show a strikingly bold and free use of the medium, and are painted in rich, earthy tones of ochre and brown, well suited to the rugged landscape through which he was travelling. His viewpoint here is from behind the Roman theatre looking north up the river valley towards the Cragus (or Taurus) mountains in the west; the Harpy and Sarcophagus Tombs can be seen on the right of the composition.

88
Richard Dadd 1817–1886
Port Stragglin

Watercolour; 190 × 142mm

Signed and dated: *R.ᵈ Dadd 1861* and inscribed on the verso *General View of Part of Port Stragglin – The Rock & Castle of Seclusion and the Blinker Lighthouse in the Distance. not sketched from Nature. by R.ᵈ Dadd 1861 Jan.ʸ Finit* and along the top and bottom edges of the verso *Not a bit like it. [?]...Style Sir[?] very; What a while you are! Of course it is! I don't like it. No.*

1919-4-12-2. Presented by the National Art-Collections Fund in memory of Robert Ross

Confined in 1844 to Bethlem Hospital and, from 1864, to Broadmoor for the murder of his father, Dadd was allowed to continue painting, producing a considerable number of works extraordinary both in conception and execution. Even before his illness he had been an imaginative artist of unusual perception, a distinguished student at the Royal Academy and a member of the Clique, a group of young avant-garde painters. The present watercolour, among the most intensely visionary that he painted, combines a delicacy of colour and a precision of drawing on a tiny scale. The towering pinnacle of rock surmounted by a castle seems to invoke Dadd's own seclusion in Bethlem, while the design is composed of many recognisable elements. The rock and the town clustered below are perhaps recollections of Dadd's travels to Greece, Egypt and the Middle East in 1842–3, and it has been suggested that the tower which he calls the Blinker Lighthouse could have been inspired by Eddystone. Dadd's own comment on the verso 'Not sketched from Nature' seems almost unnecessary, yet it is of interest partly for what it reveals of his state of mind and partly because it reflects the fact that by the 1860s sketching in colours from nature had become the norm.

89

John Ruskin 1819–1900

Fribourg, Switzerland

Watercolour and bodycolour with pen and ink on blue paper;
225 × 287mm
Signed and dated: *Sketch for etchings of Swiss towns, 1859 Signed: (1879)*
J. Ruskin
1901-5-16-4

Throughout his life Ruskin was in the habit of drawing. As a boy he took lessons from the then fashionable masters, including Copley Fielding, James Duffield Harding, and Samuel Prout, whose style remained an important influence until he fell under the spell of Turner in the 1840s. Although technically an amateur, his studies of architectural details, plants and geological specimens are unsurpassed in loving delicacy of execution and exactness of observation. On 4 January 1861 George Price Boyce recorded in his diary that 'Ruskin is now hard at work mastering the manipulation of paint under old Wm. Hunt. He expects to be 8 or 10 years at this; meantime does not mean to write or lecture'. This was clearly no more than a momentary whim, although such remarks show how seriously Ruskin took his own practice of art.

The drawings he made in the 1850s are among his most ambitious and original, combining Turnerian impressionism and Pre-Raphaelite detail. In the 1840s Ruskin had acquired a number of Turner's late Swiss watercolours, which he prized above all others. These stimulated him to return to Switzerland, where he had first been taken by his parents in the 1830s, and he made a number of extended visits to the Alps. In 1854 he planned a history of Switzerland to be illustrated with etchings after his own drawings, and in the next few years he made many watercolours in preparation for this project. They included this drawing of Fribourg, one of his most remakable landscape studies, in which he ignores all conventional ideas of composition and perspective. Although he abandoned the project, volume IV of *Modern Painters* (1856) was illustrated with a number of etchings after his own Swiss drawings.

90

Samuel Bough 1822–1878

A Manufacturing Town

Watercolour; 184 × 321mm
1886-6-7-9

By the second half of the nineteenth century the landscape created by the Industrial Revolution had ceased to seem in any way Sublime. Bough's view of a manufacturing town, crowded with chimney-stacks beneath a sky black with smoke, clearly illustrates this change of approach.

A. E. Housman, writing from Oxford in 1877, gives a vivid account of a lecture by Ruskin in which he used a watercolour by Turner as the basis for his denunciation of modern progress: 'He pointed to the picture as representing Leicester when Turner had drawn it. Then he said "You if you like may go to Leicester to see what it is like now. I never shall. But I can make a pretty good guess". Then he dashed in the iron bridge on the glass of the picture. "The colour of the stream is supplied on one side by the indigo factory." Forthwith one side of the stream became indigo. "On the other side by the soap factory." Soap dashed in. "They mix in the middle – like curds," he said, working them together with a sort of malicious deliberation. "This field, over which you see the sun setting behind the abbey is now occupied in a *proper* manner". Then there went a flame of scarlet across the picture, which developed itself into windows and roofs and red brick, and rushed up into the chimney. "The atmosphere is supplied – thus!" A puff and a cloud of smoke all over Turner's sky: and then the brush thrown down, and Ruskin confronting modern civilisation amidst a tempest of applause' (*The Letters of A. E. Housman*, ed. H. Maas, 1971, p. 13; the watercolour of Leicester is now in the Art Institute in Chicago).

Turner would not necessarily have agreed, for in spite of the unprecedented range of his art and his astonishing capacity for technical innovation, he remained in some respects a child of the eighteenth century, perhaps the last artist, in the tradition of Joseph Wright of Derby, to see in industrial change the dramatic contrast

between past and present, to feel the excitement of scientific discovery and the harnessing of power to produce wealth, and able to appreciate the forbidding but picturesque grandeur of great cities wreathed in unfamiliar atmospheric effects.

91

William Simpson 1823–1899

Summer in the Crimea

Watercolour with touches of white bodycolour over pencil; 250 × 354mm
Signed and dated: *W. Simpson 1857*
1971-5-15-10

Simpson was trained as a lithographer, but was also a well-known amateur archaeological authority, a scholar on the Bible and on Buddhism and a considerable linguist. He became the first British war artist when he was sent to the Crimea by Colnaghi and Son in 1854 to prepare a volume of lithographic illustrations of the campaign. This was the first of a long series of tours to distant parts, often undertaken to report colonial wars for *The Illustrated London News*, whose permanent staff he joined in 1866. With the development of cheap methods of reproduction such illustrated journals became widely popular in the second half of the century.

Most of Simpson's drawings are straightforward reportage, and might be compared with a modern photo-journalist's work. This watercolour, however, is quite different in mood. The scale and juxtaposition of the component elements give it, to modern eyes, an almost surreal quality. It was reproduced in chromolithography with the following explanatory text: 'Flowers, around which the bright lizards play, deck the earth; the convolvuli twine around the now rusty messengers of slaughter, while in the distance, the bombardment still continues, shot and shell dealing death around; the soldier's fate suggested by the butterfly fluttering over the burning bomb'.

92

Richard Doyle 1824–1883

Under the Dock Leaves – an Autumnal Evening's Dream

Watercolour and bodycolour; 499 × 776mm
Signed with the artist's monogram and dated 1878
1886-6-19-17

A representative example of the genre of fairy painting that, together with fairy literature, became popular in the middle of the nineteenth century. To some extent this genre was a development of a revived interest in medieval romance and folk literature, combined with sentimental whimsy. Side by side with the hard-headed economic and scientific materialism of the period went a notable degree of interest in the intangible spirit world, together with a good deal of gullibility: Dickens affirmed in *Household Words* of 1853: 'In a utilitarian age, of all other times, it is a matter of grave importance that Fairy Tales should be respected'.

Dicky Doyle was one of the most successful illustrators of fairy subjects in the period. He was the son of the caricaturist John Doyle, and was trained as an engraver. Following in his father's footsteps, he joined the staff of *Punch* in 1843, and was responsible for the famous design for its cover. He resigned from the magazine in 1850, unable to reconcile his Catholic beliefs with *Punch's* political bias and found a second career as a book illustrator. His masterpiece is probably *In Fairyland*, published in 1870, a triumph of Victorian book production, with verses by the Pre-Raphaelite poet William Allingham and thirty-six coloured wood-engravings. In the 1870s Doyle made extensive use of the watercolour medium on a large scale, as in this example. He ingeniously conveys the minuteness of the fairies by his naturalistic rendering of the leaves and trees on a much larger scale, so that we seem to have entered their world.

The artist's nephew was Sir Arthur Conan Doyle, creator of that supreme interpreter of physical evidence, Sherlock Holmes. He was also deeply interested in spiritualism, following the death of his son, and became a leading figure in the Society for Psychical Research. In

1920 he was taken in by photographs of two young girls apparently playing with fairies (who looked very like Richard Doyle's creatures) near their home in the Yorkshire village of Cottingley. For over fifty years the story was retold worldwide, and it was only in 1983 that the truth emerged: the photographs were ingeniously but simply composed using cut-out watercolours of fairies kept in position by hat-pins.

93

Myles Birket Foster 1825–1899

The Thames from Cliveden

Watercolour with scratching out; 343 × 711mm
Inscribed with the artist's monogram and *The Thames from Cliefton* [sic]
1985-6-8-32

Birket Foster's rustic scenes, like those of his follower Helen Allingham (see no. 100), enjoyed enormous popularity in his own day. He was originally trained as a wood-engraver and illustrator, but in the late 1850s turned chiefly to painting watercolours. *The Art Journal* noted in 1860 that his drawings 'must be classed with the Pre-Raphaelite school'. This is an unusually large and handsome work, probably dating from the early 1870s, before commercial pressures compelled him to turn out dreary repetitions of standard compositions, and shows the influence both of the Pre-Raphaelites in its handling and of Turner in its design. The high viewpoint, panoramic perspective and hazy distance were all devices used by Turner.

94

George Price Boyce 1826–1897

Streatley, Berkshire

Watercolour; 134 × 387mm
Signed and dated: *G Boyce June '59*
1915-2-13-2. Presented by Mrs Gillum

As a young man Boyce trained as an architect, but in 1849 he met David Cox and decided to become a landscape painter. Until well into the 1850s Boyce was still painting broad atmospheric studies of Welsh scenery in the spirit of his teacher, but towards the end of the decade his watercolours developed a consciously Pre-Raphaelite character, as in this view of hay-making at Streatley in the Thames Valley, dated 1859. Each summer from 1859 and through most of the 1860s Boyce explored the area on foot and by rowing-boat, painting in the riverside villages. His architectural training is reflected in his meticulously detailed attention to the farm buildings, and it is characteristic of his manner of composition that they should act as a screen across the design. The bright colouring (especially the sharp tones of green) and the detailed handling are also distinctly Pre-Raphaelite. Boyce sold this watercolour in February 1860 for sixteen guineas to Colonel Gillum, a notable patron of several Pre-Raphaelite artists.

Boyce had independent means (his father, like Ruskin's, had been a wine merchant and, even more profitably, a pawnbroker) and he was an avid collector both of the work of his Pre-Raphaelite friends – including Rossetti, Millais, Burne-Jones, Inchbold and Seddon – and of French artists. He kept a diary between 1851 and 1875 (which reflects an attractive, if unnecessary, degree of modesty about his own talents), an important source of information about the Pre-Raphaelite circle.

95

William Henry Millais 1828–1899

A Scottish Farm

Watercolour and bodycolour with touches of gum arabic; 179 × 330mm
Signed: *W. H. Millais*
1974-6-15-8

Overshadowed by the success of his younger brother John Everett Millais, William (a teacher of mathematics) never took the step of becoming a professional artist; nevertheless, during the 1850s he produced a number of works, mainly watercolours, which show the application of Pre-Raphaelite principles to the painting of landscapes. During the summers of 1851 to 1853 he spent long periods sketching from nature; this watercolour may date from 1853, when he accompanied his brother and the Ruskins on the fateful visit to Glenfinlas in the Trossachs when the attachment developed between John Millais and Effie Ruskin that was to lead to their marriage in 1855. The intense colouring, in particular the use of violet-blue and emerald-green, is characteristically Pre-Raphaelite.

96

Alfred William Hunt 1830–1896

The Tarn of Watendlath between Derwentwater and Thirlmere

Watercolour with bodycolour and scratching out; 322 × 492mm
Signed and dated: *A. W. Hunt 1858*
1969-9-20-1

Unusually for a professional artist, Hunt could have followed an academic career. A scholar of Corpus Christi College, Oxford, and in 1851 winner of the Newdigate Prize with a poem called *Nineveh*, in 1853 he was elected to a Fellowship which he held until his marriage in 1861 to the novelist Margaret Raine (celibacy being then an essential condition of Fellowships at Oxford and Cambridge). However, he had always been encouraged to paint by his father, himself a landscape artist and friend of David Cox, and first exhibited in 1847. By the mid-1850s he had decided to make art his profession, the chief formative influences on his mature style being the drawings of Turner and the writings of Ruskin, who had praised his exhibits at the Royal Academy. He was never, in the full sense of the term, a 'Pre-Raphaelite' – his notion of landscape painting as involving an annual sketching tour must have seemed rather old-fashioned – but he was associated with their circle in the late 1850s and his watercolour landscapes, many of which were painted out of doors, have something of the Pre-Raphaelite quality of intensity.

Inspired apparently by the chapters on geology in volume IV of Ruskin's *Modern Painters* (1856) and by the Pre-Raphaelite emphasis on painting entire pictures from nature, Hunt developed an obsessive, quasi-scientific interest in rocks, pebbles and lichenous stones, painstakingly stippled in and scratched out. Allen Staley has aptly characterised this stippling in Hunt's watercolours as 'exhausting', and even Ruskin came to denounce his 'plethoric labour' as a debasement of the Pre-Raphaelite 'truth to nature' that he had once championed; but for Hunt's many admirers the technical virtuosity and dramatic colouring of his watercolours produced an ideal combination of poetical imagination and scientific truth which made him a worthy heir of Turner.

In his choice of subject Hunt followed long-established precedent. Like Turner, Cotman and Cox, he painted many views in the north of England and Wales, often including, as in this watercolour of Watendlath Tarn in the Lake District, spectacular effects of light. The bird's-eye viewpoint and the treatment of the distance are derived from Turner, while the foreground detail demonstrates his indebtedness to Ruskinian principles.

97

Frederick Walker 1840–1875

The Spring of Life

Watercolour and bodycolour; 269 × 221mm
Signed: *F.W.*
1954-5-8-22. Bequeathed by Cecil French

Fred Walker began his career as one of the most distinguished of the group of draughtsmen, including his friends G. J. Pinwell and J. W. North, who in the early 1860s specialised in making drawings for book and magazine illustration. He soon turned to painting, evolving a highly wrought and elaborate watercolour technique involving much use of bodycolour which was denounced by Ruskin as 'a semi-miniature, quarter fresco, quarter wash manner of his own'. The term 'painting in watercolour' is exactly applicable to these drawings, which are so like his oil paintings in subject and treatment that in reproduction, when there is no indication of scale, they can hardly be distinguished.

Inevitably, Walker was influenced by the Pre-Raphaelites. In accordance with their strict principle of absolute fidelity to nature, he did his best, in conditions of difficulty and often even hardship, to paint large-scale canvases out of doors, but he was never a pure landscape artist. Though natural appearances are always minutely observed and sensitively rendered – as J. W. North wrote, 'his knowledge of nature was sufficient to disgust him with the ordinary conventions that do duty for grass, leaves and boughs' – the figures in his pictures are never subordinated to the landscape setting. In Pre-Raphaelite paintings the figures tend to be seen in some intensely charged moment of spiritual or moral crisis; in his, their action is usually incomplete and only vaguely definable. It might be said of him that he painted subject pictures without subjects, as here in *The Spring of Life*. Moreover, there is about his figures an element of poetic idealisation that sets his art apart from the obsessive truth-to-nature of the realistic wing of the Pre-Raphaelites; in this watercolour Walker narrowly escapes over-sentimentalisation.

In his own personal and intensely English way some of Walker's paintings might be seen as a parallel to the work of Continental contemporaries, such as Giovanni Costa or Jules Breton. Unfortunately Walker died before he was able to resolve his stylistic contradictions. It is interesting that he should have been greatly admired by Van Gogh, who in a letter of 1885 says of Walker and Pinwell: 'They did in England exactly what Maris, Israëls, Mauve, have done in Holland, namely restored nature over convention; sentiment and impression over academic platitudes and dullness...They were the first tonists'.

98

John William North 1842–1942

A Coastal Scene

Watercolour and bodycolour; 283 × 448mm
Signed and dated: *J. W. North 1873*
1970-3-7-2

North was one of a small group of artists including Frederick Walker who later became known as the Idyllists. Like Walker, North had trained as a wood-engraver and illustrator before turning to watercolour. None of the Idyllists painted pure landscape, choosing instead the relationship between figures and their immediate surroundings. Pre-Raphaelite truth to nature was a guiding principle, especially in his work of the 1860s, but his style gradually became softer and more atmospheric, less dependent on direct observation. In this dated watercolour of 1873 (which has echoes of Walker's 1869–70 canvas, *The Plough*) North depicts rural subject matter in a characteristically 'idyllic' manner.

99
Walter Crane 1845–1915
An Orchard by a Stream

Watercolour and bodycolour; 228 × 318mm
Signed with the artist's monogram and dated *June 25 '74*
1989-9-30-138

A leading figure in the Arts and Crafts movement, Crane was also a book illustrator and designer and a social and political writer. He had been apprenticed to one of the leading engravers of the period, W. J. Linton, and from this technical background he was able to develop considerable craftsmanship in the art of the book. He studied illuminated manuscripts, early printed books, the works of the Pre-Raphaelites and Japanese prints, all of which were to influence the design of the children's books for which he is best known today; with their flat tints and strong, simplified outlines they set new standards.

Crane's landscapes are little known, but for a period in the 1870s and 1880s he painted a small number of haunting, dream-like watercolours under the influence of Edward Burne-Jones's 'twilight world of dark mysterious woodlands, haunted streams, meads of deep green starred with burning flowers, veiled in a dim and mystic light' (Walter Crane, *An Artist's Reminiscences*, 1907, p. 84). This watercolour is dated June 1874, a year after Crane and his wife returned from a two-year visit to Italy, where he had devoted most of his time to painting and drawing landscape.

100
Helen Allingham 1848–1926
A Cottage near Haslemere, Surrey

Watercolour with scratching out; 303 × 414mm
Signed: *H. Allingham*
1967-10-14-35. Bequeathed by Dr Eric George Millar

Helen Allingham's watercolours represent the sentimental close of the Picturesque movement, with its nostalgia for a supposedly happier rural past. Like her mentor Myles Birket Foster, she saw country life as an idyllic refuge from the squalor and ugliness of an increasingly urbanised and industrial society. She was also, however, deeply concerned for the condition of the rural poor in a period of agricultural depression. Trained at the Birmingham School of Art and at the Royal Academy Schools, she married the Irish poet William Allingham in 1874, and thus came into the circle of the Pre-Raphaelites. Together with her friend Kate Greenaway, she was much admired by Ruskin.

From 1881 Helen Allingham lived in Surrey for some years – then on the point of losing most of its rural character. The catalogue to an exhibition of her work held at the Fine Art Society in 1886 included an essay (unsigned, but almost certainly written by her) in which she lamented the rapid changes that were taking place. The characteristic cottages in villages such as Haslemere were being 'improved' by landlords and incomers, 'they supplant fine old work...rub out a piece of Old England...the cherry or apple-tree that pushed its blossoms almost into a lattice, will probably be cut down, and the wild rose and honeysuckle hedge be replaced by a row of pales or wires'. She felt, with some reason, that her watercolours might be seen as a record of a disappearing way of life.

Select bibliography

Allderidge, Patricia, *The Late Richard Dadd 1817–1866*, exhibition catalogue, Tate Gallery, London 1974

Barbier, Carl Paul, *William Gilpin, His Drawings, Teaching and Theory of the Picturesque*, Oxford 1963

Bayard, Jane, *Works of Splendor and Imagination: The Exhibition Watercolour 1770–1870*, exhibition catalogue, Yale Center for British Art, New Haven 1981

Bicknell, Peter, *Beauty, Horror and Immensity: Picturesque Landscape in Britain 1750–1850*, exhibition catalogue, Fitzwilliam Museum, Cambridge 1981

Brown, David, *Samuel Palmer 1805–1881*, exhibition catalogue, Hazlitt, Gooden & Fox, London 1982

Bury, Adrian, *Francis Towne, Lone Star of Watercolour Painting*, London 1962

Butlin, Martin, *The Paintings and Drawings of William Blake*, 2 vols, New Haven and London 1981

Chandler, Richard, *Travels in Asia Minor*, London 1775 (edited and abridged by Edith Clay with an appreciation of William Pars by Andrew Wilton, 1971)

Clarke, Michael, *The Tempting Prospect: A Social History of Watercolours*, London 1981

Cohn, Marjorie B., *Wash and Gouache: A Study of the Development of the Materials of Watercolour*, exhibition catalogue, Fogg Art Museum, Cambridge, Mass. 1977

Connor, Patrick, *William Alexander, an English Artist in Imperial China*, exhibition catalogue, Royal Pavilion Art Gallery and Museum, Brighton 1981

Cormack, Malcolm, *Bonington*, Oxford 1989

Croft-Murray, Edward, and Paul Hulton, *Catalogue of British Drawings* [in the British Museum], vol. I: XVI & XVII centuries, 2 vols, London 1960

Crouan, Katherine, *John Linnell. A Centennial Exhibition*, exhibition catalogue, Fitzwilliam Museum, Cambridge 1982

Dayes, Edward, *The Works of the late Edward Dayes*. Originally published London 1805, republished London 1971, with an introduction by R. W. Lightbown

Farington, Joseph, *The Farington Diary*, 16 vols (I–VI ed. Kenneth Garlick and Angus Macintyre; VII–XVI ed. Kathryn Cave), New Haven and London 1978–84

Fleming-Williams, Ian, *Constable: Landscape Drawings and Watercolours*, London 1976

Gilpin, Revd William, *Three Essays on Picturesque Beauty; on Picturesque Travel; and on Sketching Landscape; to which is added a poem, on Landscape Painting*, London 1792

Girtin, Thomas, and David Loshak, *The Art of Thomas Girtin*, London 1954

Griffiths, Antony, and Gabriela Kesnerova, *Wenceslaus Hollar: Prints and Drawings from the Collections of the National Gallery, Prague, and the British Museum, London*, exhibition catalogue, British Museum, London 1983

Grigson, Geoffrey, *Samuel Palmer, The Visionary Years*, London 1947

Guiterman, Helen, *David Roberts R.A., 1796–1864*, London 1978

Guiterman, Helen, and Briony Llewellyn, *David Roberts*, exhibition catalogue, Barbican Art Gallery, London 1986

Hamilton, Jean, *The Sketching Society 1799–1851*, exhibition catalogue, Victoria and Albert Museum, London 1971

Hardie, Martin (ed. Dudley Snelgrove, Jonathan Mayne and Basil Taylor), *Watercolour Painting in Britain*, 3 vols, London 1966–8

Harley, Rosamund D., *Artists' pigments c.1600–1835: a study of English documentary sources*, 2nd edn, London 1982

Hawcroft, Francis, *Watercolours by John Robert Cozens*, exhibition catalogue, Whitworth Art Gallery, Manchester, and Victoria and Albert Museum, London 1975

Hawcroft, Francis, *Travels in Italy 1776–1783, based on the Memoirs of Thomas Jones*, exhibition catalogue, Whitworth Art Gallery, Manchester 1988

Hayes, John, *The Drawings of Thomas Gainsborough*, 2 vols, London 1970

Hayes, John, *Thomas Rowlandson: Drawings and Watercolours*, London 1972

Hayes, John, and Lindsay Stainton, *Gainsborough Drawings*, exhibition catalogue for The International Exhibitions Foundation, Washington 1983

Hedley, Gill, *The Picturesque Tour in Northumberland and Durham c.1720–1830*, exhibition catalogue, Laing Art Gallery, Newcastle-upon-Tyne 1982

Hermann, Luke, *Paul and Thomas Sandby*, London 1986

Hofer, Philip, *Edward Lear as a Landscape Draughtsman*, Harvard 1967

Holloway, James, and Lindsay Errington, *The Discovery of Scotland*, exhibition catalogue, National Gallery of Scotland, Edinburgh 1978

Jones, Thomas (ed. A. P. Oppé), 'Memoirs', *The Walpole Society*, XXXII (1946–8)

Joppien, Rüdiger, and Bernard Smith, *The Art of Captain Cook's Voyages*, 3 vols, New Haven and London 1985–88

Kauffmann, C. M., *John Varley 1778–1842*, London 1984

Kingzett, Richard, 'A Catalogue of the Works of Samuel Scott', *The Walpole Society*, XLVIII (1980–2)

Kitson, Sydney D., *The Life of John Sell Cotman*, London 1937

Krill, John, *English Artists' Paper*, exhibition catalogue, Victoria and Albert Museum, London 1987

Lambourne, Lionel, and Jean Hamilton, *British Watercolours in the Victoria and Albert Museum, An Illustrated Summary Catalogue*, London 1980

Lewis, Frank, *Myles Birket Foster 1825–1899*, Leigh-on-Sea 1973

Lister, Raymond, *Edward Calvert*, London 1962

Lister, Raymond, *Samuel Palmer and the Ancients*, exhibition catalogue, Fitzwilliam Museum, Cambridge 1984

Lister, Raymond, *Catalogue Raisonné of the Works of Samuel Palmer*, Cambridge 1988

Mallalieu, H. L., *The Dictionary of British Watercolour Artists up to 1920*, Woodbridge 1976

Morris, Susan, *Thomas Girtin 1775–1802*, exhibition catalogue, Yale Center for British Art, New Haven 1986

Newall, Christopher, *Victorian Watercolours*, Oxford 1987

Newall, Christopher, and Judy Egerton, *George Price Boyce*, exhibition catalogue, Tate Gallery, London 1987

Oppé, A. P., 'Francis Towne, Landscape Painter', *The Walpole Society*, VIII (1919–20), pp. 95–126

Oppé, A. P., *The Drawings of Paul and Thomas Sandby...at Windsor*, London 1947

Oppé, A. P., *Alexander and John Robert Cozens*, London 1952

Owen, Felicity, and Eric Stanford, *William Havell 1782–1857*, exhibition catalogue, Tate Gallery, London 1973

Parris, Leslie, *Landscape in Britain, c.1750–1850*, exhibition catalogue, Tate Gallery, London 1973

Parris, Leslie, and Ian Fleming-Williams, *Constable*, exhibition catalogue, Tate Gallery, London 1976

Pragnell, Hubert, *The London Panoramas of Robert Baker and Thomas Girtin*, London Topographical Society, 1968

Rajnai, Miklos (ed.), *John Sell Cotman 1782–1842*, exhibition catalogue, Victoria and Albert Museum, London 1982 (touring exhibition arranged by the Arts Council of Great Britain, 1982–3)

Reynolds, Graham, *The Later Paintings and Drawings of John Constable*, 2 vols, New Haven and London 1984

Robertson, Bruce, *The Art of Paul Sandby*, exhibition catalogue, Yale Center for British Art, New Haven 1985

Roget, John Lewis, *A History of the Old Water-Colour Society*, 2 vols, London 1891

Roundell, James, *Thomas Shotter Boys*, London 1974

Ruskin, John, *Notes on Samuel Prout and William Henry Hunt*, London 1879

Russell, John, and Andrew Wilton, *Turner in Switzerland*, Zurich 1976

Scrase, David, *Drawings and Watercolours by Peter de Wint*, exhibition catalogue, Fitzwilliam Museum, Cambridge 1979

Shanes, Eric, *Turner's Picturesque Views in England and Wales 1825–1838*, London 1979

Skelton, Jonathan (ed. Brinsley Ford), 'The Letters of Jonathan Skelton written from Rome and Tivoli in 1758', *The Walpole Society*, xxxvi (1956–8), pp. 23–82

Sloan, Kim, *Alexander and John Robert Cozens: The Poetry of Landscape*, London 1986

Smith, Bernard, *European Vision and the South Pacific 1768–1850*, Oxford 1960

Smith, Greg, and Sarah Hyde, *Walter Crane: Artist, Designer and Socialist*, exhibition catalogue, Whitworth Art Gallery, Manchester 1989

Spencer, Marion, *Richard Parkes Bonington*, exhibition catalogue, Nottingham Museum and Art Gallery, 1965

Stainton, Lindsay, *British Artists in Rome 1700–1800*, exhibition catalogue, The Iveagh Bequest, Kenwood 1974

Stainton, Lindsay, *Turner's Venice*, London 1985

Stainton, Lindsay, and Christopher White, *Drawing in England from Hilliard to Hogarth*, exhibition catalogue, British Museum, London 1987

Staley, Allen, *The Pre-Raphaelite Landscape*, Oxford 1973

Taylor, Basil, *Joshua Cristall*, exhibition catalogue, Victoria and Albert Museum, London 1975

Walton, Paul, *The Drawings of John Ruskin*, Oxford 1972

White, Christopher, *English Landscape 1630–1850: Drawings, Prints and Books from the Paul Mellon Collections*, exhibition catalogue, Yale Center for British Art, New Haven 1977

Whitley, William T., *Whitley Papers* (deposited in the Print Room, British Museum)

Wilcox, Scott, *British Watercolours*, catalogue of exhibition organised by the Yale Center for British Art, New Haven, for The American Federation of Arts, 1985

Wildman, Stephen, with Richard Lockett and John Murdoch, *David Cox 1783–1859*, exhibition catalogue, Birmingham City Art Gallery, 1983 and Victoria and Albert Museum, London 1984

Williams, Iolo A., *Early English Watercolours*, London 1952

Wilton, Andrew, *Turner in the British Museum*, exhibition catalogue, British Museum, London 1975

Wilton, Andrew, *British Watercolours 1750–1850*, Oxford 1977

Wilton, Andrew, *The Life and Work of J. M. W. Turner*, London 1979

Wilton, Andrew, *The Art of Alexander and John Robert Cozens*, exhibition catalogue, Yale Center for British Art, New Haven 1980

Witt, Sir John, *William Henry Hunt 1790–1864*, London 1982

Woodbridge, Kenneth, *Landscape and Antiquity: Aspects of English Culture at Stourhead 1718–1838*, Oxford 1970

Index of Artists

The Plates

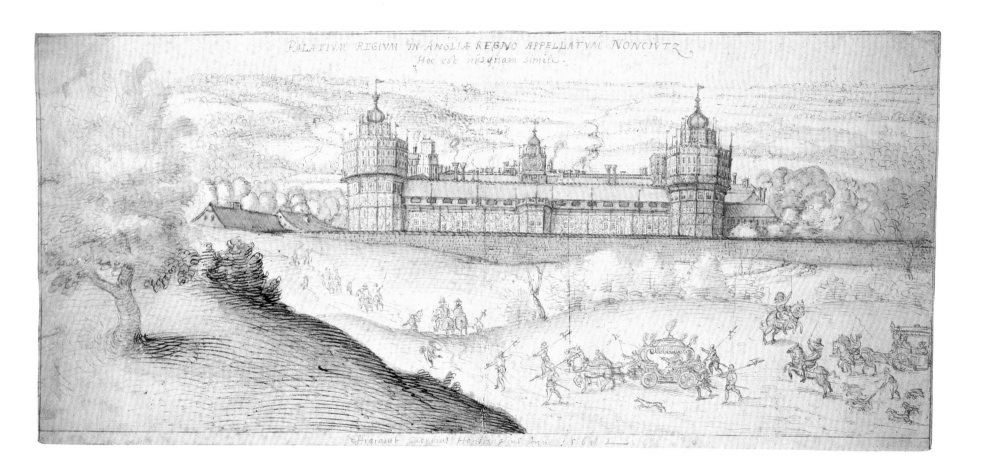

In the image, the inscriptions on the drawing read:

PALATIVM REGIVM IN ANGLIÆ REGNO APPELLATVM NONCIVTZ
Hoc est nusquam simile.

Effigiauit Georgius Houfnaglius Anno 1568

1 Joris Hoefnagel *Nonsuch Palace, Surrey*

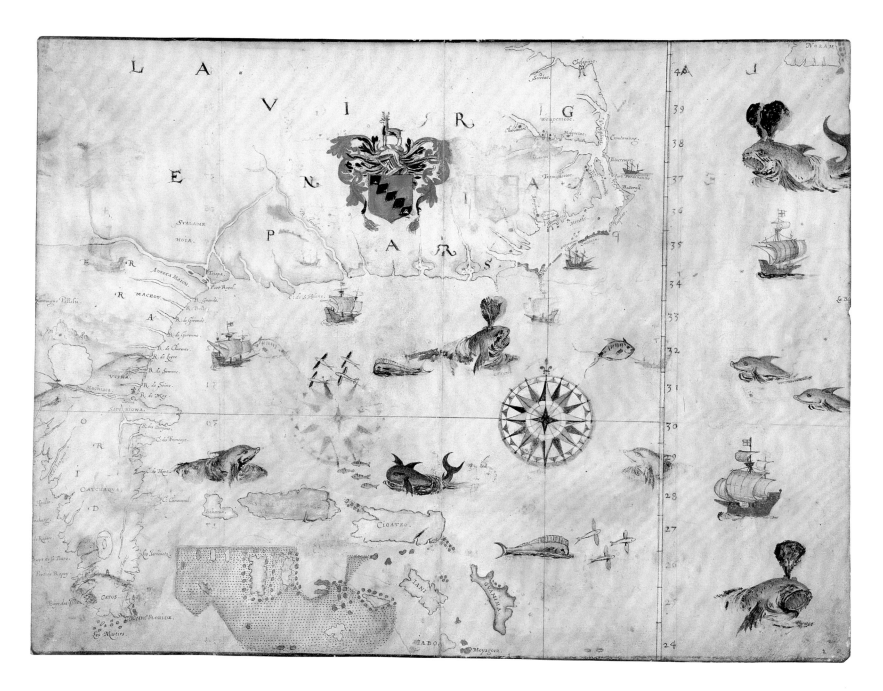

2 John White *North America from Florida to Chesapeake Bay*

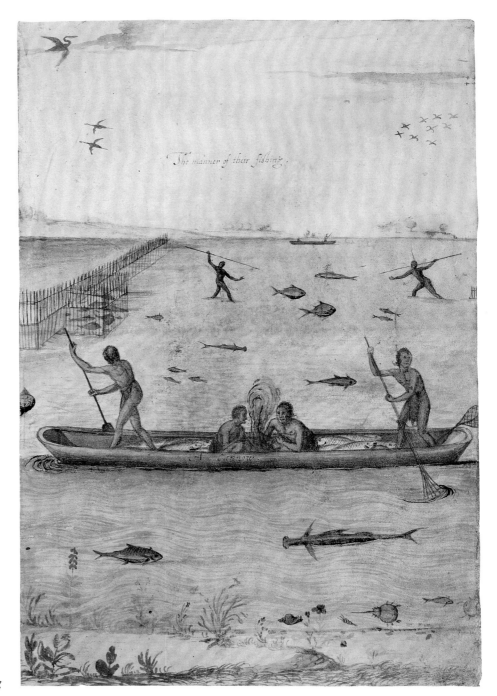

The manner of their fishing.

3 John White *Indians Fishing*

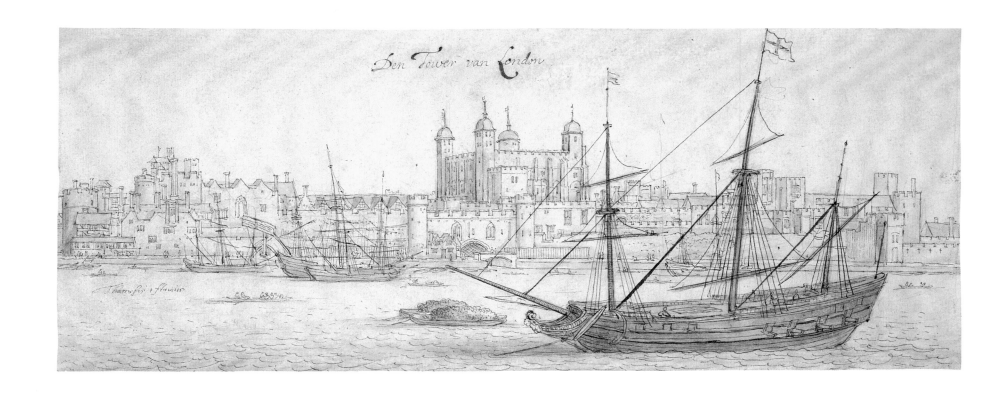

Den Tower van London

4 Wenceslaus Hollar *The Tower of London*

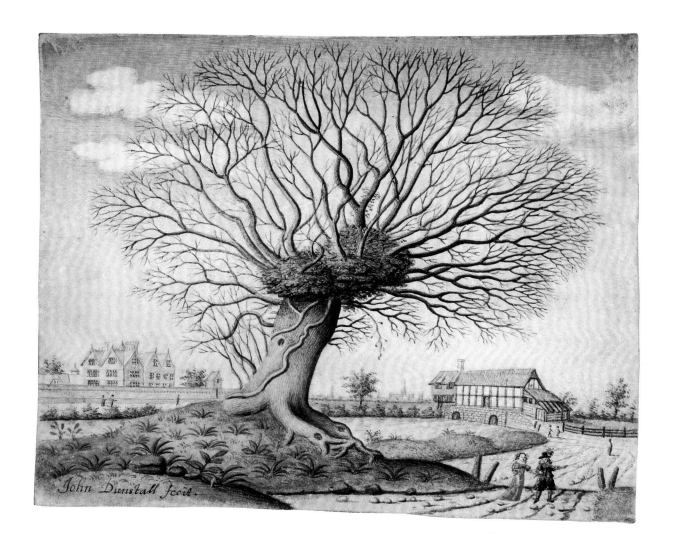

John Dunstall fecit.

5 John Dunstall *A Pollard Oak near West Hampnett Place, Chichester*

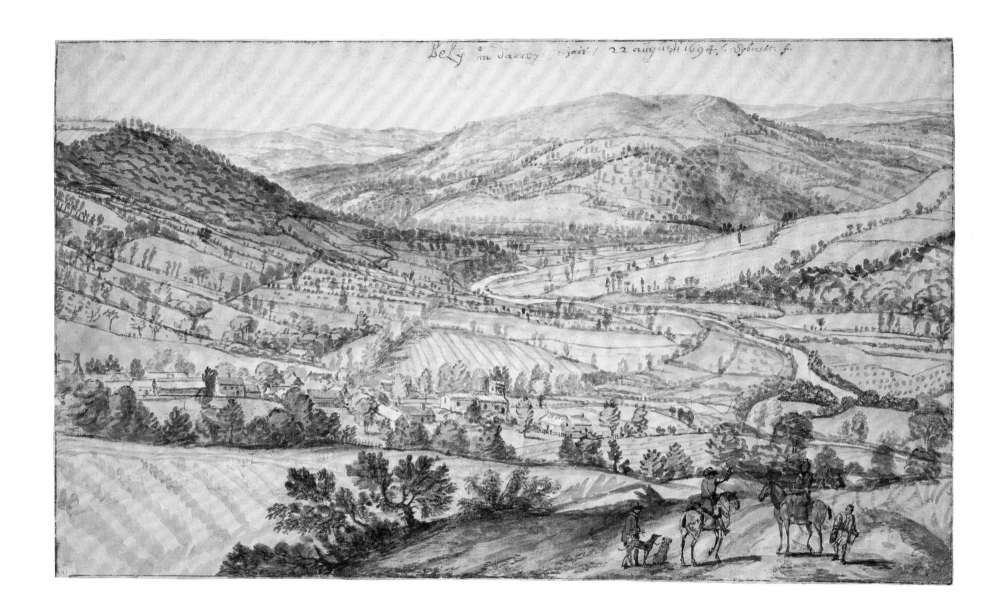

6 Jan Siberechts *A View of Beeley, near Chatsworth*

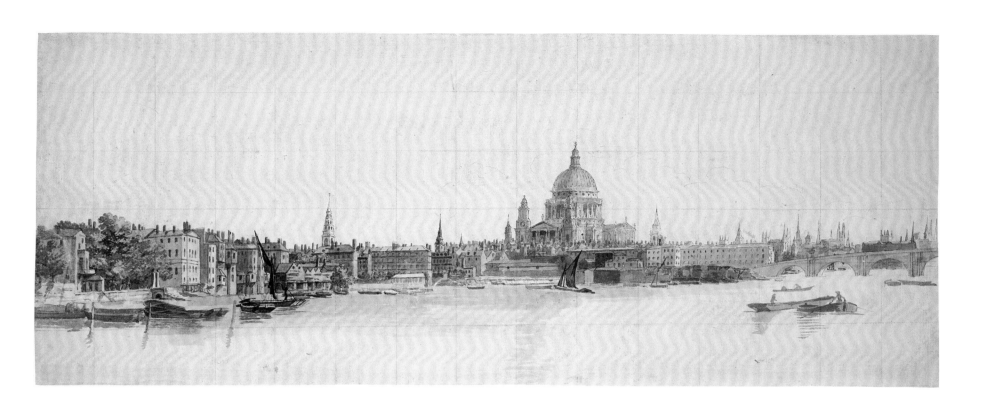

7 Samuel Scott *St Paul's from the Thames*

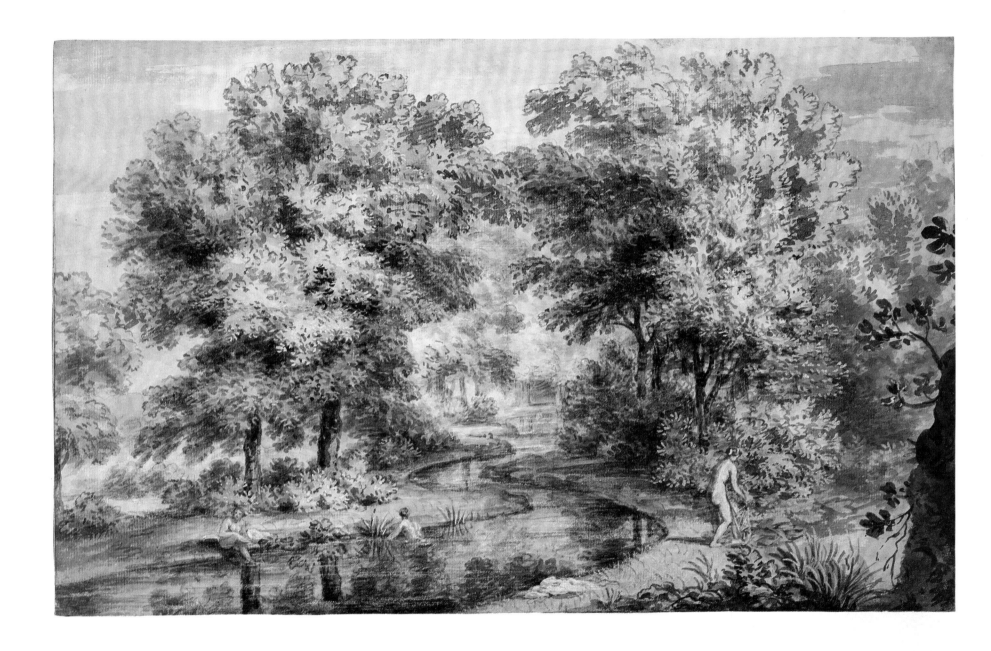

8 William Taverner *Landscape with a Winding River and Nymphs Bathing*

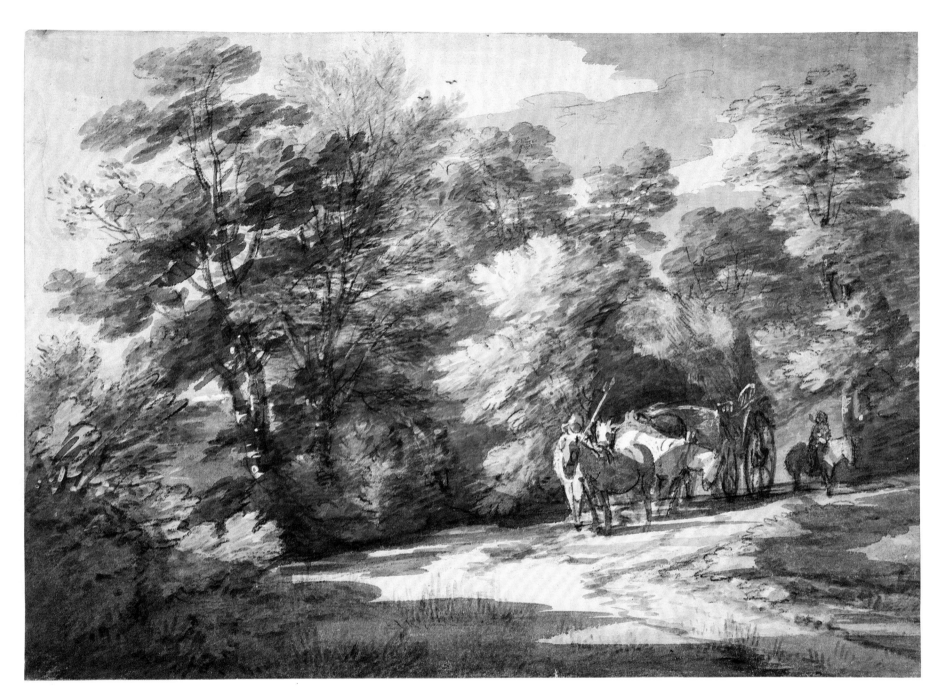

9 Thomas Gainsborough *A Cart passing along a Winding Road*

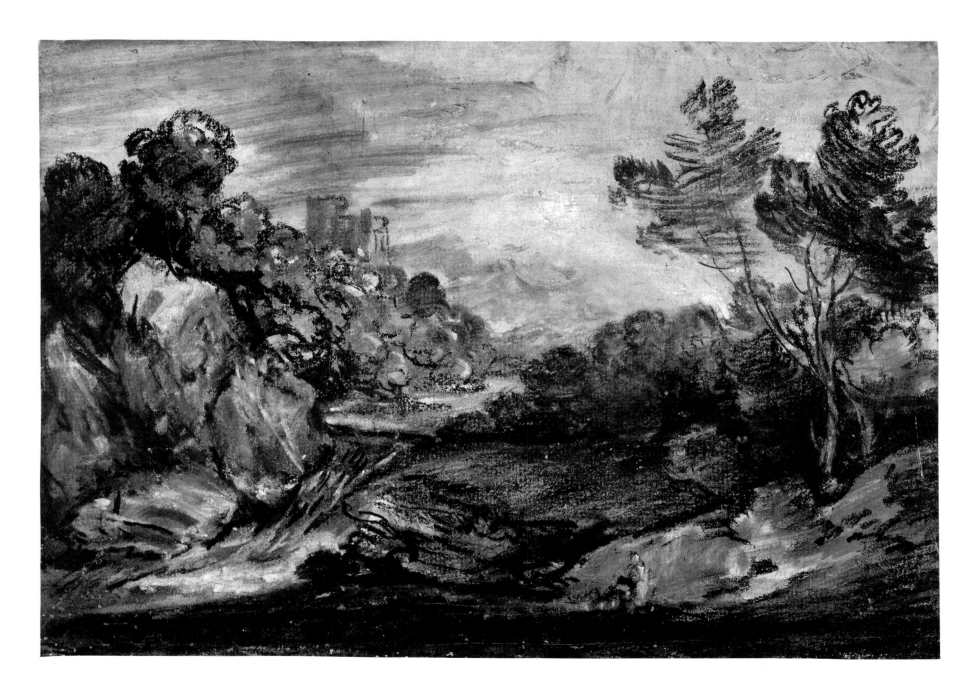

10 Thomas Gainsborough *Landscape Composition*

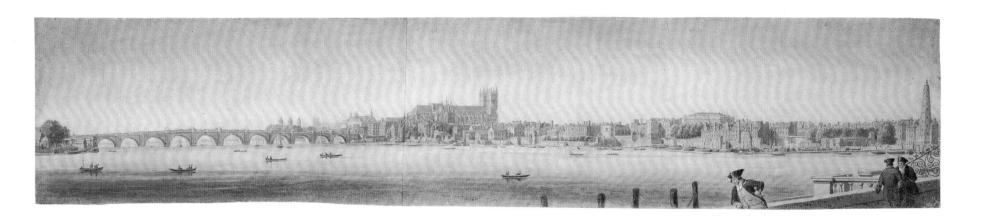

11 ? Thomas and Paul Sandby *Westminster Abbey from Somerset House*

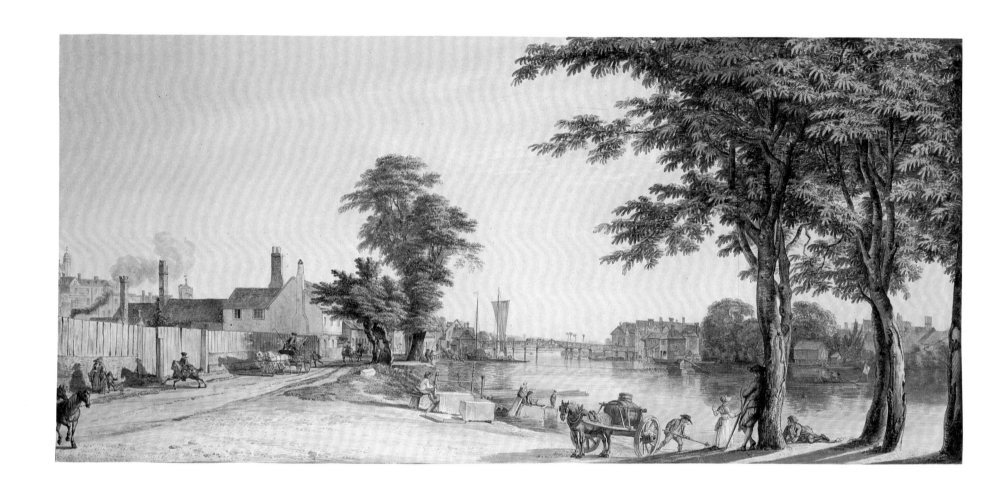

12 Paul Sandby *Windsor Bridge from Datchet Lane*

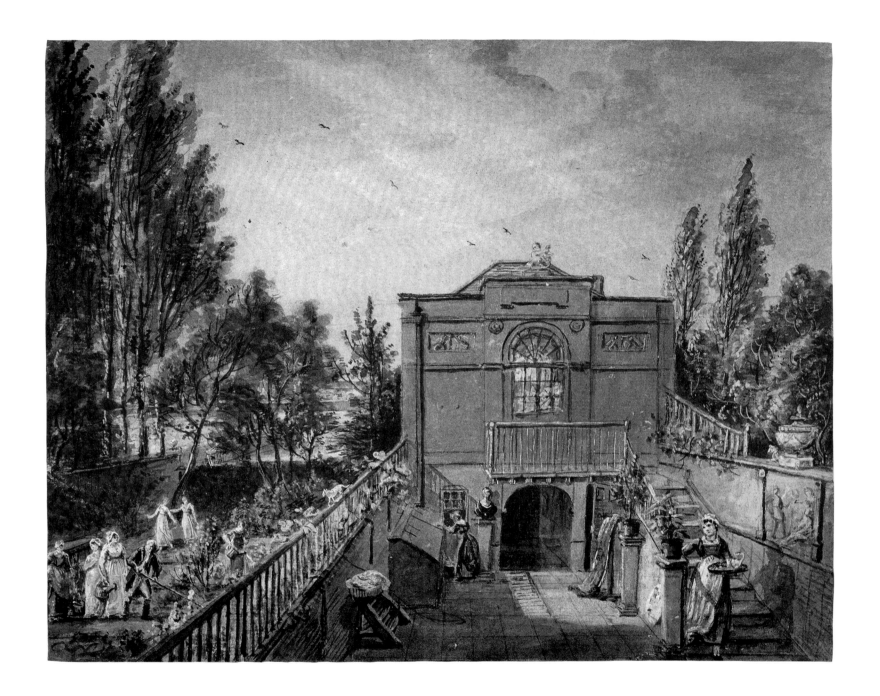

13 Paul Sandby *The Artist's Studio, St George's Row, Bayswater*

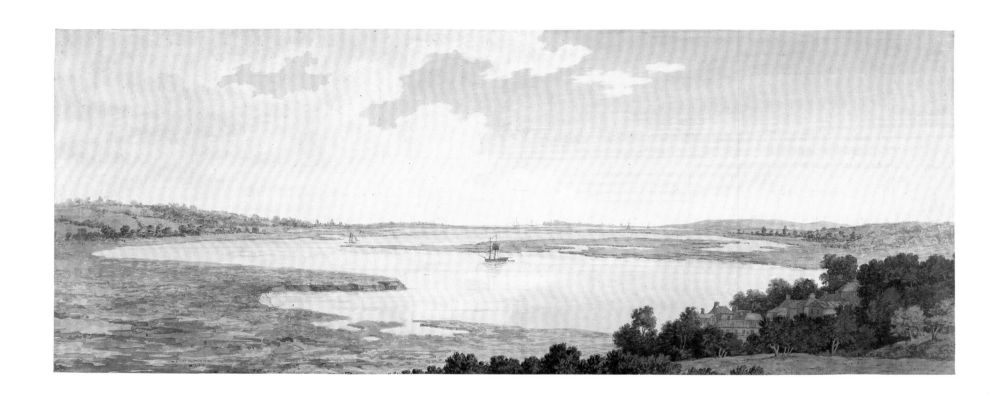

14 Jonathan Skelton *The Medway near Sheerness*

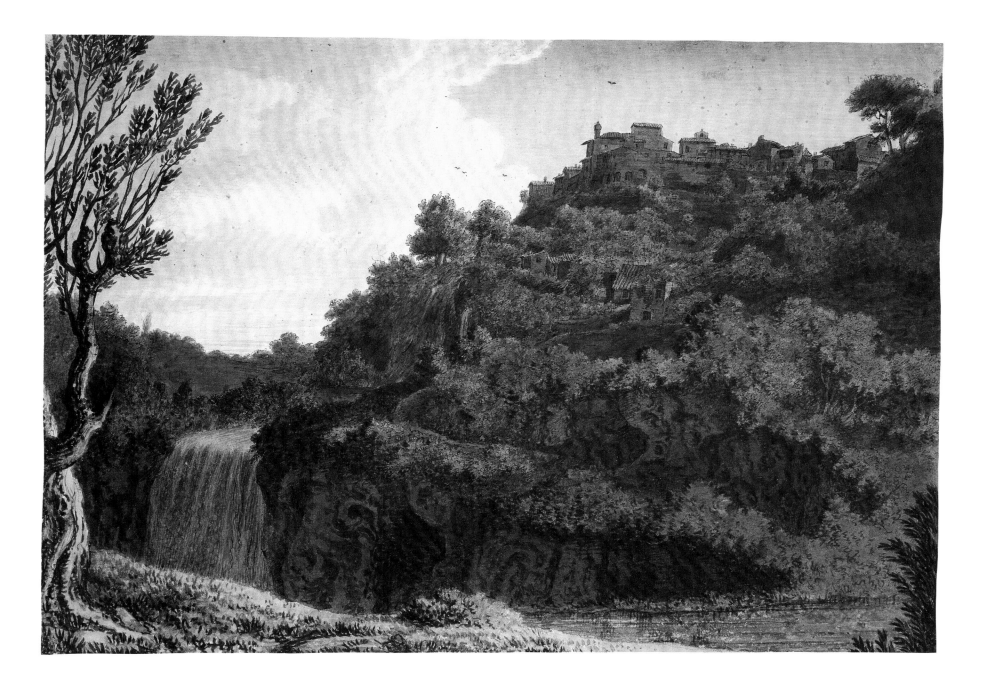

15 Jonathan Skelton *Tivoli*

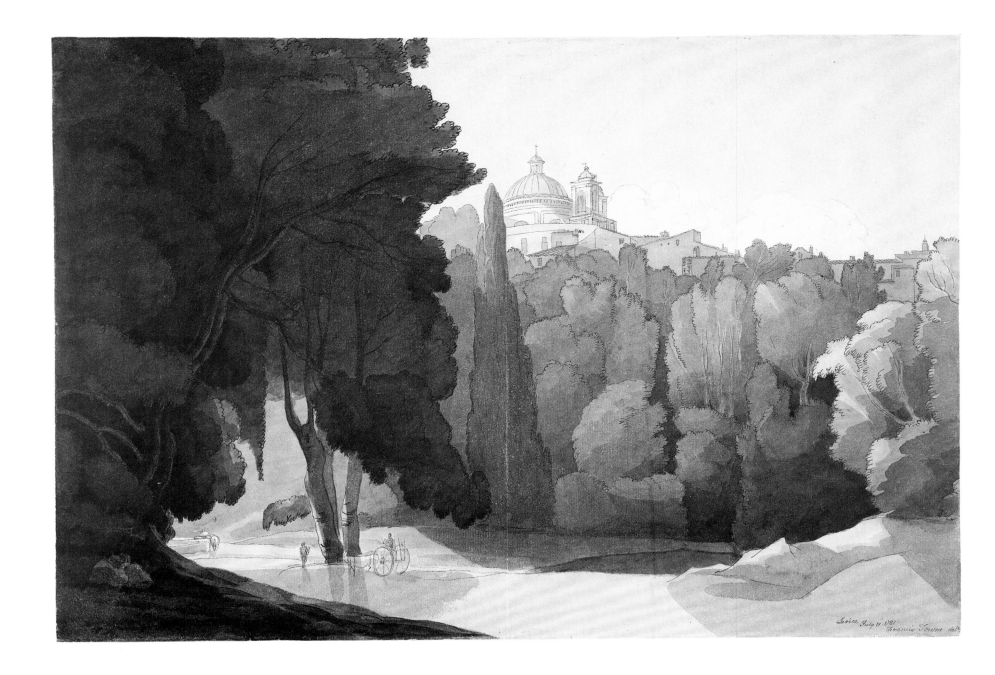

16 Francis Towne *Ariccia*

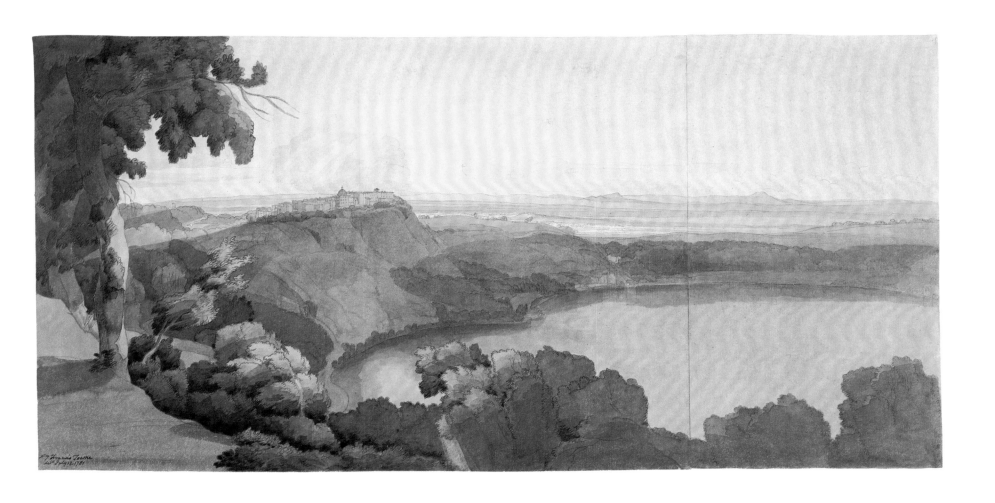

17 Francis Towne *Lake Albano with Castel Gandolfo*

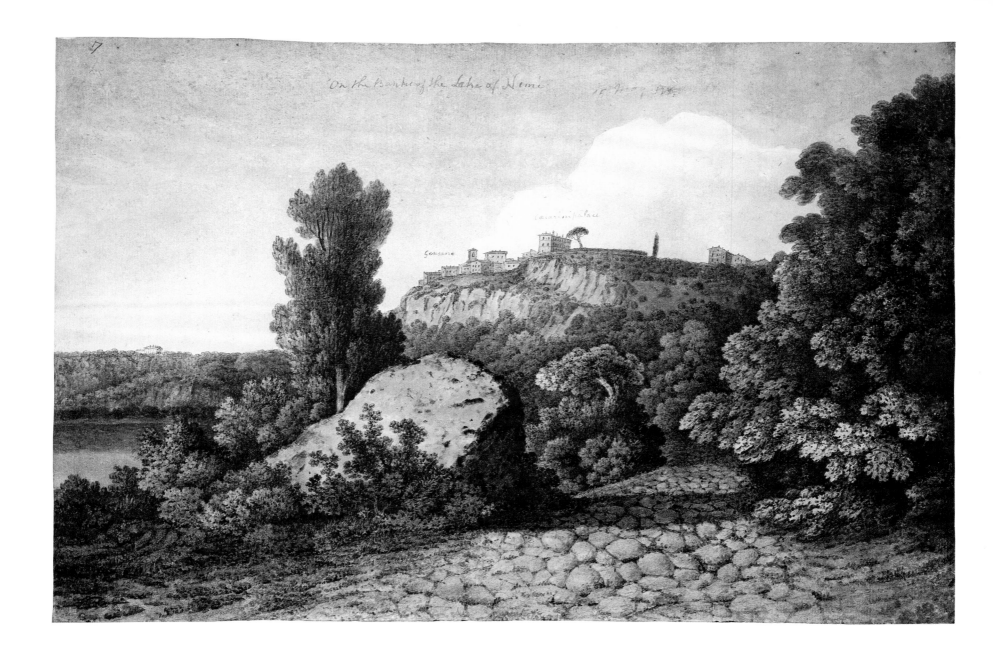

On the Banks of the Lake of Nemi

Genzano

Casarini Palace

18 Thomas Jones *Genzano, Lake Nemi*

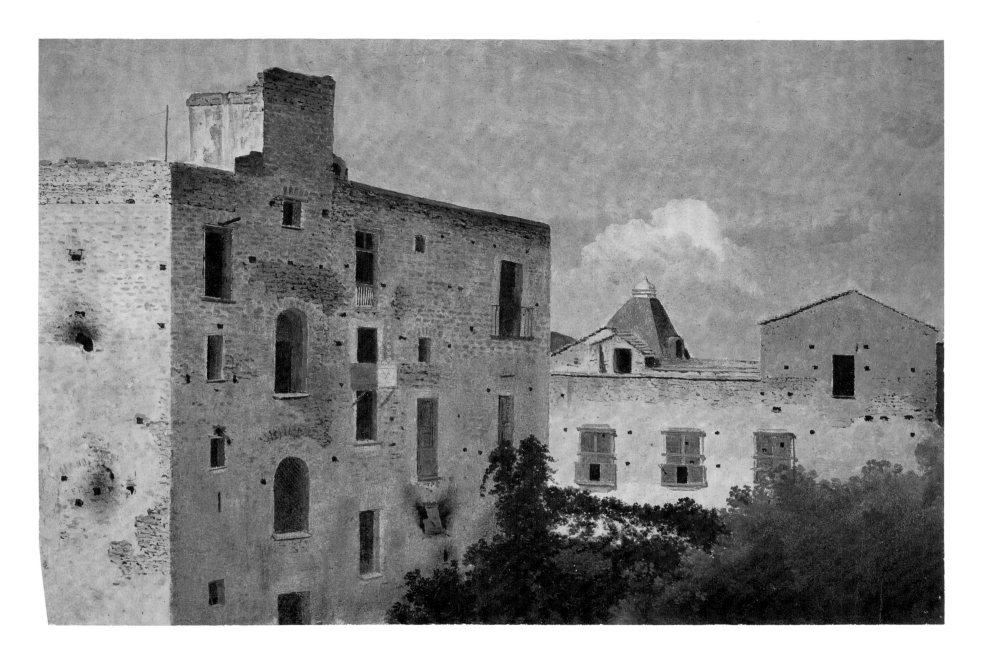

19 Thomas Jones *Houses in Naples*

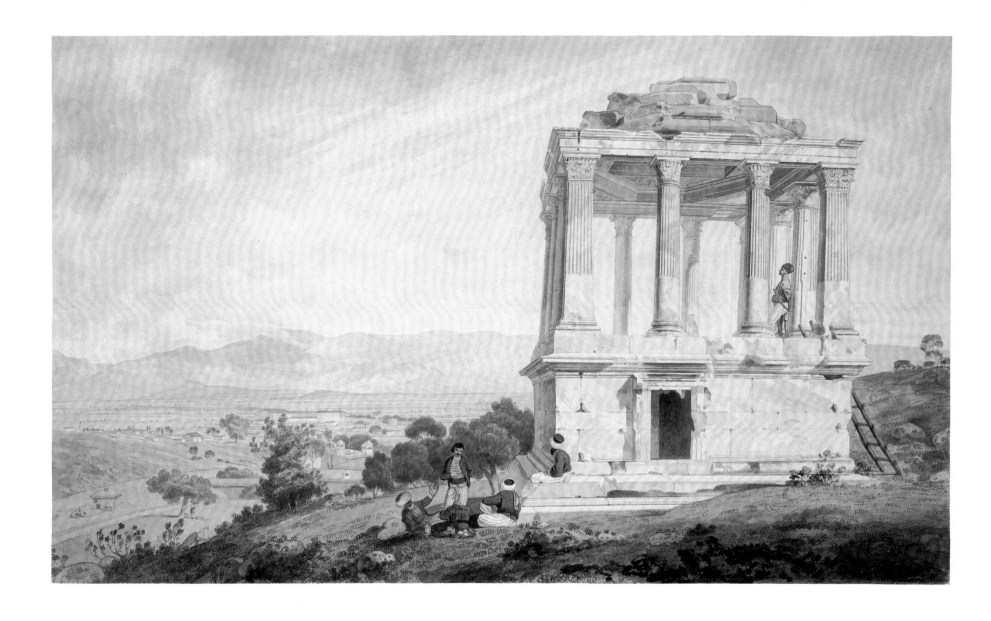

20 William Pars *A Sepulchral Monument at Mylasa*

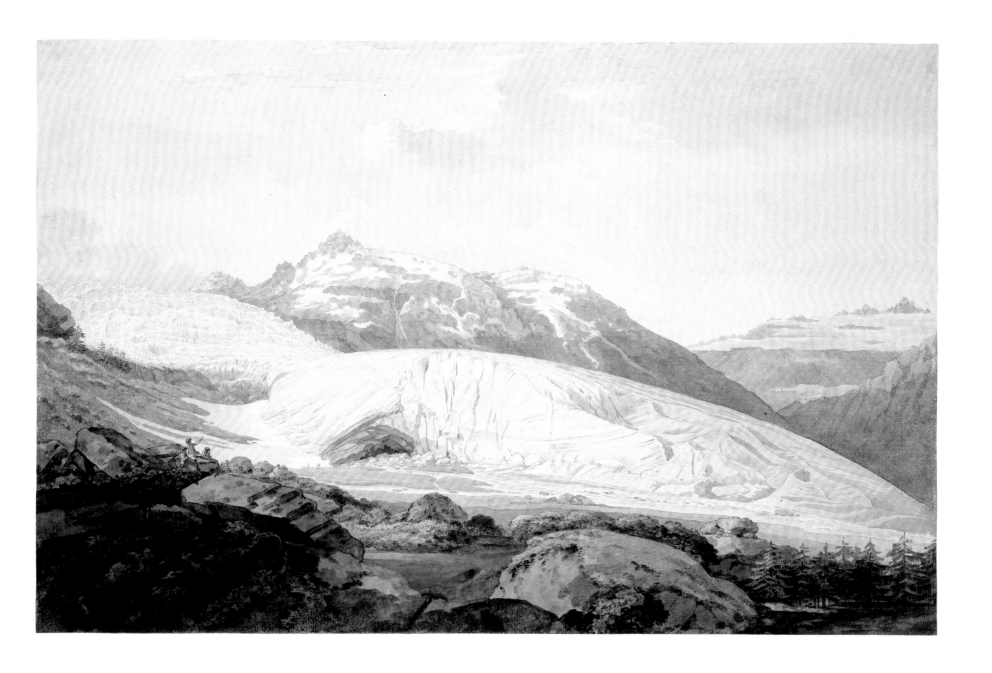

21 William Pars *The Rhône Glacier and the Source of the Rhône*

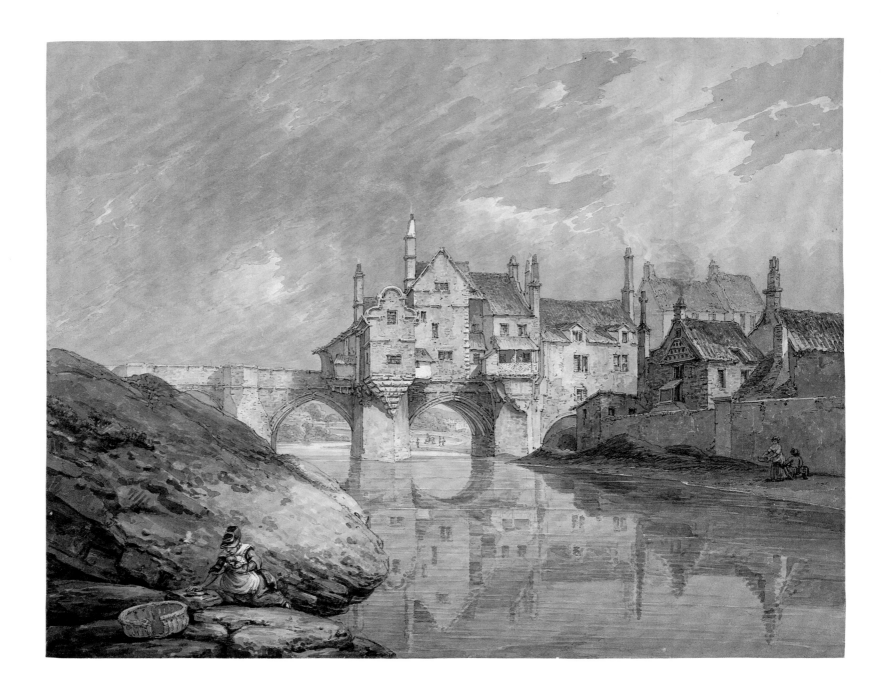

22 Thomas Hearne *Elvet Bridge, Durham*

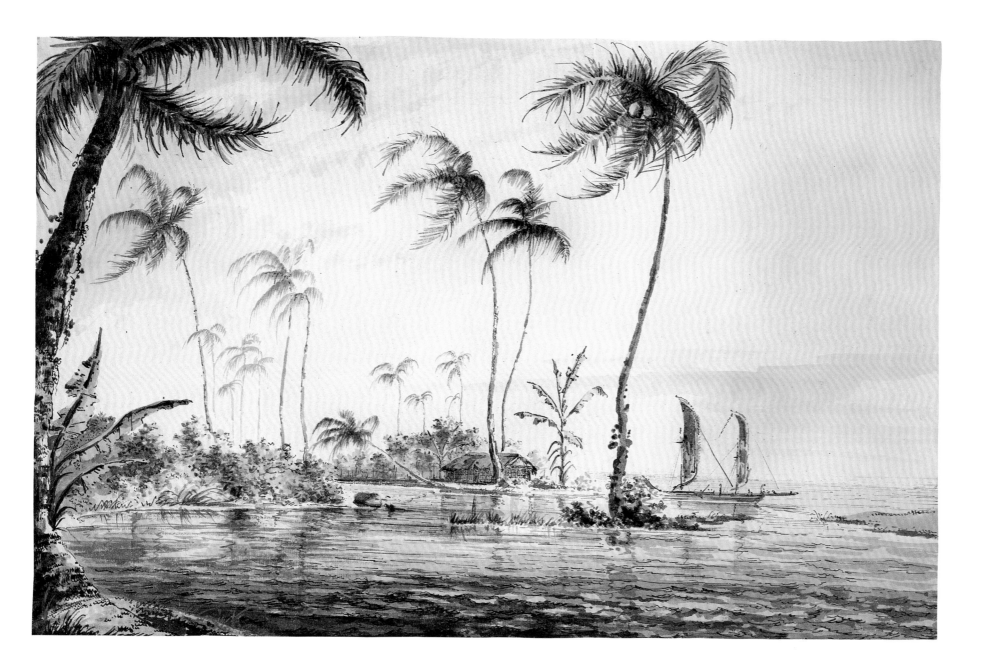

23 William Hodges *A View on the Island of Otaheite*

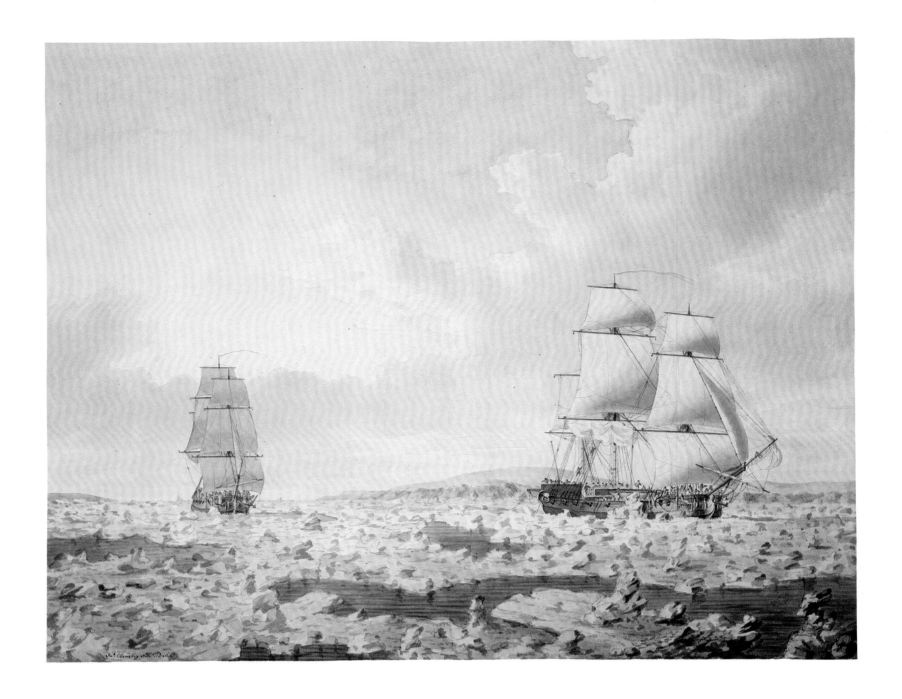

24 John Cleveley the Younger *The 'Racehorse' and 'Carcass' forcing their way through the Ice, 10 August 1773*

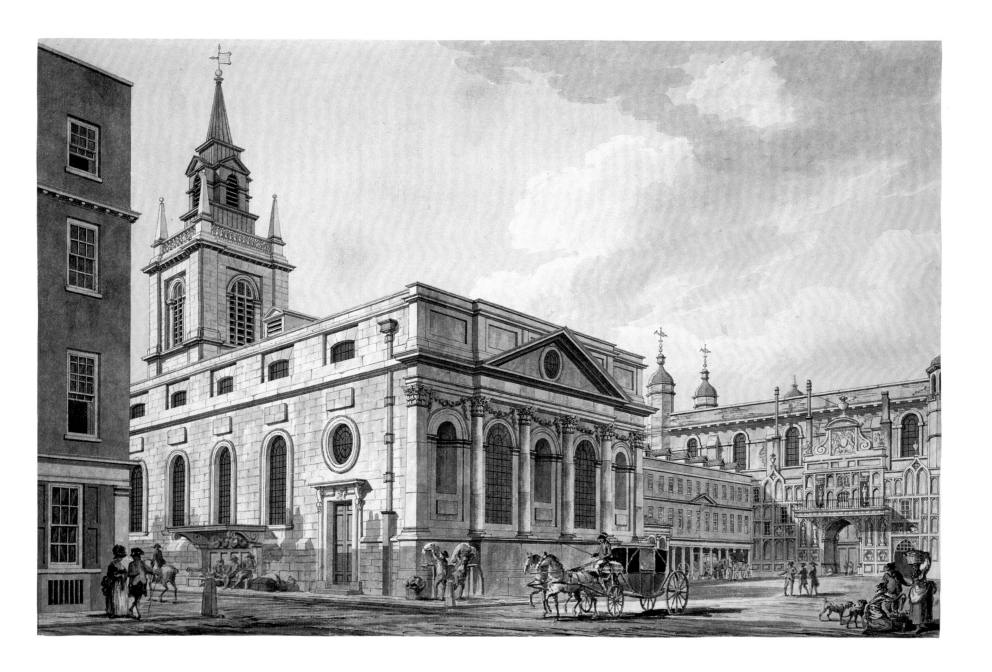

25 Thomas Malton *St Lawrence Jewry and Guildhall*

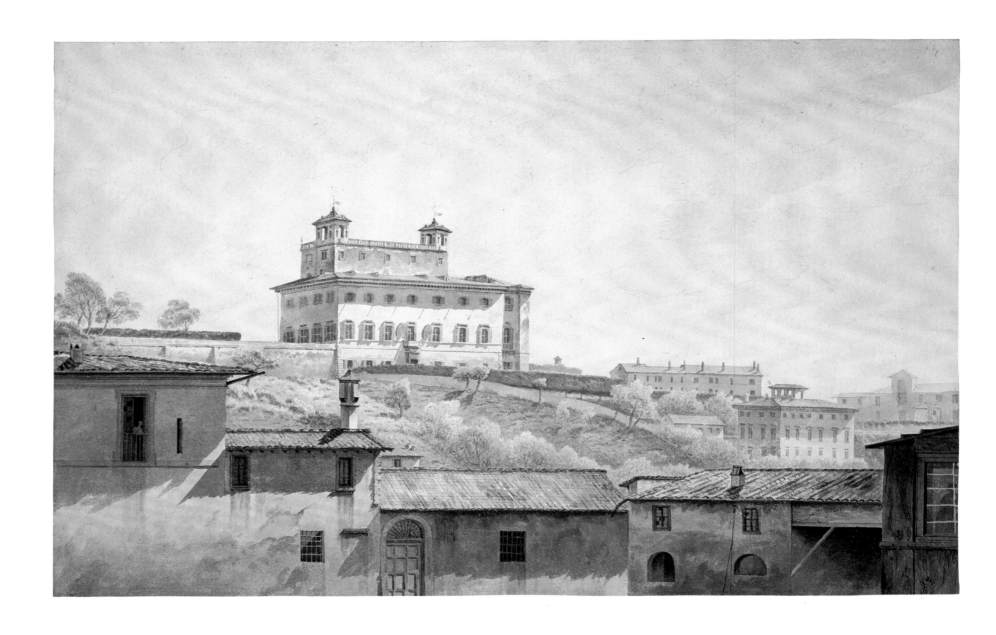

26 John 'Warwick' Smith *The Villa Medici, Rome*

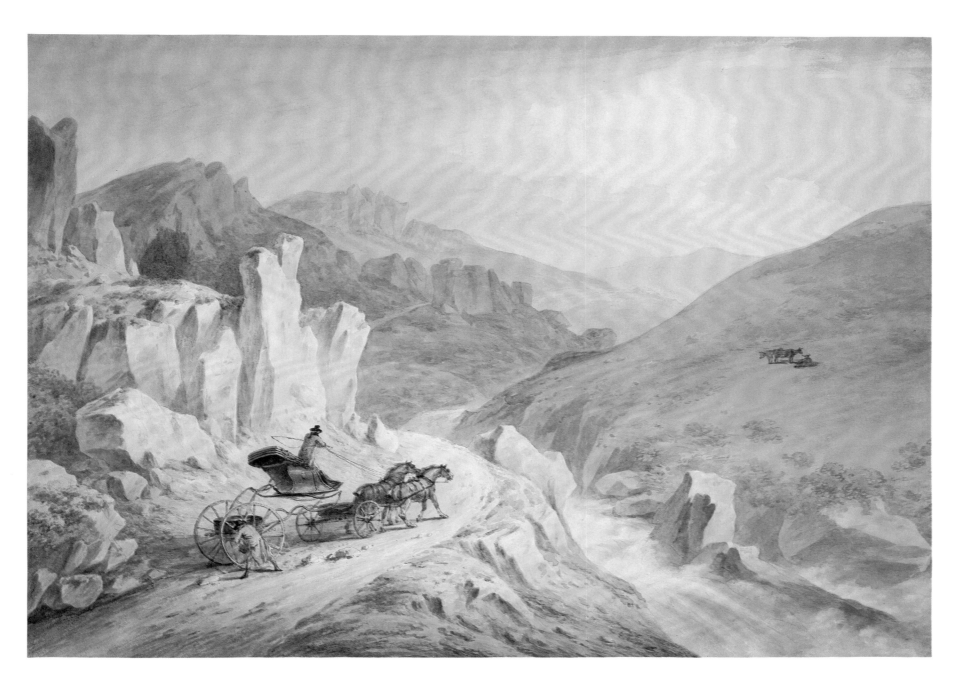

27 John 'Warwick' Smith and Julius Caesar Ibbetson
The Hon. Robert Fulke Greville's Phaethon crossing the Mountains between Pont Aberglaslyn and Tan-y-bwlch

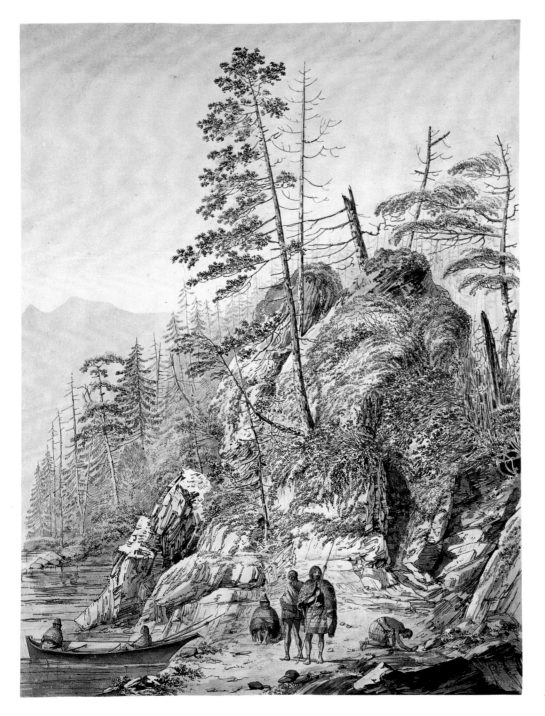

28 John Webber *A View in Nootka Sound, Vancouver Island*

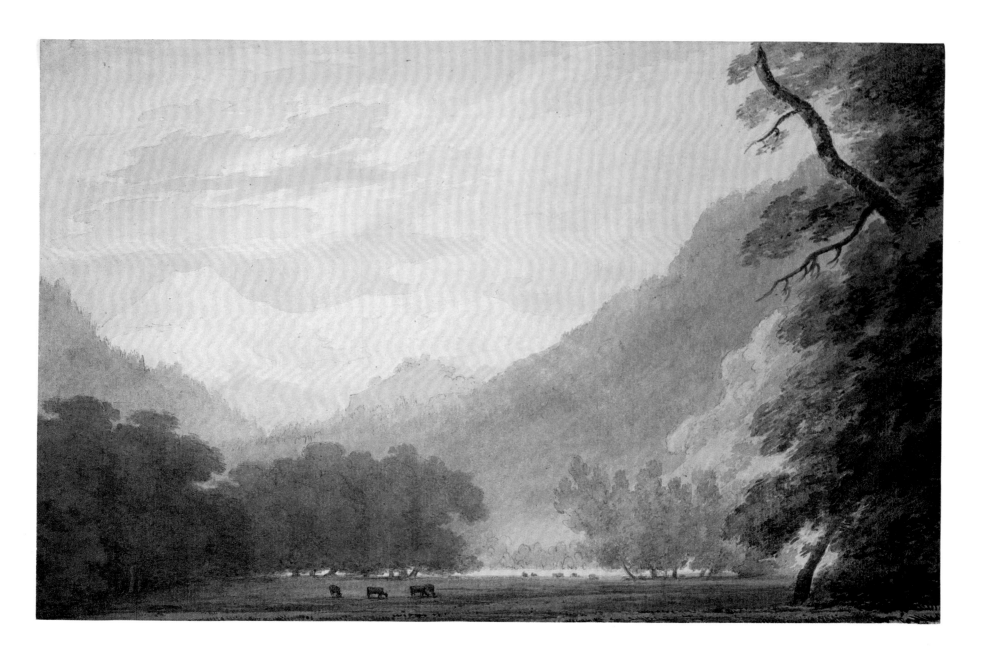

29 John Robert Cozens *From the Road between the Lake of Thun and Unterseen*

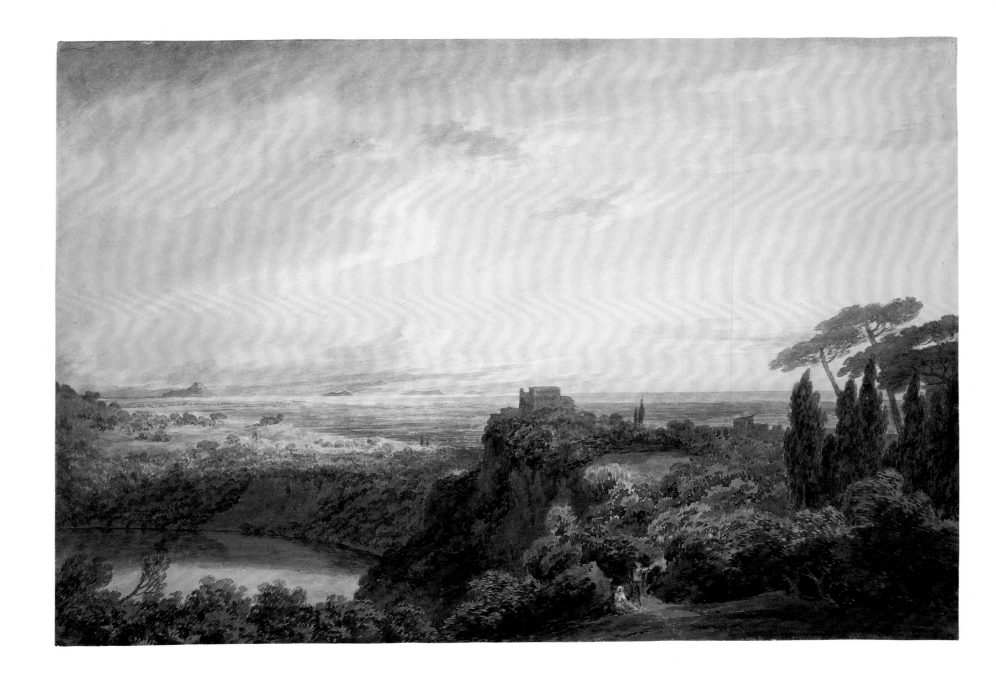

30 John Robert Cozens *Lake Nemi, looking towards Genzano*

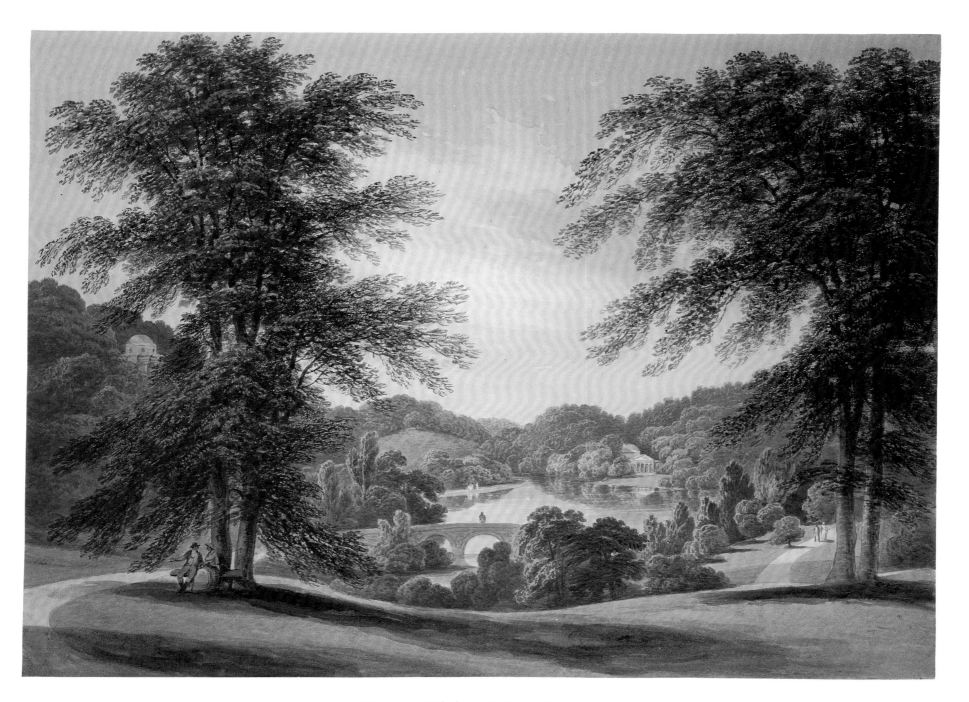

31 Francis Nicholson *A View at Stourhead*

32 Thomas Rowlandson *Greenwich Fair*

33 William Blake *Beatrice on the Car, Dante and Matilda*

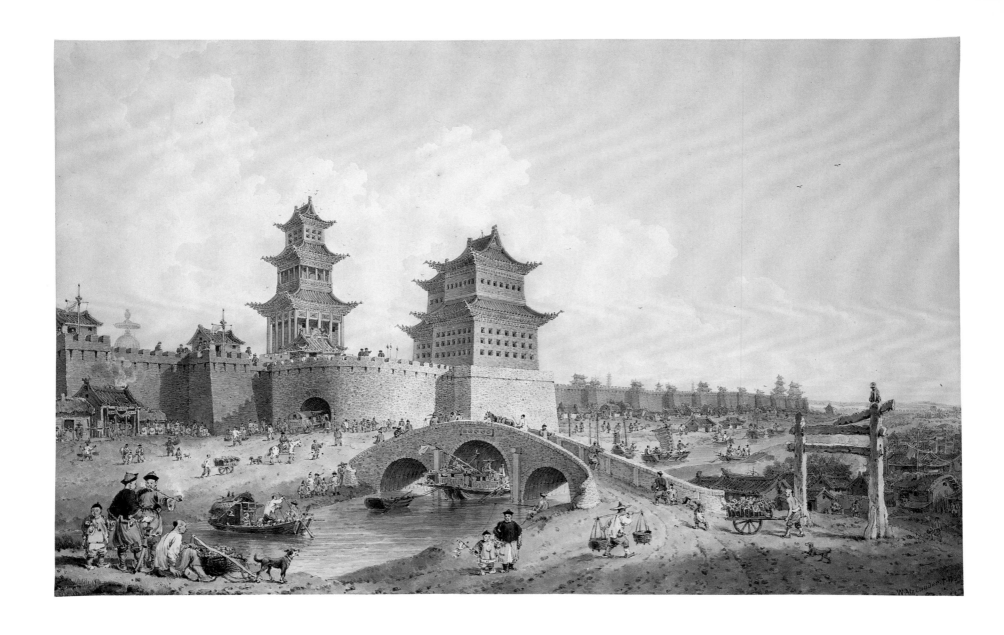

34 William Alexander *Pingze Men, the Western Gate of Beijing*

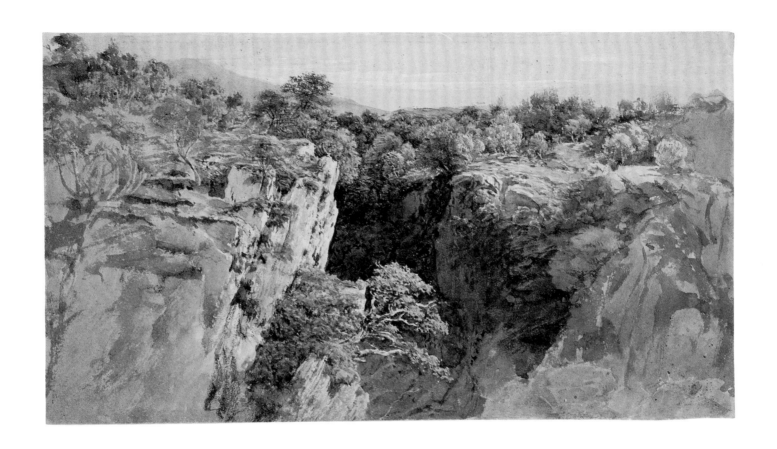

35 John Glover *A Rocky Gorge*

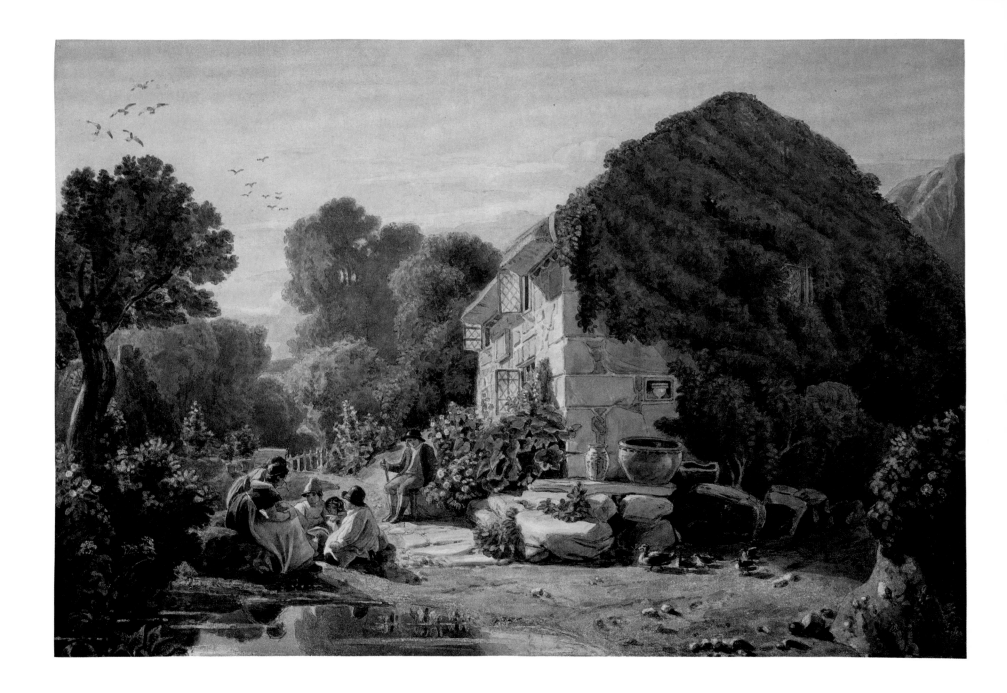

36 Joshua Cristall *A Cottage at St Lawrence, Isle of Wight*

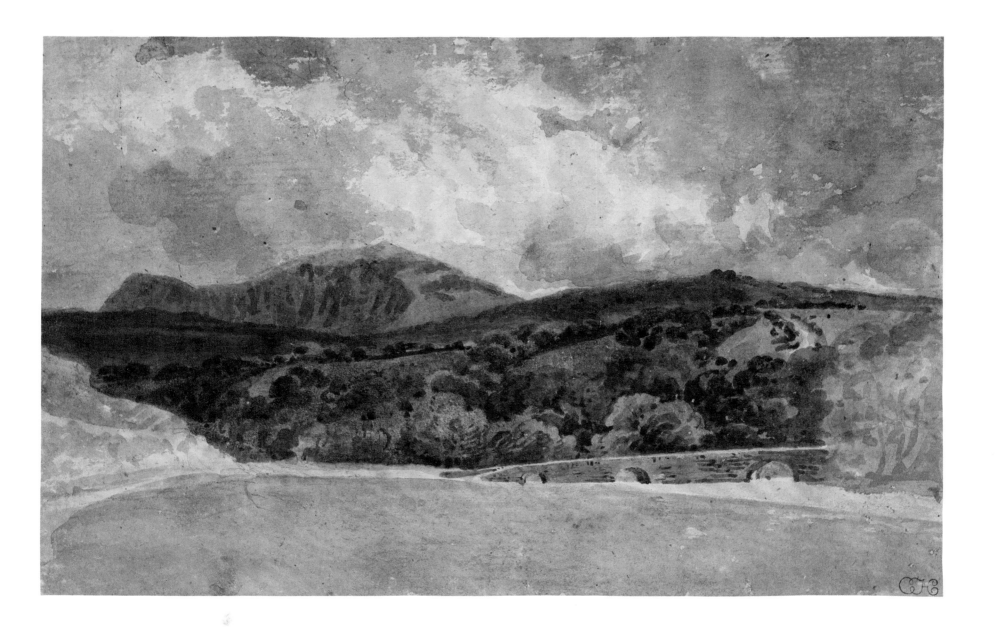

37 Thomas Girtin *Landscape with Hills and Clouds: Mynydd Mawr*

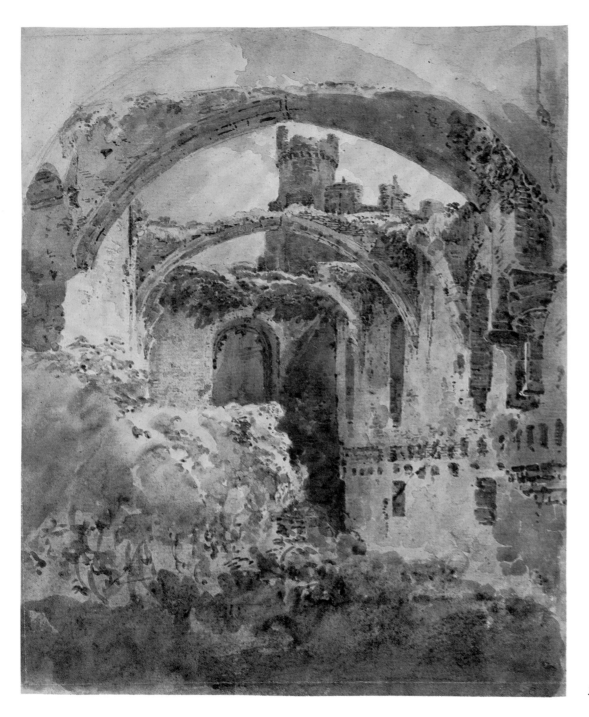

38 Thomas Girtin *The Great Hall, Conway Castle*

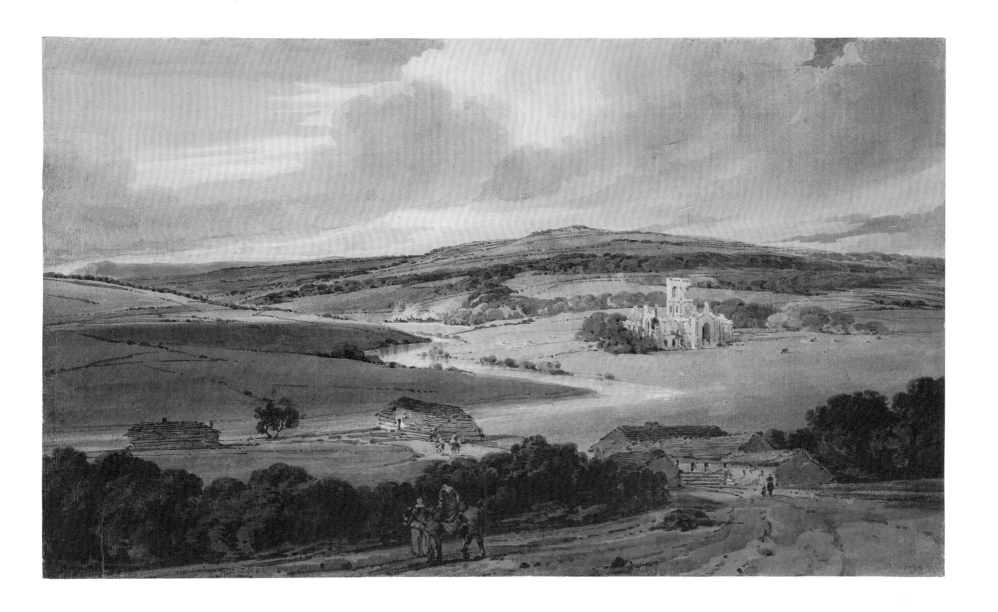

39 Thomas Girtin *Kirkstall Abbey*

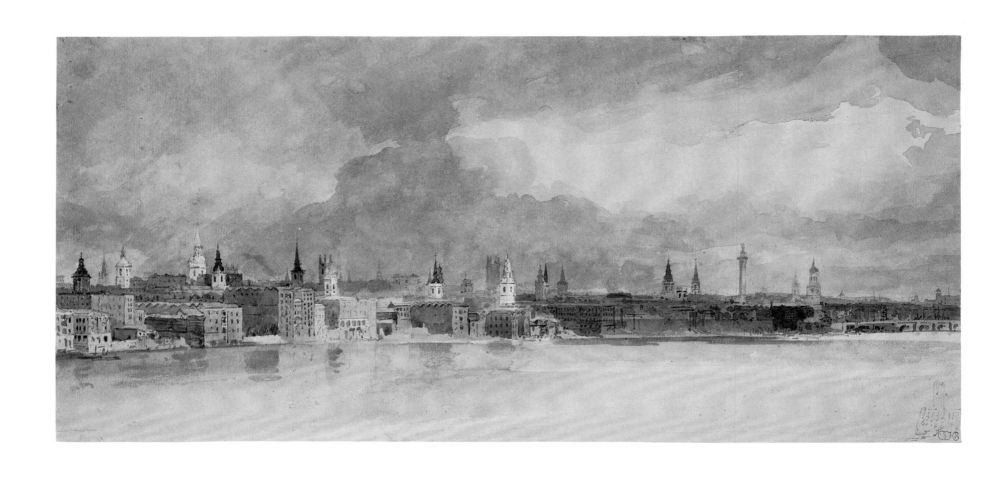

40 Thomas Girtin *The Thames from Queenhithe to London Bridge*

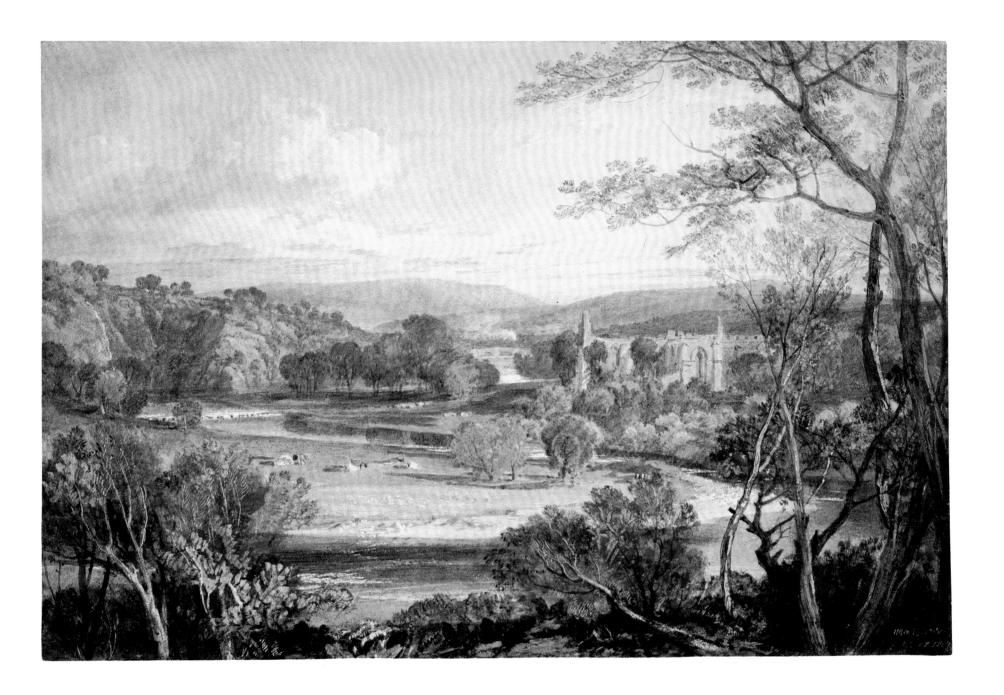

41 J. M. W. Turner *Bolton Abbey, Yorkshire*

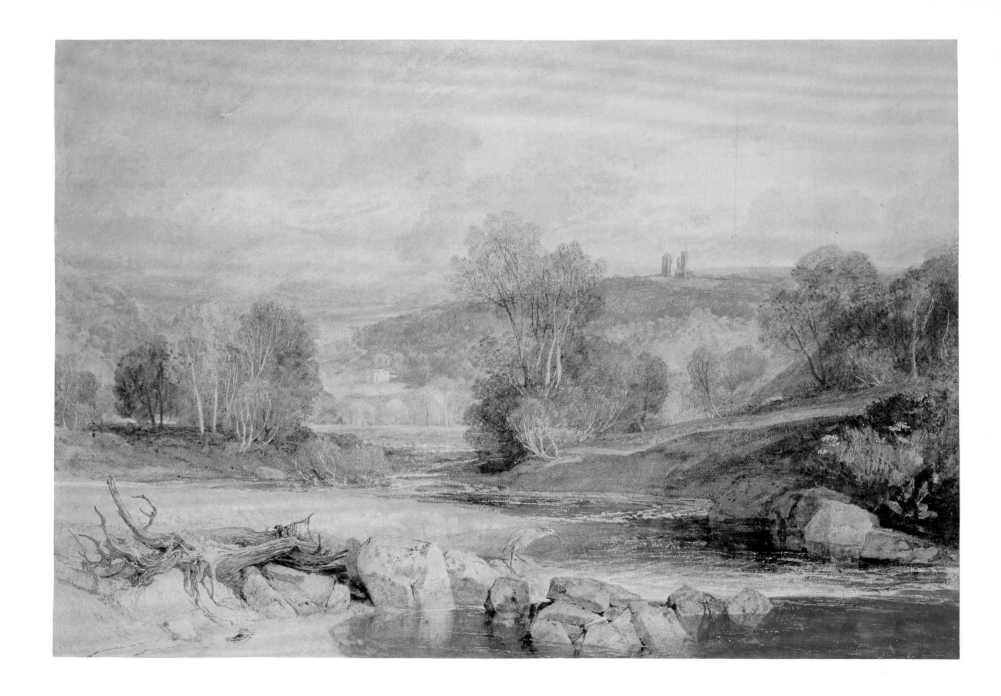

42 J. M. W. Turner *On the Washburn*

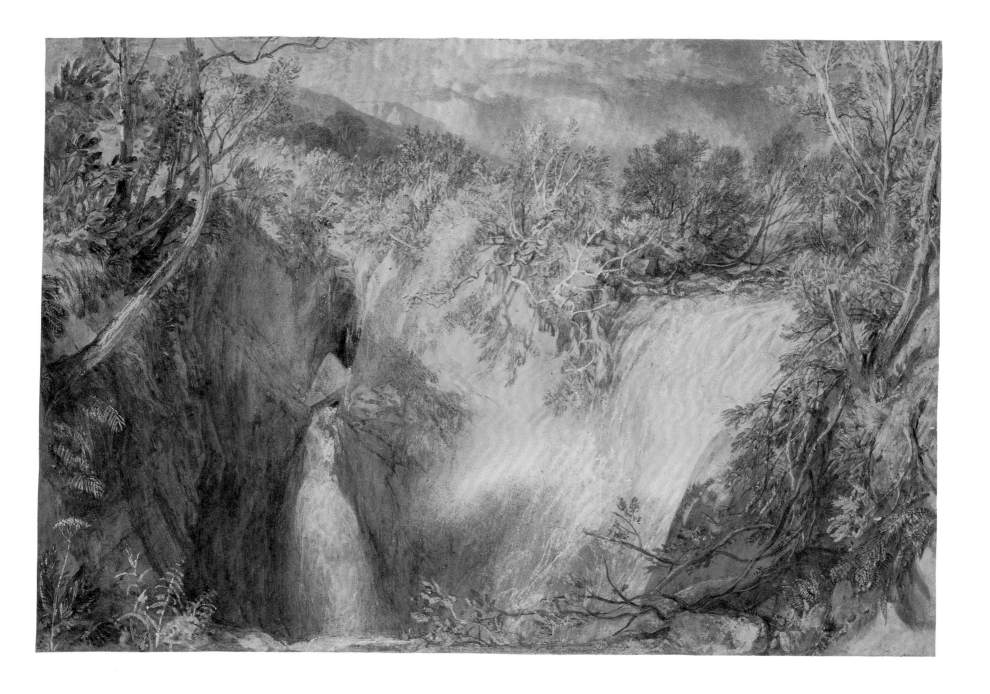

43 J. M. W. Turner *Weathercote Cave, near Ingleton*

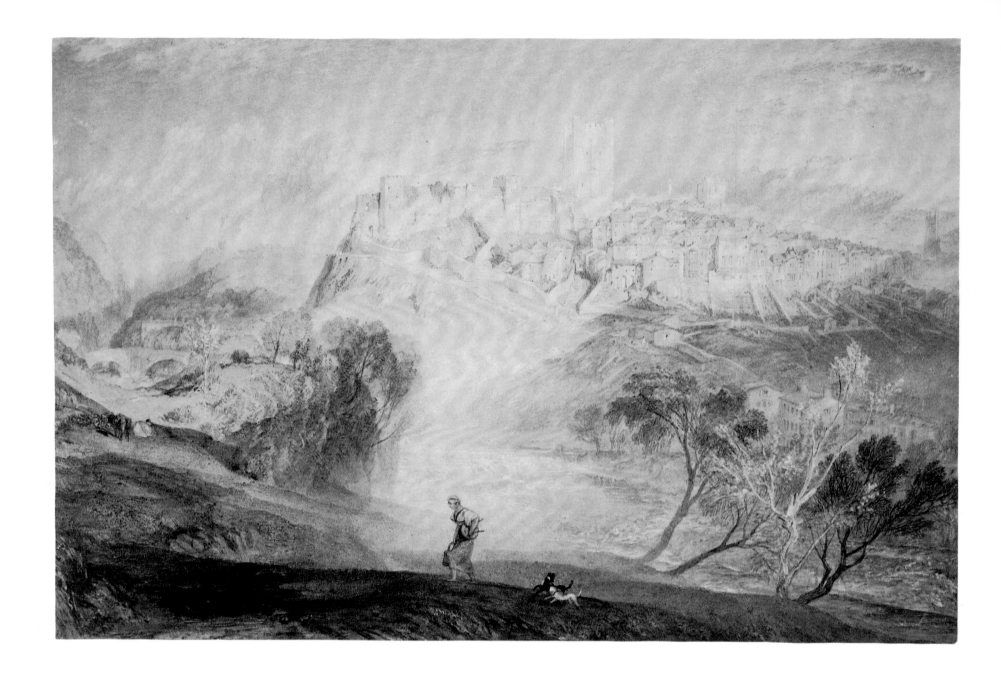

44 J. M. W. Turner *Richmond, Yorkshire*

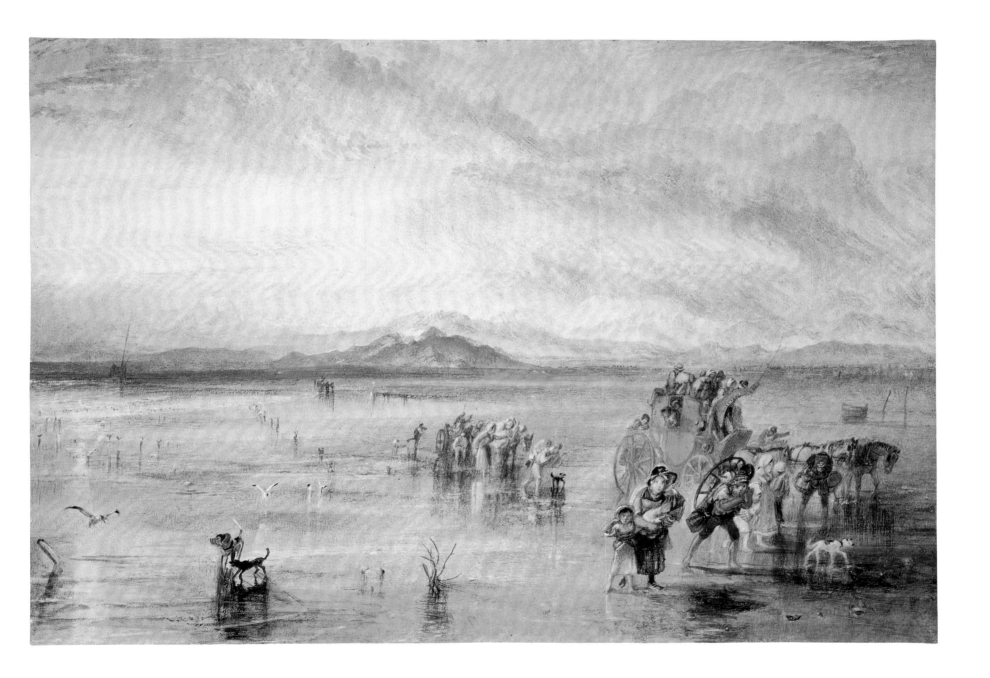

45 J. M. W. Turner *Lancaster Sands*

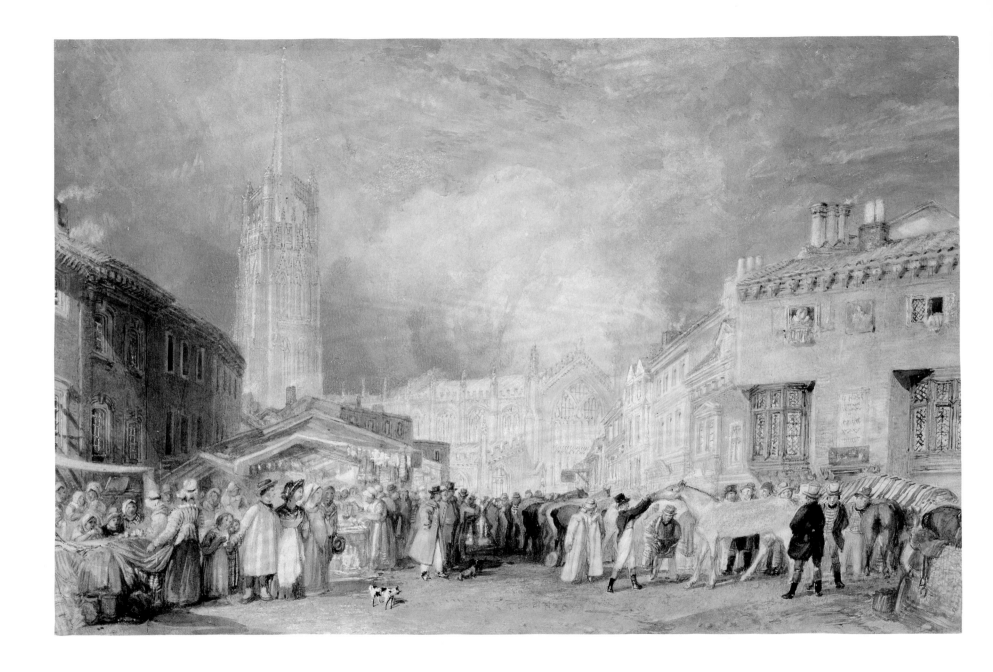

46 J. M. W. Turner *Louth, Lincolnshire*

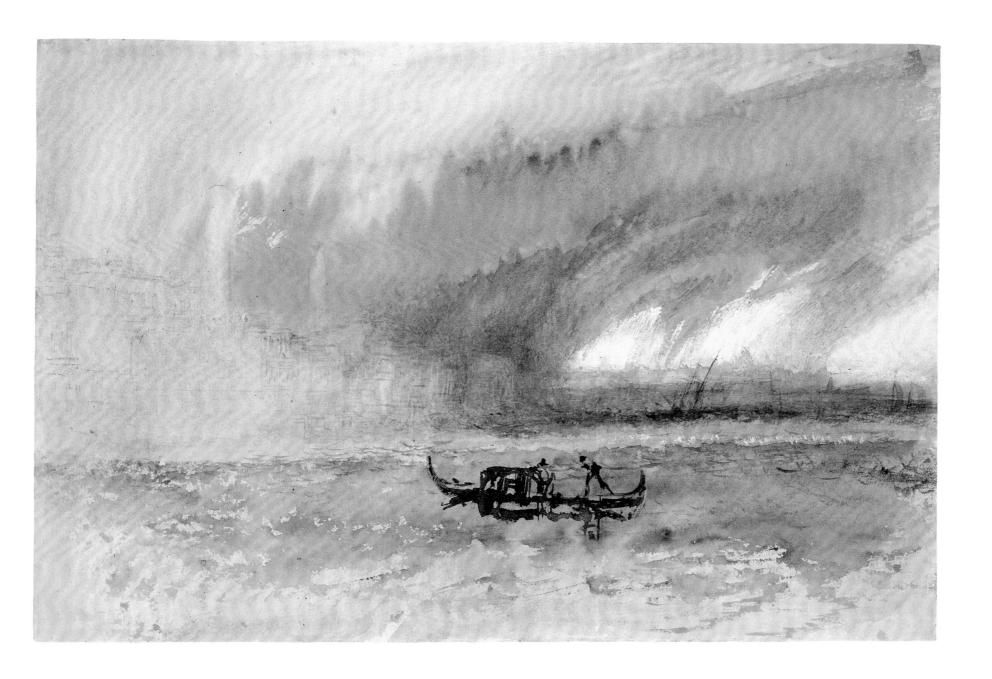

47 J. M. W. Turner *A Storm on the Lagoon, Venice*

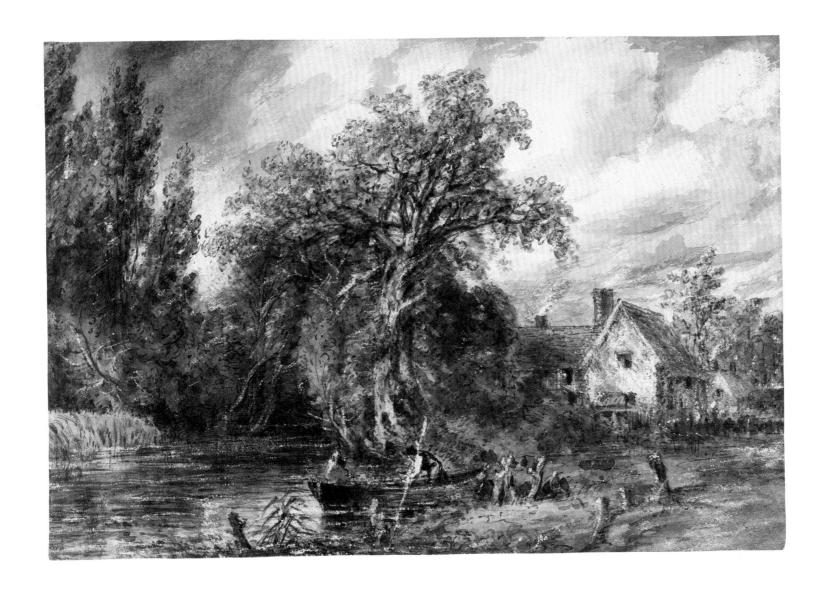

48 John Constable *A Farmhouse near the Water's Edge*

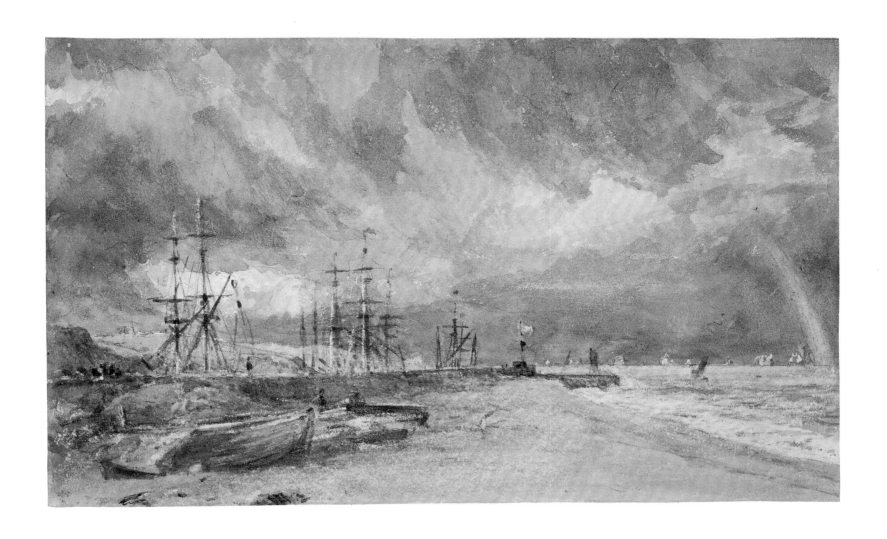

49 John Constable *Folkestone Harbour, with a Rainbow*

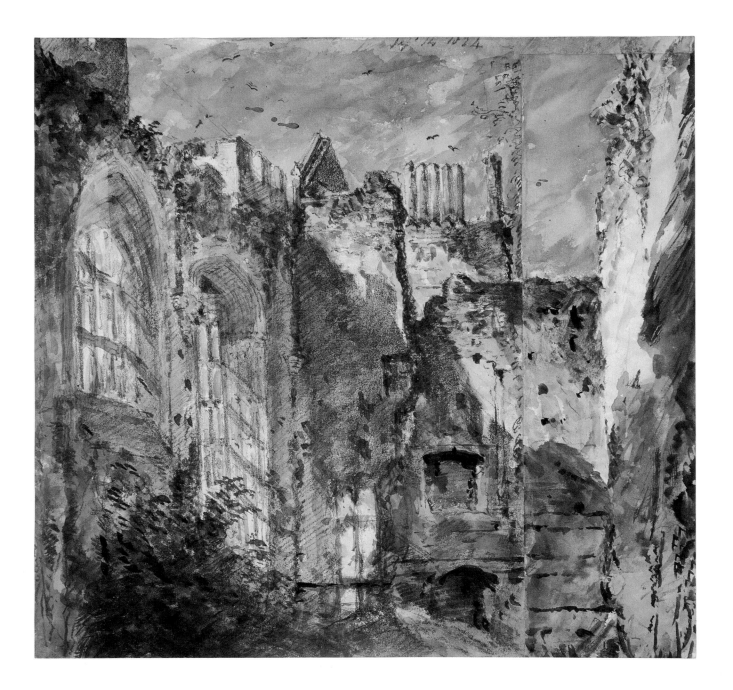

50 John Constable *Cowdray House: the Ruins*

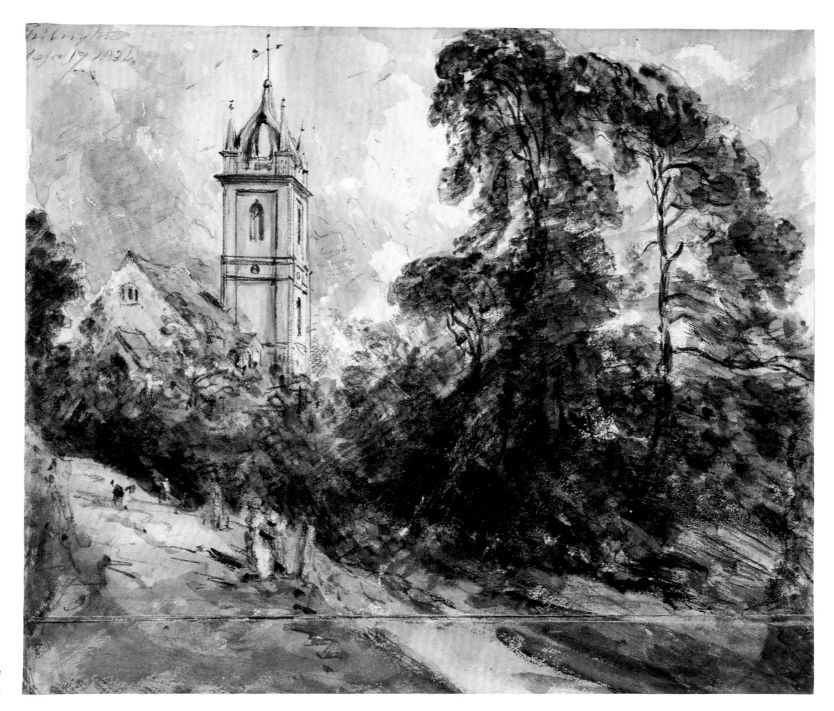

51 John Constable
Tillington Church

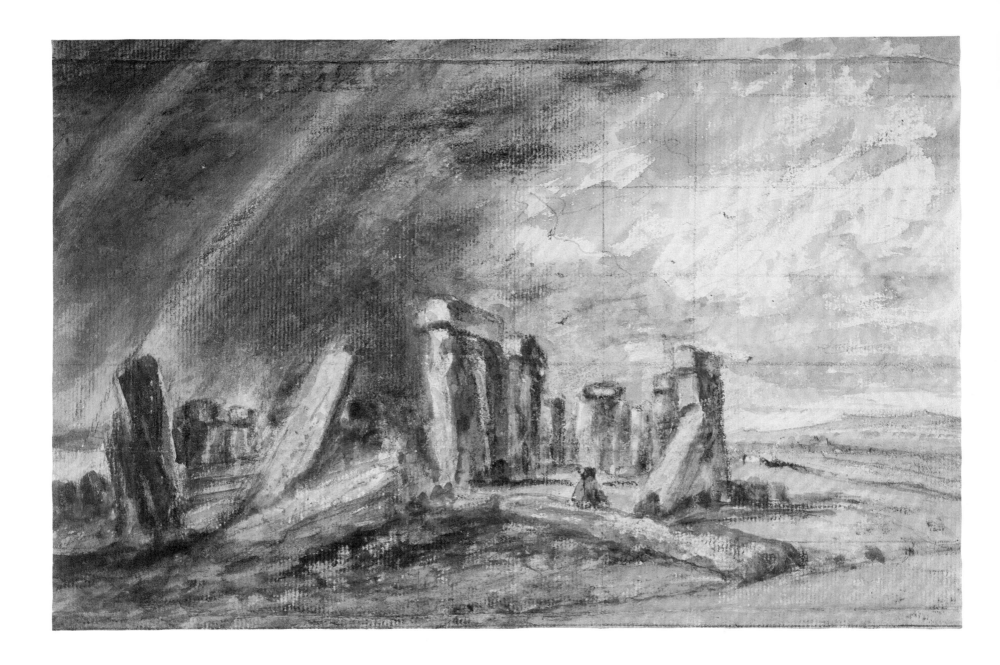

52 John Constable *Stonehenge*

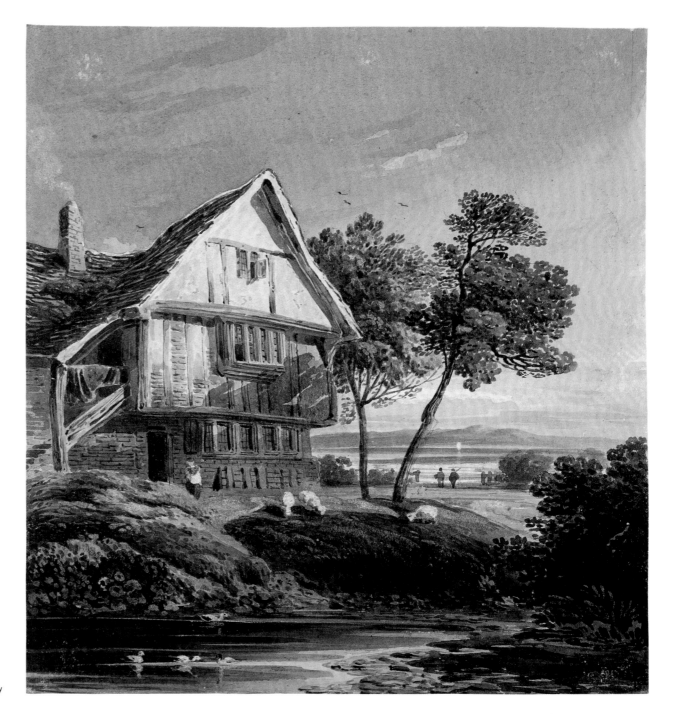

53 John Varley *A Cottage near an Estuary*

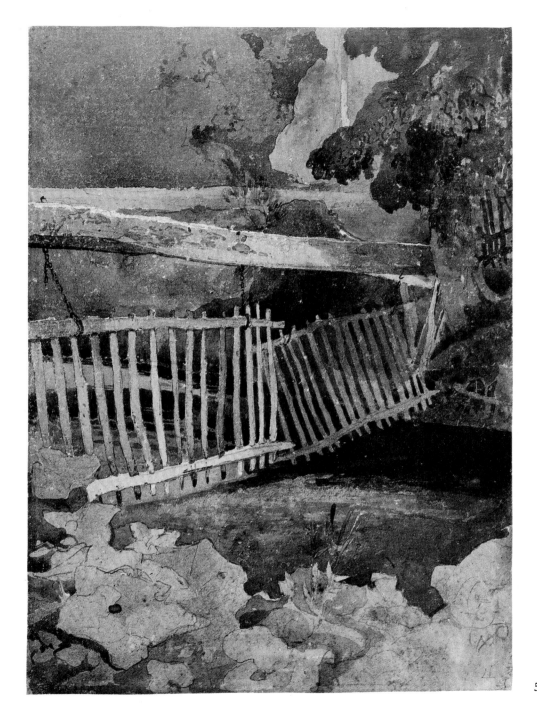

54 John Sell Cotman *The Drop Gate, Duncombe Park*

55 John Sell Cotman *The Scotchman's Stone on the Greta, Yorkshire*

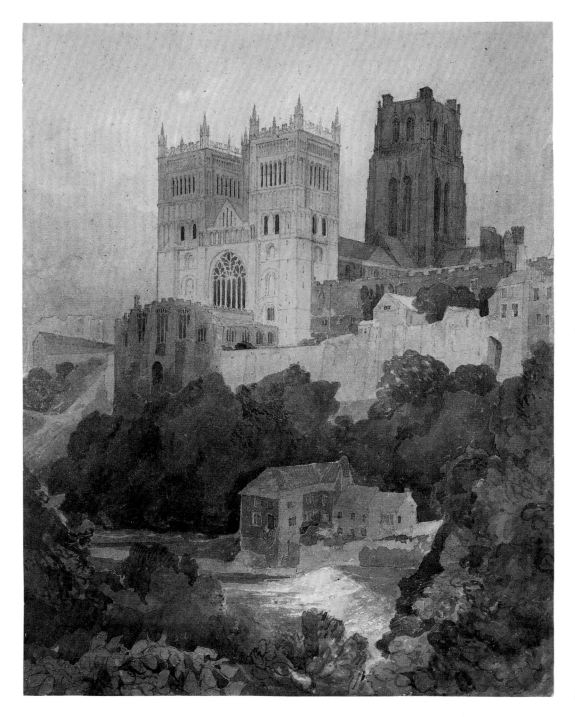

56 John Sell Cotman *Durham Cathedral*

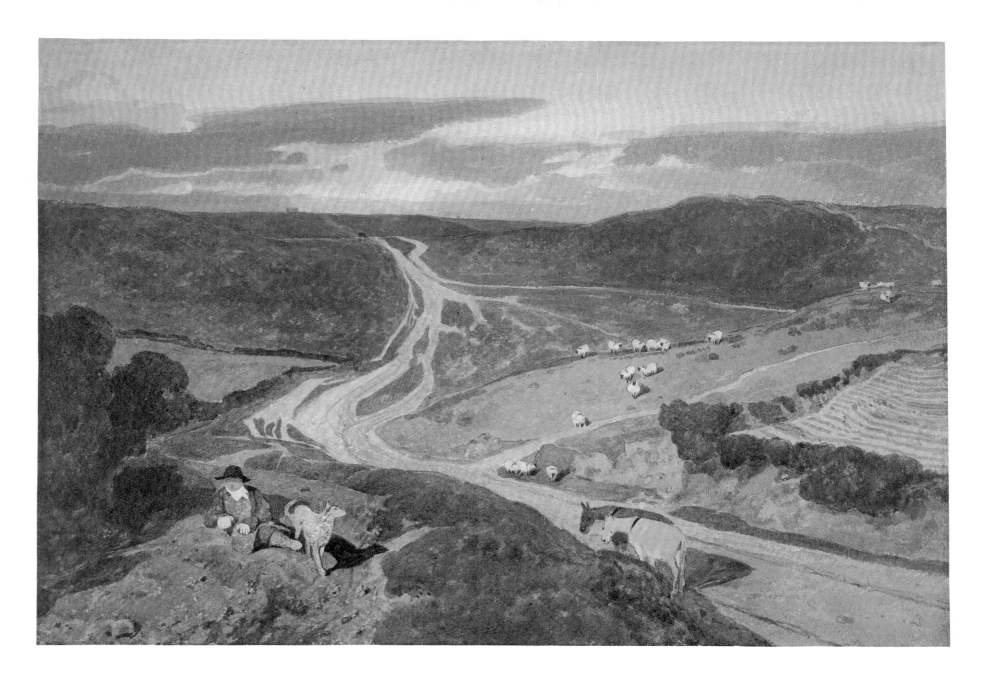

57 John Sell Cotman *Mousehold Heath*

58 John Sell Cotman *The Dismasted Brig*

59 John Sell Cotman *A Mountain Tarn*

60 William Havell *Windermere*

61 David Cox *Flying a Kite*

62 David Cox *Stepping Stones, Bettws-y-Coed*

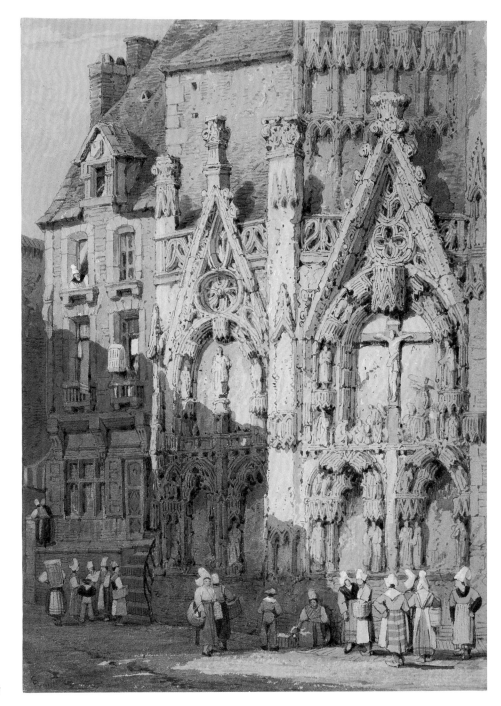

63 Samuel Prout *The Church of St Lô, Normandy*

64 Peter De Wint *Harvesting*

65 Matilda Heming *A Backwater at Weymouth*

66 Anthony Vandyke Copley Fielding *Scarborough*

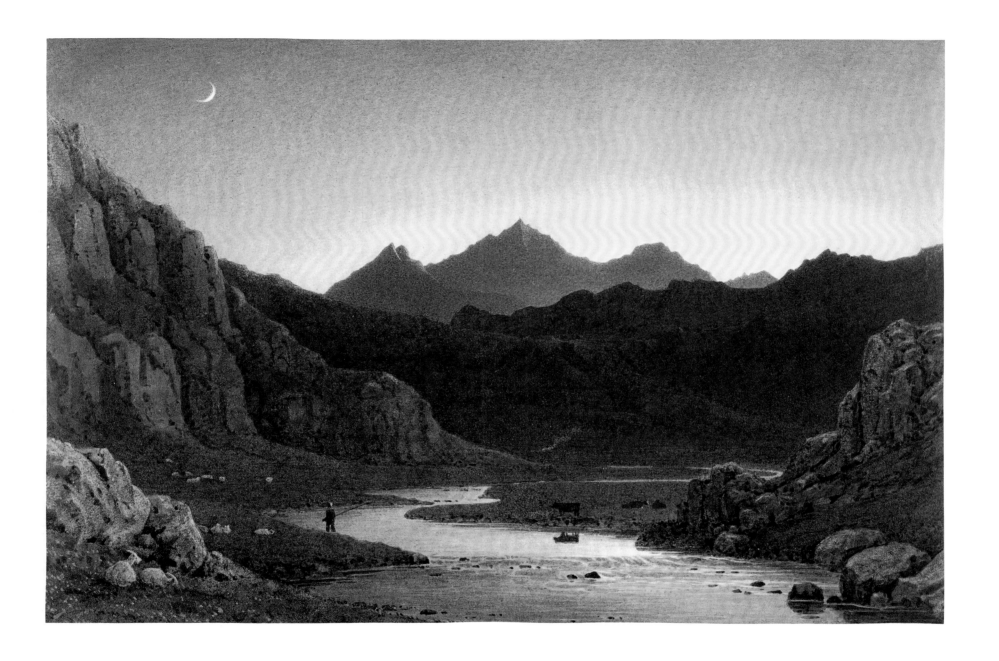

67 George Fennel Robson *Sunset in the Highlands*

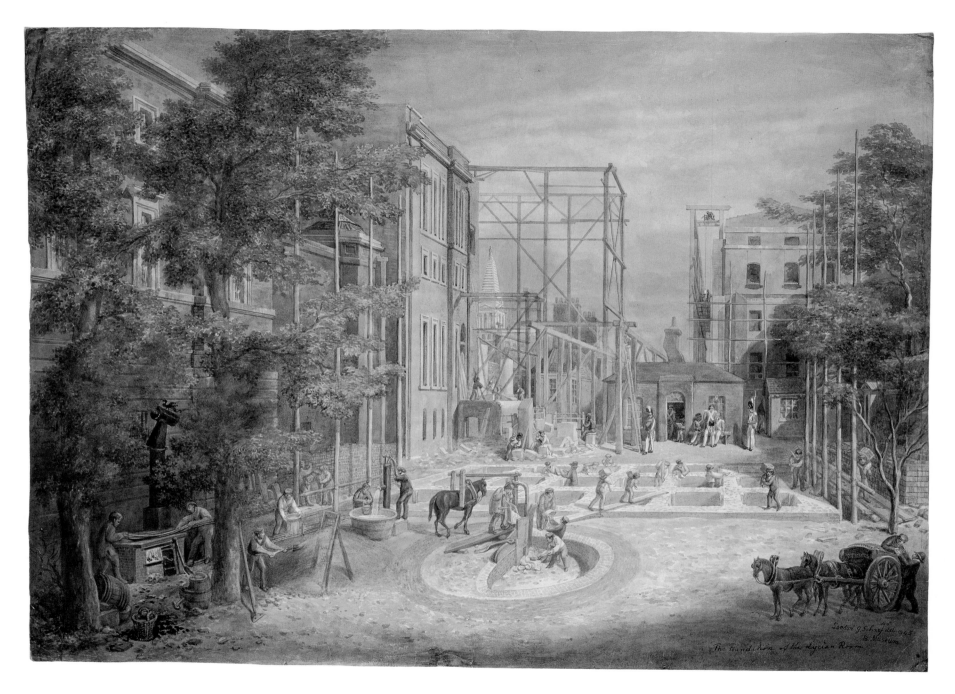

68 George Scharf the Elder *Laying the Foundations of the Lycian Room at the British Museum*

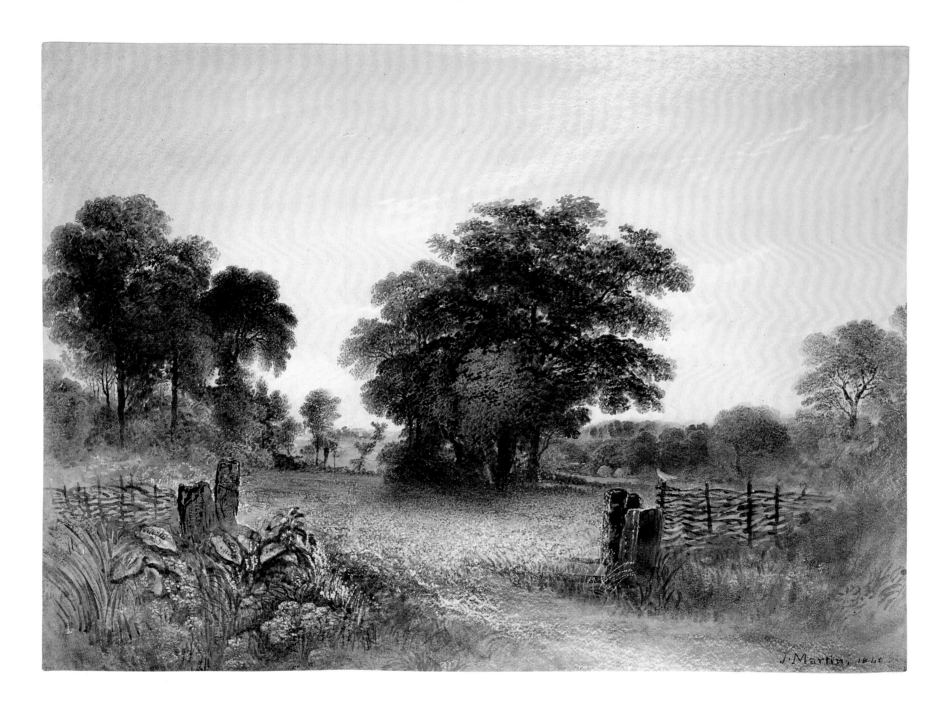

69 John Martin *A Meadow*

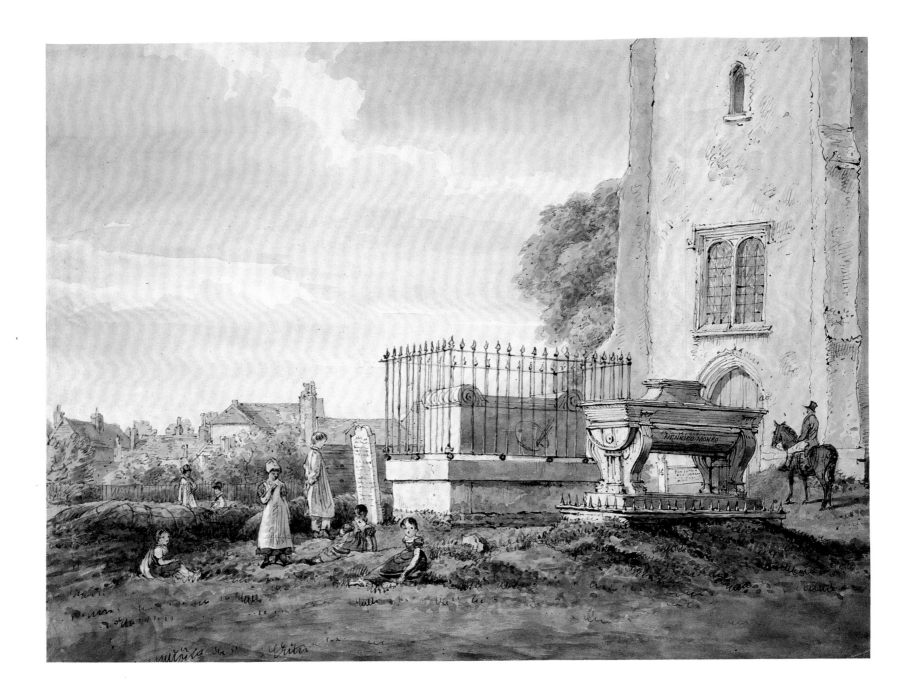

70 William Henry Hunt *Bushey Churchyard*

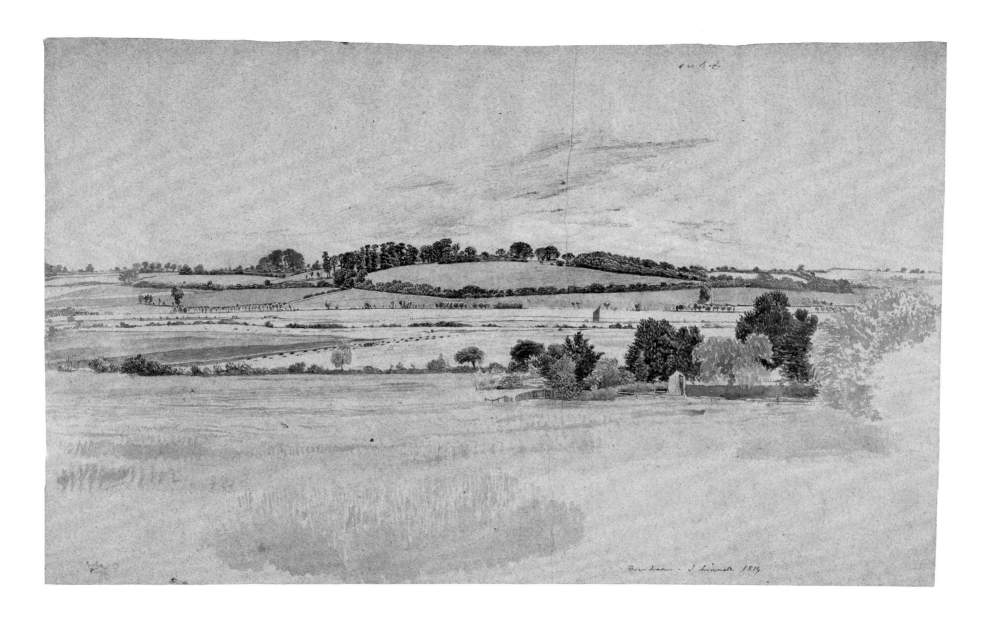

71 John Linnell *The Valley of the River Lea, Hertfordshire*

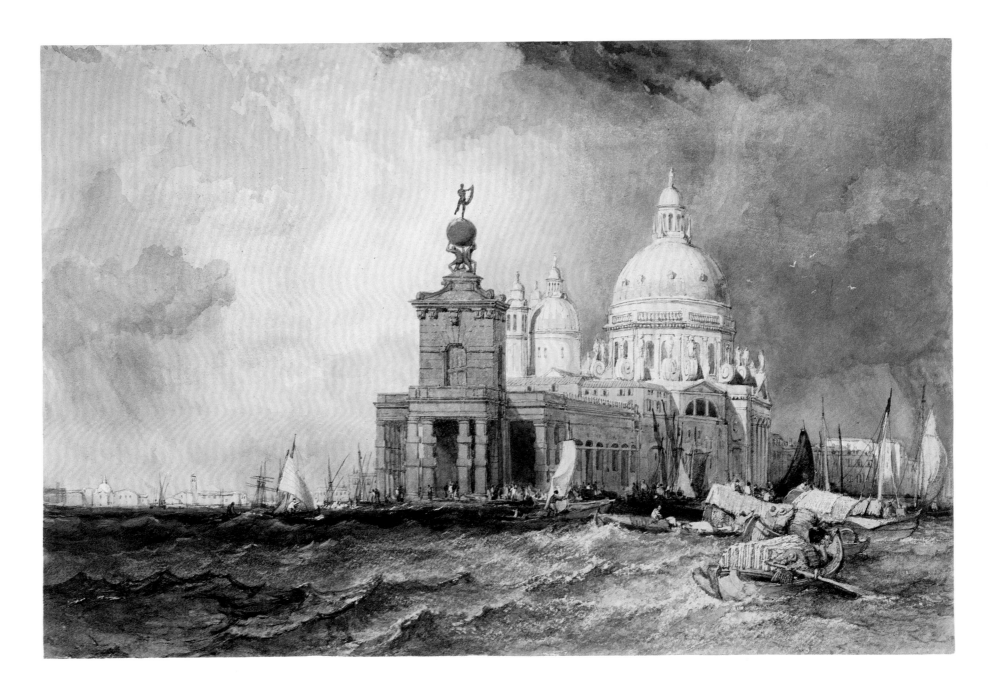

72 Clarkson Stanfield *The Dogana and the Church of the Salute, Venice*

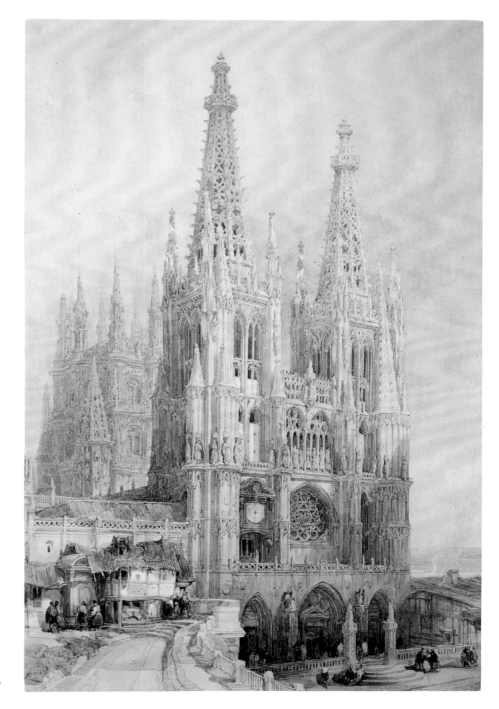

73 David Roberts *Burgos Cathedral*

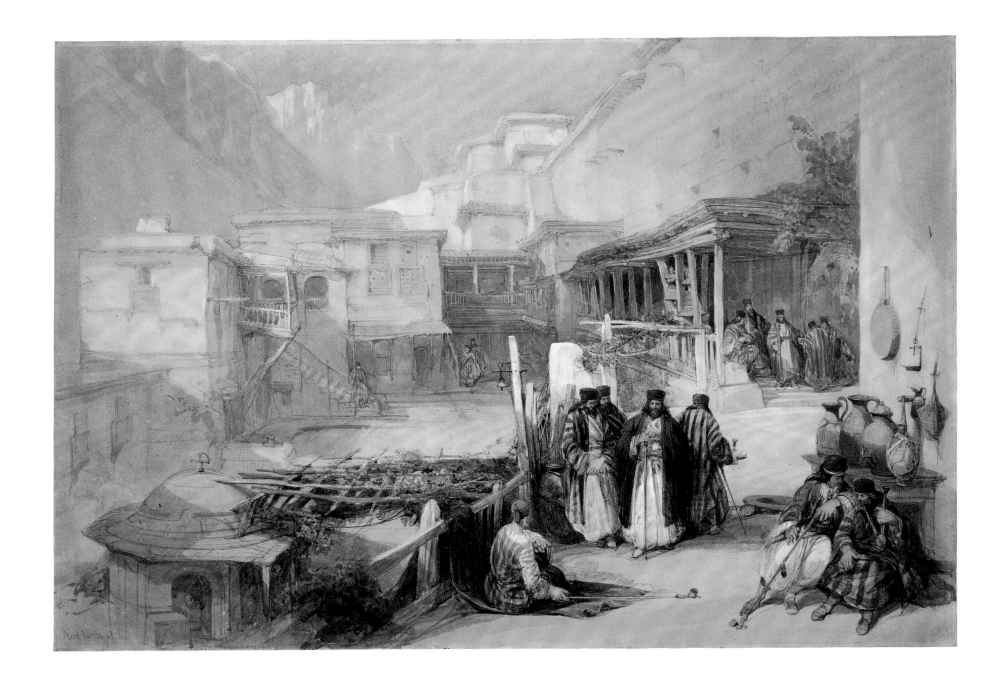

74 David Roberts *The Convent of St Catherine, Mount Sinai*

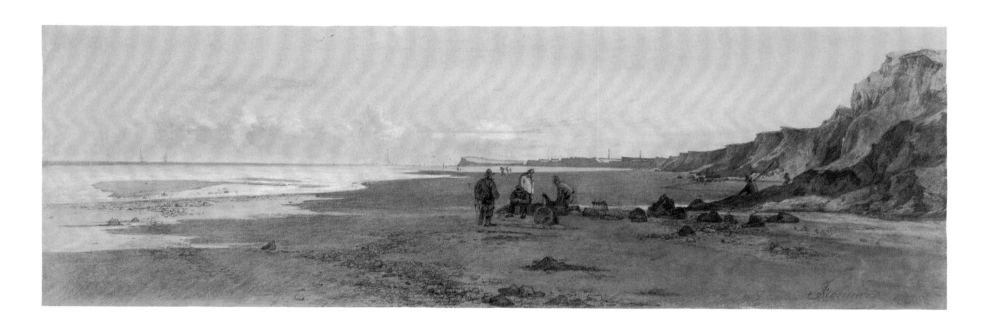

75 Joseph Stannard *The Beach at Mundesley, Norfolk*

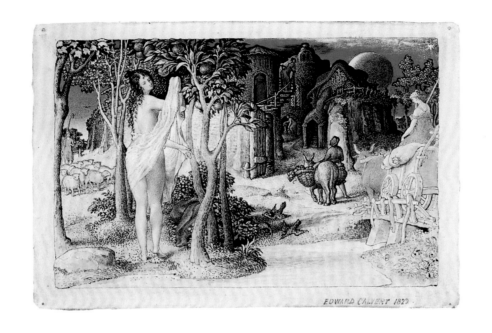

76 Edward Calvert *A Primitive City*

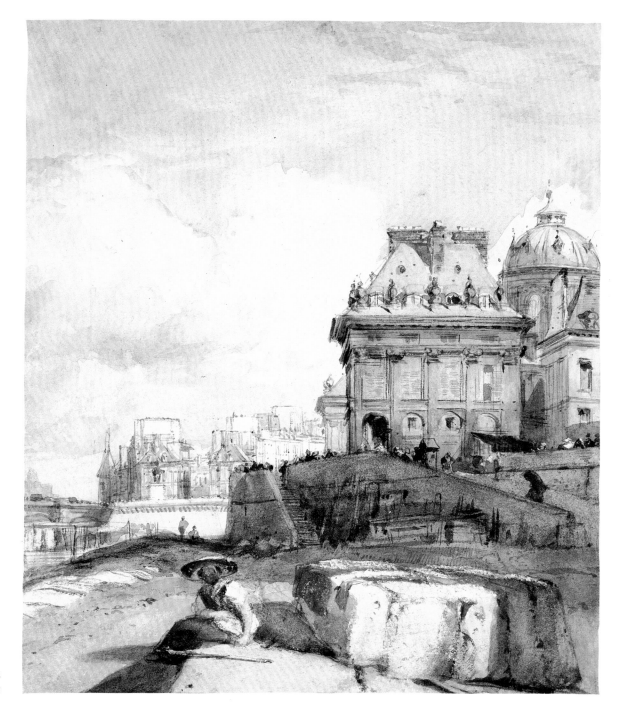

77 Richard Parkes Bonington
The Institut seen from the Quai, Paris

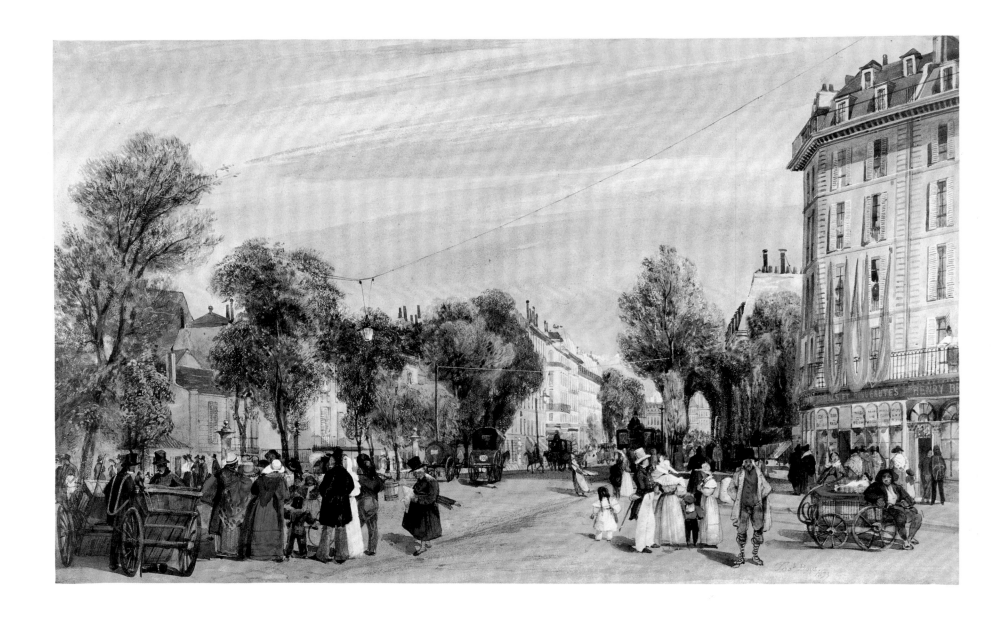

78 Thomas Shotter Boys *The Boulevard des Italiens, Paris*

79 William Leighton Leitch *S. Croce in Gerusalemme, Rome*

80 John Frederick Lewis *The Alhambra*

81 Samuel Palmer *A Cornfield by Moonlight with the Evening Star*

82 Samuel Palmer *A Study for 'The Bright Cloud'*

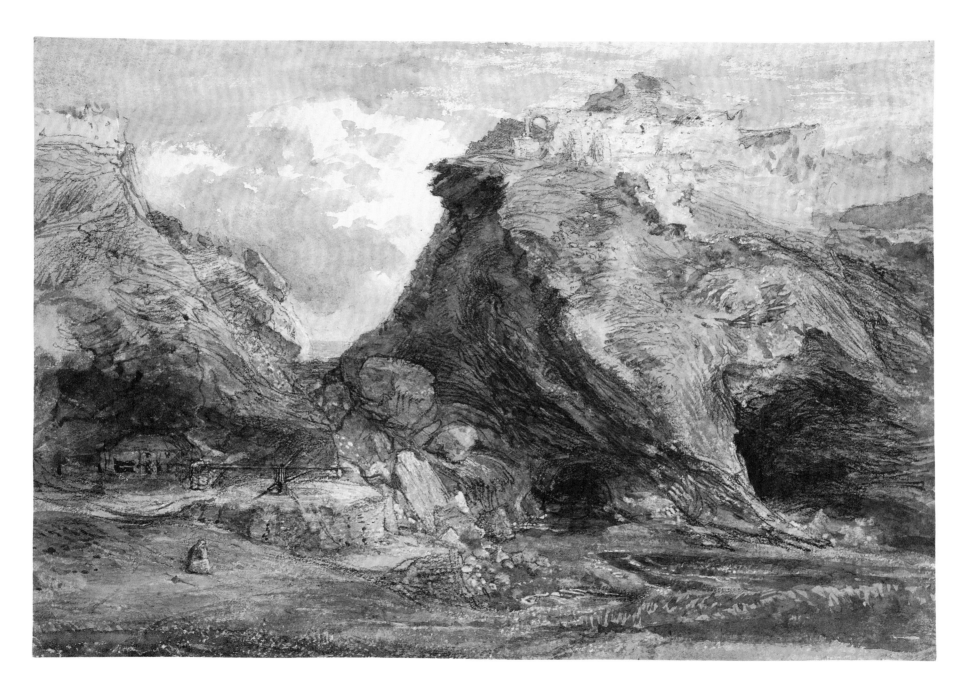

83 Samuel Palmer *Tintagel Castle*

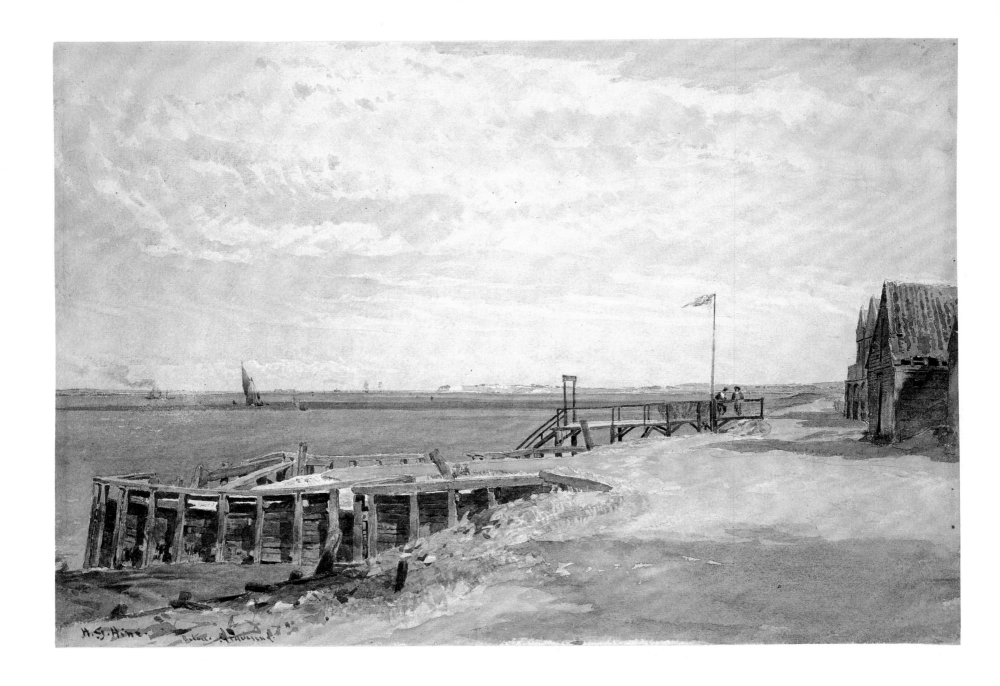

84 Henry George Hine *Gravesend*

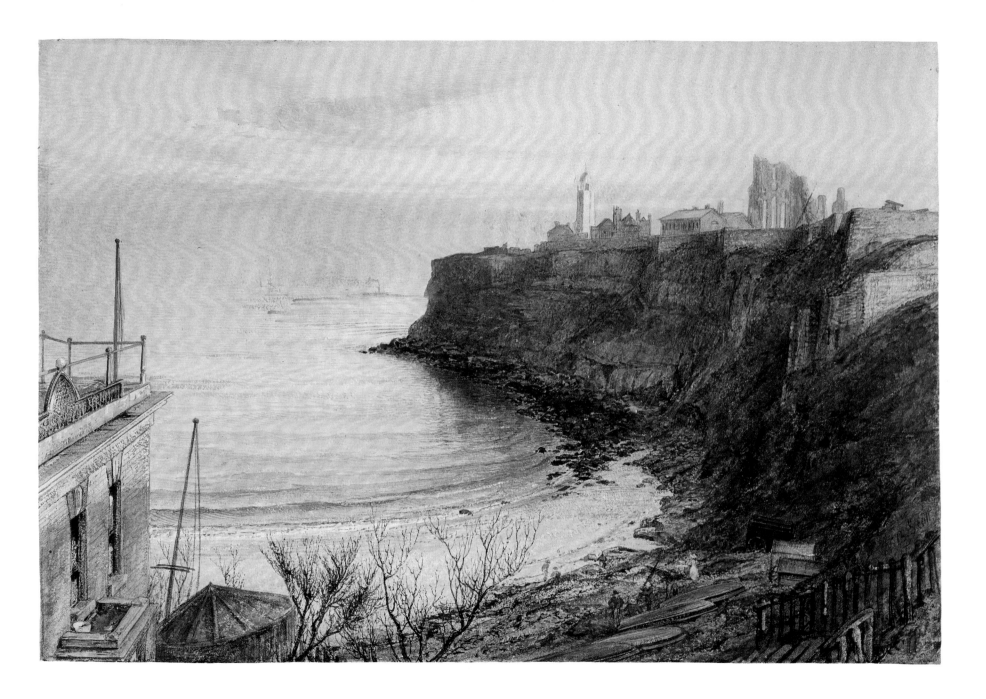

85 William Bell Scott *King Edward's Bay, Tynemouth*

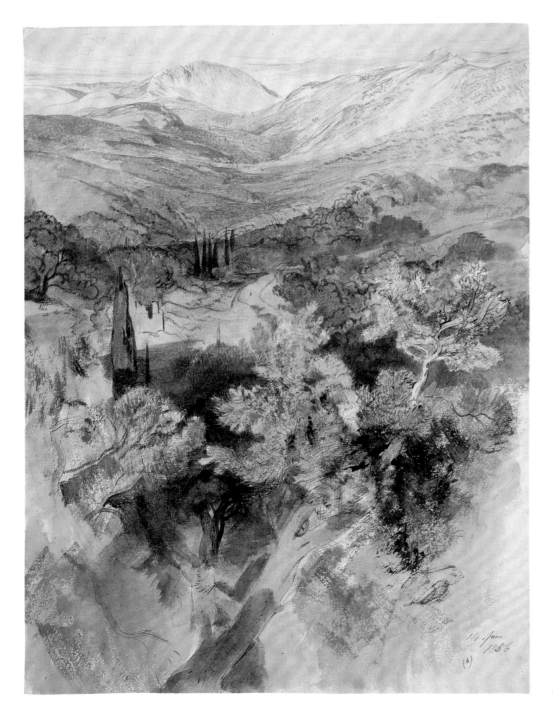

86 Edward Lear *Choropiskeros, Corfu*

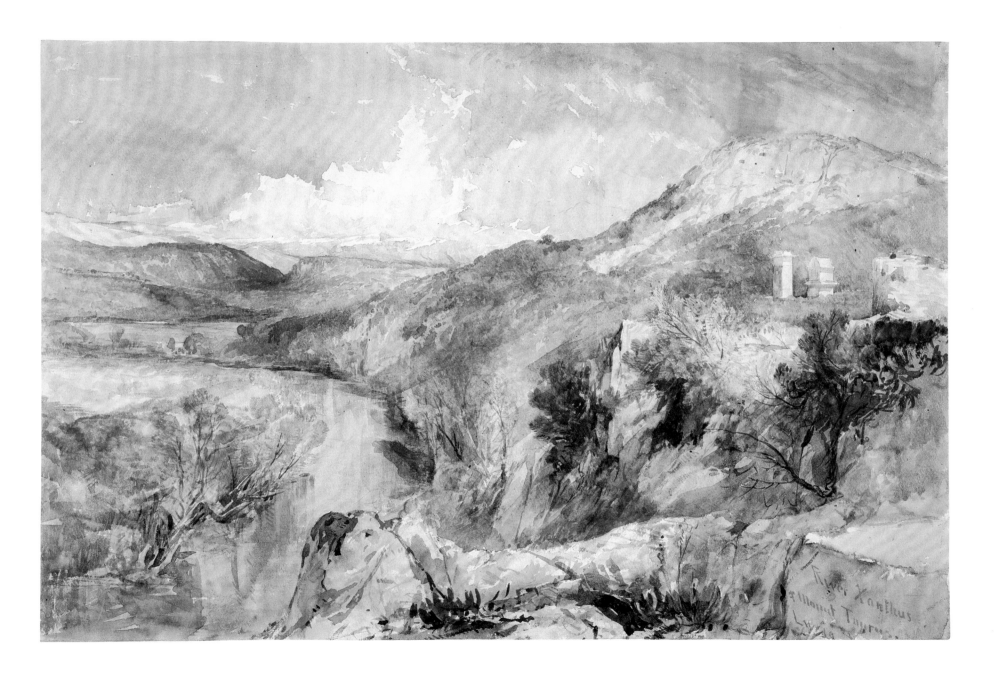

87 William James Müller *The River Xanthus*

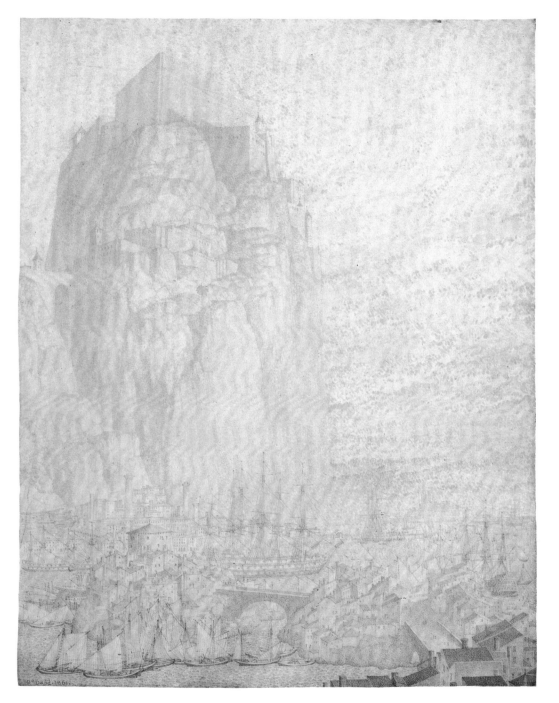

88 Richard Dadd *Port Stragglin*

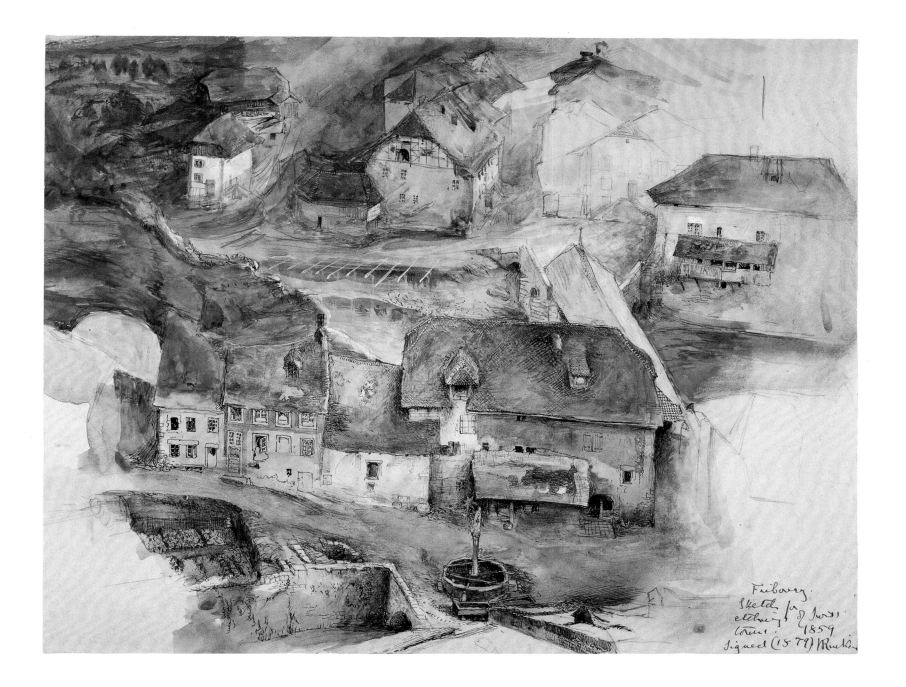

89 John Ruskin *Fribourg, Switzerland*

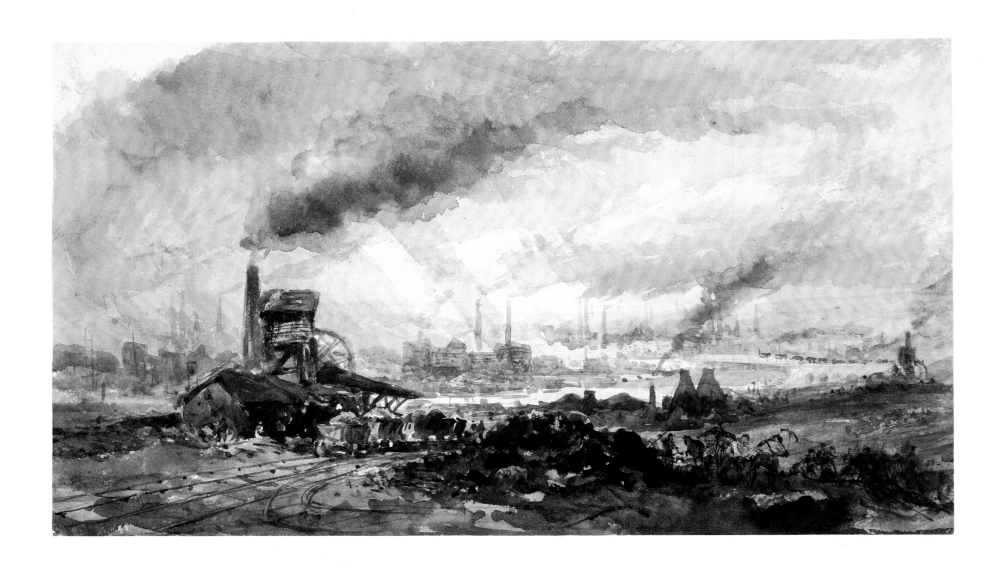

90 Samuel Bough *A Manufacturing Town*

91 William Simpson *Summer in the Crimea*

92 Richard Doyle *Under the Dock Leaves – an Autumnal Evening's Dream*

93 Myles Birket Foster *The Thames from Cliveden*

94 George Price Boyce *Streatley, Berkshire*

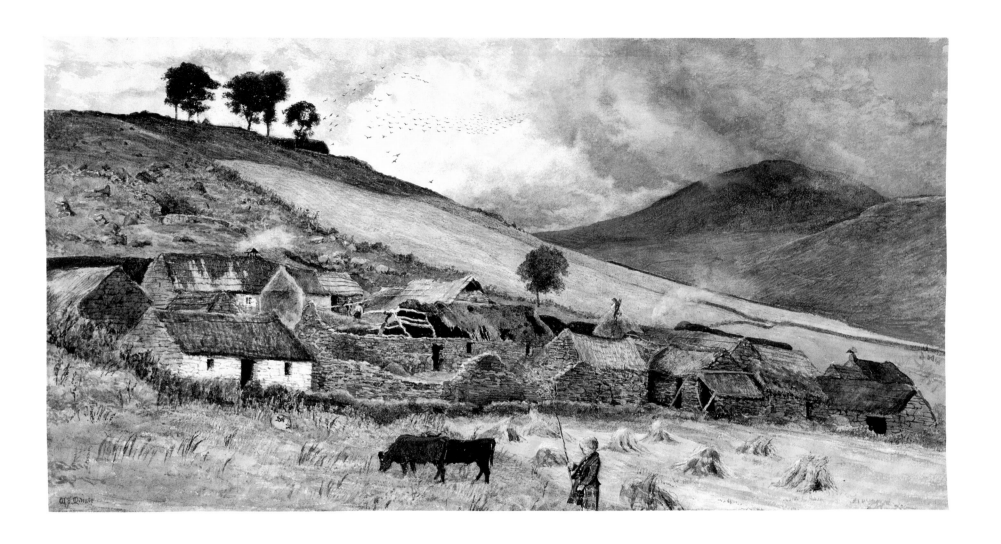

95 William Henry Millais *A Scottish Farm*

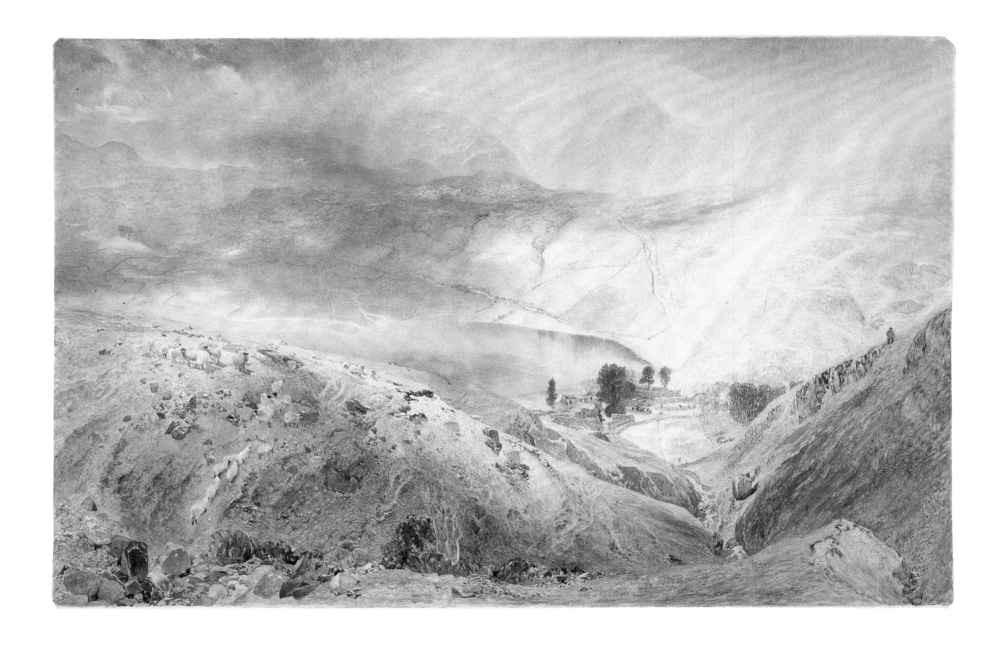

96 Alfred William Hunt *The Tarn of Watendlath between Derwentwater and Thirlmere*

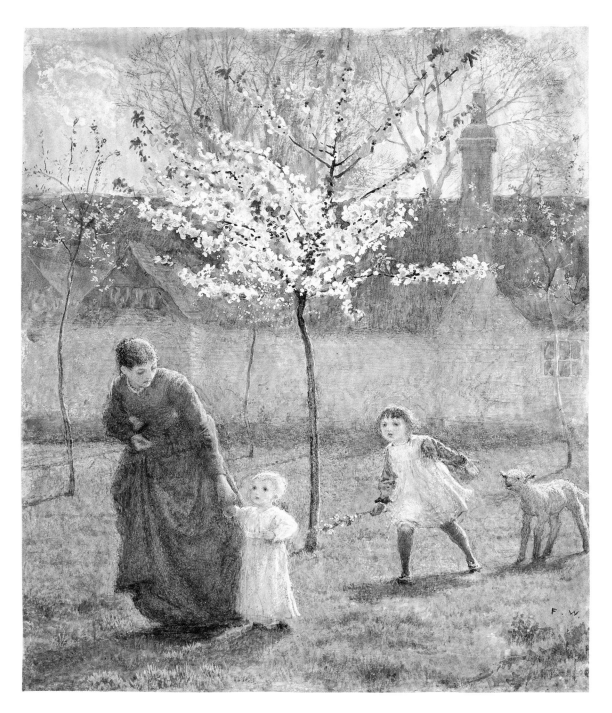

97 Frederick Walker *The Spring of Life*

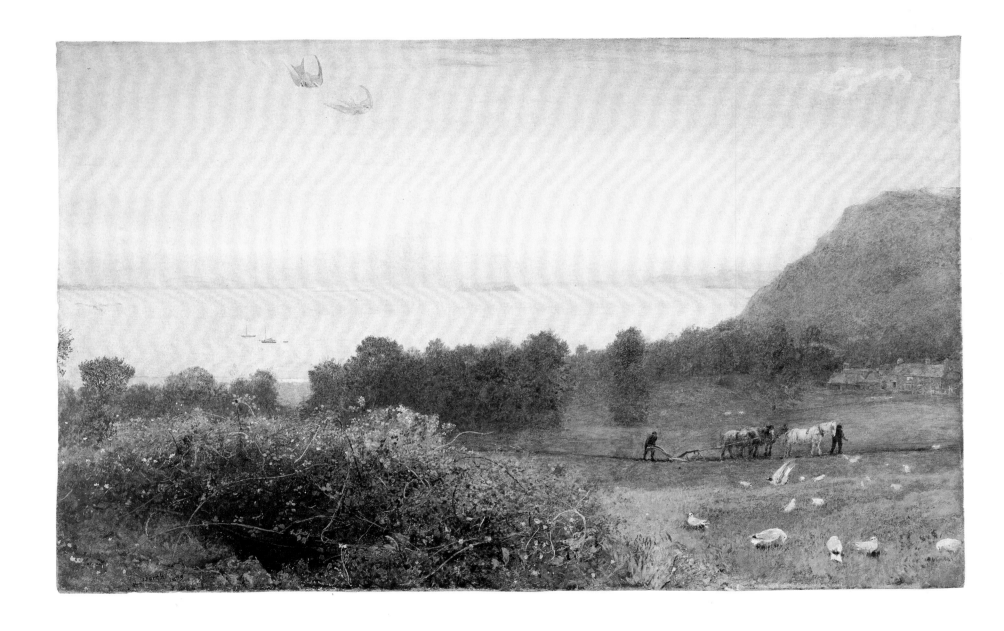

98 John William North *A Coastal Scene*

99 Walter Crane *An Orchard by a Stream*

100 Helen Allingham *A Cottage near Haslemere, Surrey*